175

SO-CPE-321

SEP 83 XXY

WOMEN IN LATIN AMERICAN HISTORY

REVISED EDITION

UCLA LATIN AMERICAN STUDIES SERIES

Volume 51

Series Editor: Johannes Wilbert

Editorial Committee: Robert Burr Mildred E. Mathias

John E. Englekirk Stanley L. Robe

Edward Gonzalez Jonathan D. Sauer

Thomas J. La Belle Robert M. Stevenson

REVISED EDITION

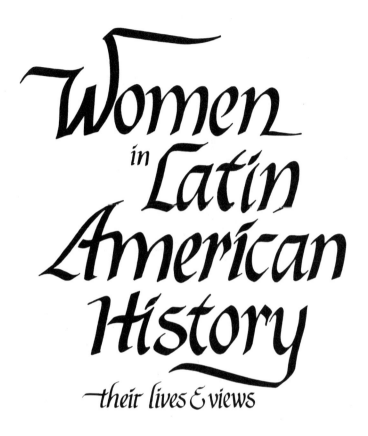

Women in Latin American History

their lives & views

edited by
JUNE E. HAHNER

UCLA LATIN AMERICAN CENTER PUBLICATIONS
UNIVERSITY OF CALIFORNIA, LOS ANGELES, CALIFORNIA

UCLA Latin American Center Publications
University of California, Los Angeles

Copyright © 1976, 1980 by The Regents of the University of California
All rights reserved

Library of Congress Catalog Card Number: 80-620044
ISBN: 0-87903-051-8
Printed in the United States of America

To the memory of my grandmother

1881 – 1971

Preface to Revised Edition

The field of women's history has expanded greatly since this volume was originally published in 1975. Even though more work on women in Latin America appears every year, the gap remains large between the amount of research conducted on women in the United States as compared with that on women in many other parts of the world. The increase in publications on Latin American women is reflected in the revised and updated bibliographical survey included at the end of the book.

The volume originated with a search for materials for a course I developed on the history of women in the Americas, first offered in 1972 at the State University of New York at Albany. A few of the selections herein were originally used in that course, and the students' reactions to them proved useful. This revision adds three new selections in addition to the expanded bibliography, and incorporates changes in the introduction and elsewhere.

I wish to express my gratitude to Asunción Lavrin, who has long studied the history of Latin American women, for her valuable suggestions, comments, and for the letter used in selection 3, which she most generously provided. I appreciate Dauril Alden's many suggestions and those made by Joan Miller, Carlos Astiz, Warren Dean, Robert Comarck, and Peter Furst. Robert Novak assisted me in the original bibliographical investigations. I am also indebted to Frank G. Carrino, with whom I worked in translating selections 9, 12, and 15 (I translated selections 2, 4, 5, 7, 10, 14, and 20 myself), and to Kathleen A. Golday, who typed much of the original manuscript. Of course, I alone am responsible for the contents of this book.

Albany, New York JUNE E. HAHNER
August, 1980

Contents

IV. Twentieth Century: Economic and Sexual Roles

V. Twentieth Century: Change and Nonchange

Introduction

Although women comprise an indispensable element in the evolution of Latin America, their activities have received scant scholarly attention. Histories of Latin America are traditionally written as though women scarcely existed. Even with the recent increase in publications on Latin American women, historical research on women in Latin America lags far behind that on their counterparts in the United States or Western Europe.

As long as historians, themselves generally male, devoted their major efforts to investigating the transmission and exercise of power, then women were basically ignored in Latin America as in other areas of the world. There was little room in political, diplomatic, or military history for women, who for so long have been largely outside the power structure. But in recent decades, the traditional historical concentration on elites and upper classes and on great public events like national elections, war, civil strife, and revolution has given way to new approaches. Scholars have brought to light information about social groups previously considered too unimportant or obscure to merit investigation. With the rise of social and economic history and with increasing concern for groups out of power, women have begun receiving more attention. It is nevertheless still often assumed that what was said of men historically held equally true for women.

Whereas the history of women in the United States has benefited from a dramatic growth in scholarship during the past two decades, the same is not true of Latin America. Socioeconomic changes occurring in the twentieth century reinforce the need for a historical perspective and understanding of women's roles, status, and activities in Latin America, which in turn will enrich our knowledge of the Latin American past. Women are essential for achieving a balanced and multidimensional view of reality, past and present.

1

Women must be studied on their own terms, in the light of their activities and positions within their societies. Although some people have attempted to draw parallels between the treatment of women and that of ethnic or racial minorities, no precise parallel exists. At various times and in different places women have formed not an unintegrated, uniformly oppressed minority but actually a majority of the population. For centuries women have been excluded from positions of power, political and economic, but some individual women as members of particular families were often closer to actual power than were many men. If women have swelled the ranks of the oppressed and exploited, some women have also been among the oppressors and exploiters. Class divisions loom large. While some women protested their limited opportunities, many adapted themselves to their circumstances and did not welcome change. Yet women comprise fully half of the population of their regions and countries, and their activities have always been an essential and integral part of the history of their countries, even though generally unrecognized as such.

This is certainly the case with Latin America, a complex, diverse, deeply stratified region composed of nations differing widely among and within themselves. A thorough study of women in Latin America would examine women's activities within their distinct societies and would deal with their public and private lives, perceptions, legal status, family life, political power, and economic and sexual roles over the centuries, both in the cities and the countryside and among diverse social groups. No brief formula can adequately explain or summarize the variety of women's lives in Latin America.

In exploring new areas of investigation more questions can be raised than can be easily answered. How can we reconstruct the past from the point of view of women of different classes and social groups? How can a valid and useful conceptual framework for the study of women be developed? How can we even conceptualize women? As, generally, a majority of humankind, women clearly comprise the largest "group" in the world. Yet they also participate in nearly every other group within society; women are dispersed throughout the population, and except for special interest organizations, they have not combined together. This simultaneous oneness and diversity has confounded almost everyone who has tried to come to grips with it.

To make the problem even more difficult, women are the only group which as a whole tends to be treated unequally yet which as individuals live in greater intimacy with their "oppressors" than with each other. We must ask how different women in Latin America adapted to the male-dominated society surrounding them. How and why did a society which upheld the image of the chaste, protected, passive female uphold certain deviations from that ideal? Under what circumstances did women assume more active roles? How can we resolve questions posed by apparently conflicting evidence? For example, foreign travelers' accounts of the same colonial society describe some women of the elite as serving as property owners and managers and others as cloistered and isolated in their homes. Many questions of numbers, changes over time, class, and particular circumstances remain to be investigated. Why and how did attitudes toward women, held by both men and women, change? How can we characterize nuns, prostitutes, mothers, slaves, professional women, urban slum dwellers, and modern middle-class housewives? What did these and other women have in common? What have been the most significant variables in their lives? It is well to keep such questions in mind while reading the accounts in this book by different women in Latin America.

Some of the earliest studies of women in Latin American history, as of women elsewhere in the world, concerned notable women, "important" women left out of traditional history, and their uncommon achievements. This approach is a form of compensatory or remedial history. It serves as a necessary counter to conventional history, to a traditional view of women as a second sex or deviant from the dominant male sex. Although exceptional women such as Sister Juana Inés de la Cruz (selection 2) or Eva Perón (selection 13) deserve our attention, this approach does not tell us of the mass of women in history, like peasant women (selection 18) or urban slum dwellers (selection 17).

Other studies describe women's contributions to society, as well as their status in a male-dominated society. Related questions concern the oppression of women and its opposite, the struggle for women's rights. Although less attention has been paid to such subjects in Latin America than in the United States, materials for the study of feminist and suffrage movements clearly do exist (selections 7, 10, and 11). But scholars cannot stop there, either.

The history of women in Latin America is not a history of oppression any more than it is a history of the accomplishments of famous women. Nor is it just a study of the images of women, or their sex roles, although all of these are important and well deserving of close scholarly scrutiny. The connections between changes in class and in sex relations need to be understood and changes in the roles of men and women need to be investigated in the light of fundamental changes in the mode of production. These approaches have been employed in studies on Latin American women in varying degrees, as listed in the Bibliographical Survey of Writings on Latin American Women at the end of this volume. But huge gaps remain. The complexity of women's experience, the duality of that experience, renders the task of investigating their experiences, activities, functions, problems, perceptions, and values all the more difficult and challenging, for women remain simultaneously at both the center and the margin, numbering among the oppressed as among the oppressors.

Traditional methods and sources alone, especially the old political approaches, will not suffice to reconstruct this complex reality. Although the methodologies of social history and of family history prove very useful, new approaches and new sources and bodies of data must also be explored, ranging from ballads to family memorabilia to the minutes of women's organizations and the records of charitable institutions. The use of documents such as wills and testaments or judicial and notarial records has made it possible to distinguish the formal ideal of women's behavior expressed by law from the actual scope of women's activities, including their participation in regional or national economic structures. Baptismal and parish registers for the colonial period and census and civil records for the nineteenth and early twentieth centuries provide basic information permitting historians to reconstruct the family and establish patterns of marriage and fertility rates. More conventional printed sources such as congressional debates and newspapers and magazines illuminate a variety of issues, such as divorce, women's suffrage, or feminism, including both traditional concepts and reformers' views of women and the family. The new methodologies of oral history, demography, quantitative history, collective biography, iconography, psychohistory, and comparative

cross-national studies have much to contribute to the study of women. Researchers need to gather the materials needed to explore the effects of demographic and geographic changes on family structure and on kinship systems, or to investigate the effects of philosophic and religious movements on women's perceptions of their roles and on female-male power relationships, or to research role prescription and role discontent and attempt to relate these to actual behavior.

The writings of women themselves are the most valuable sources for reconstructing the female past. Certainly they constitute the richest source for examining self-perceptions and self-definitions. These writings give us an intimate view of women's feelings and attitudes, even though one must question how closely the personal experiences and reality of a few women reflect those of other women in the same period and what the relationship is between an individual and society.

This volume endeavors to let Latin American women speak for themselves. The selections reflect the experience of a variety of women in Latin America in different periods, countries, and economic and social circumstances viewed from their own perspectives. The selections serve as a sample of this variety and as an indication of sources for future research. At the same time, they help demolish the myth of the inactive and secluded Latin American woman. Although a limited number of women, however diversified their life styles and activities, cannot fully represent what it was to be a woman in Latin America, these accounts, written by women and extending across time, space, and class lines, can help to clarify women's general condition. The selections are meant to provoke more questions than they answer. They are also meant to provide some materials useful for comparative studies of women in different societies, and, it is hoped, stimulate new interpretations and further research into the past.

Historians are largely dependent on written sources and on the availability of those sources. From earliest days until the mid-twentieth century, most women in Latin America were unable to read and write, and that narrows the range of possible selections for this volume. Diaries are rarely kept by so-called ordinary people, male or female, especially in a region where the majority have long been illiterate. Only with the advent of the

tape recorder has other than an occasional scholar shown much interest in recording the life stories of lower class, nonliterate individuals.

As even fewer women than men were literate in colonial Latin America, and they came from the upper strata of society, the number of firsthand accounts is most limited. Our selections for this period can present only a circumscribed, impressionistic portrait of women's lives and experiences. The feelings, thoughts, and emotions of the vast majority of women in the European empires of the New World are probably lost. What largely remain from the earliest period of contact between Indians and Europeans, and even from the long centuries of colonial rule, are a number of accounts by men, ranging from those by conquerors to those by missionaries, government officials, and foreign travelers.

Some of those firsthand reports prove basic sources of information on the position and activities of women in the distinct Indian groups which, along with the Iberian societies, formed the base cultures contributing to the development of much of Latin American civilization. Although Friar Diego de Landa, Bishop of Yucatán, burnt many of the old Maya codices in an effort to blot out superstition, he also preserved much of what is now known of Maya civilization in his *Account of the Things of Yucatán*, written in the 1560s.[1] With his descriptions of Mayan women as morally superior and chaste, no doubt he was commenting upon Spanish society as well as judging New World people by Spanish standards. In contrast, Bernardino de Sahagún, another Franciscan, who spent many years among the Aztecs of the central plateau region of Mexico and who wrote his monumental *General History of the Things of New Spain* in their language, Nahuatl, provides us with the Aztecs' own view of women in their highly developed civilization.[2] Few of the early Spanish arrivals in Peru, which, like Mexico, was the seat of an impressive Indian civilization and great mineral wealth, paid such close attention to the status of women in Inca society—unlike a son of both cultures, the Inca

[1]Diego de Landa, *Landa's Relación de las Cosas de Yucatán*, trans. and notes Alfred M. Tozzer (Cambridge, Mass.: Peabody Museum, 1941; Papers of the Peabody Museum of American Archaeology and Ethnology, Harvard University, 18).

[2]Bernardino de Sahagún, *General History of the Things of New Spain (Florentine Codex)*, trans. Charles E. Dibble and Arthur J. O. Anderson, 13 vols. (Santa Fe: The School of American Research and The University of Utah, 1950–1969).

Garcilaso de la Vega, as he was generally called. His defense of
Inca civilization presents an idealized version of the role of many
women in that society, with a stress on virginity, reflecting his
desire to display everything in the best possible light from the
standpoint of European morality and belief.[3]

The hardships and violence of the Spanish conquest
in America were deeply felt by both Indian and European
women. But very few of the individual women involved appear in
the pages of this period's history. Perhaps the best remembered
by those of European descent is Hernán Cortés's Indian inter-
preter and general aid and companion, La Malinche, or Doña
Marina, as the Spanish called her, who played a crucial role in the
Spanish conquest of Mexico. But what of less exceptional women
and of other aspects of their lives? Relatively little is known or
understood concerning the impact of the Conquest on the mass
of the indigenous female population. How did this event change
their lives?

Although relatively few Spanish women participated
in the Conquest itself, their bravery and courage clearly matched
those of the men, as shown in one of the rare accounts written by a
woman during this period. Isabel de Guevara, who accompanied
Pedro de Mendoza's ill-fated expedition of 1535 to the Rio de la
Plata, later dramatically described the starvation and hardships
they suffered and the harsh physical labor the women performed
to save the colony (selection 1).

Slowly a new society arose in America starting with the
first racial intermixing of Indian women and European men.
Only limited numbers of Spanish and Portuguese women made
the long, arduous journey across the Atlantic during the early
colonial period. But those European women exercised an in-
fluence on the development and nature of colonial society far out
of proportion to their numbers. In Peru, for example, Spanish
women constituted a large minority of the settlers in the first
decades after the Conquest. Generally living in cities and often
serving as heads of large households, the women of the second
generation taught Spanish ways to those around them, to chil-
dren of different races and parentages, and they ensured that
Peru became and remained Spanish in culture.[4] But what of the

[3]The Inca Garcilaso de la Vega, *First Part of the Royal Commentaries*,
trans. Harold V. Livermore, 2 vols. (Austin: University of Texas press, 1966).
[4]James Lockhart, *Spanish Peru 1532–1560, A Colonial Society* (Madi-
son: University of Wisconsin Press, 1968), pp. 150–170.

Indians? We know far less about the contributions of Indian women to the organization of sixteenth-century society. Nor has the world of African slave women during the colonial period been explored, not even the experiences and longings of those very few who left any personal written traces (selection 5).

In colonial Latin America, women of all kinds lived out their lives: European, Indian, African, and mixed bloods; slave and free; in towns or in isolated regions of the interior. Is it possible to generalize about such a variety of women? The commonly advanced contention that Latin American women of the elite endured centuries of Moorish seclusion and obscurity should be questioned and examined. Were all women confined to the private sphere of the home and excluded from the public sphere assigned to men? Some specific women are known to have run plantations and to have ranged far from their homes. Did such women acquire their money or positions only in the socially acceptable way of inheritance from a man? If colonial women occupied an extraordinary legal position as transmitters of property, as appears to have been the case, did this influence husbands in choosing administrators of their estates? Women could be economically powerful though still sexually submissive. What influence did women exercise indirectly, behind the scenes, on men occupying formal positions in the public sphere? In contrast to such women, others of the elite, or would-be members of the elite, renounced the secular life and retired to convents. What kinds of lives did they lead? Lives of self-fulfillment and accomplishments or of self-denial? The public deference accorded these women may have been a factor in determining expectations as to the proper behavior of women remaining outside the convent walls, as well as helping to form the image of the ideal woman.

Although the Spanish and Portuguese may have considered the noblest life a woman could lead to be that of a nun and may have used the lives and sufferings of particular nuns, such as Saint Rose of Lima, to exemplify saintliness, humility, and self-sacrifice expected of the true woman, they did not treat all individual women with the same awe or solicitude, as in the case of Sister Juana Inés de la Cruz of Mexico. Sister Juana, one of the outstanding intellectuals of the seventeenth century and the finest lyrical poet of the colonial period, lived in a society in which the only choices open to a respectable woman were marriage or

the nunnery. This brilliant woman suffered deeply from the conflict between religion and intellect within herself, as well as from her struggles against the prejudices and incomprehension of her time and place. In reply to the censures of the Bishop of Puebla for her alleged neglect of religious literature and fondness for profane letters, she wrote her *Reply to Sister Philotea*. She not only defended herself from the prelate's strictness and upheld the right of women to education and intellectual activity, but revealed many details of her life and thought (selection 2).

Masculine attitudes toward all women, not just outstanding women like Juana Inés de la Cruz, should be closely examined, including the origins of the masculine tendency to place women on a pedestal—an uncomfortable position for some, but perhaps an improvement for others. What is the relationship of this phenomenon to the ideal of the pure, self-sacrificing saint-mother and to the Marianism of the Iberian world? What are the origins of the long-held values of obedience, chastity, virginity, and moral strength for women? Why would the purer and nobler of the sexes be thought to be so easily corrupted if she stepped down from her pedestal and out of the isolation of the home? Religion was an important element in women's lives during the colonial period, but how important? What of the assertions that the Roman Catholic Church had vested interests in maintaining the existing order and in keeping women submissive to men and that Church doctrines relegated women to a secondary and suspect position? While the economic relations of society and their effects on the economic position of women must be examined, images as well as realities must also be considered. We must investigate the concept of the pure saint-mother as well as the lives of women performing harsh labor on the agricultural plantations.

Foreign travelers' accounts provide one of the best narrative sources for the study of these and other women during much of Latin American history, often furnishing information which can be used to test various assertions concerning Latin American women. Although the Spanish crown basically discouraged foreigners from entering its American territories, various exceptions were made—from German merchants to English priests to scientists of a variety of nationalities—and some of these men left valuable reports. So did several unwelcome visitors, like Lionel Wafer, surgeon to a band of English buc-

caneers attempting to break into the Pacific by way of the Isthmus of Panama in the seventeenth century, whose observations on the Cuna Indians include a perceptive portrait of male–female relations among this farming and hunting people.[5] Some visiting Spaniards also wrote perceptively on Latin American society, as did Jorge Juan and Antonio de Ulloa, two young naval officers assigned to a French scholarly expedition sent to South America by Philip V of Spain in 1735. Like previous voyagers to Peru, they were especially intrigued by the women of Lima, noted both for their manner of address and behavior and for their distinctive attire, which "to Spaniards at their first coming . . . appears extremely indecent."[6] Vivacious, fond of rich clothing and jewelry, and even impudent according to some detractors, the Limeña could use the virtual anonymity of her street dress to exercise her sharp wit to the utmost.

For the Spanish and Portuguese colonies in the New World, the first quarter of the nineteenth century was filled with the traumatic experience of securing political independence from their mother countries. During the next decades, major economic and political changes occurred in most Latin American nations, although in different degrees and at different rates. But we still know little about how those changes or the growing secularization, urbanization, and industrialization of the region as a whole in the late nineteenth century affected women.

Following the independence movements, people, ideas, and goods moved more freely from the Old World to the New, and more European travelers committed their observations to paper. One of the most important of these accounts, and one of the few written by a woman, is that by Fanny Calderón de la Barca, an intelligent, spirited, and observant Scotswoman married to a Spanish diplomat who served as Spain's first envoy to independent Mexico (selection 6). Although their sojourn in Mexico from 1839 to 1842 embraced a politically chaotic period, Mexican family life was far less disturbed. Fanny Calderón de la Barca sympathetically described the circumscribed lives of upper-class women in Mexico, including their personal modesty and warmth and the negligible education they received.

[5] Lionel Wafer, *A New Voyage and Description of the Isthmus of Panama* 2d ser., no. 73 (Oxford: The Hakluyt Society, 1934), pp. 78–80, 83, 88, 92–102.

[6] Jorge Juan and Antonio de Ulloa, *A Voyage to South America . . .*, trans. John Adams, 2d ed., 2 vols. (London, 1760), 2:56–64.

As a woman dealing with women, able to penetrate convents and other areas closed to men, Fanny Calderón de la Barca perhaps obtained a truer picture of women's lives than that reported by various male visitors. Certainly, apparent contradictions appear in some male travelers' accounts of the nineteenth century, just as in the colonial period. For example, two capable Englishmen journeying through Minas Gerais, Brazil, returned conflicting reports as to the independence or seclusion of women in the interior of Brazil. The Reverend Robert Walsh, chaplain to the British Ambassador, encountered in the mountains of Minas Gerais in the late 1820s a woman, riding with her attendant, who "dismounted like a man before us, without the smallest embarrassment" at a roadside store where she drank a glass of sugar cane brandy "to fortify her against the mountain air, re mounted,—examined her pistols, to see that all was right for any event she might be liable to,—and again set off, her own protector." Walsh claimed that "such figures are very common in the country. The wives of fazendeiros [owners of plantations or *fazendas*] are frequently left widows, manage by themselves, afterwards, the farms and slaves, and in all respects assume the port and bearing of their husbands."[7] In contrast, drawing upon his extensive travels in Minas Gerais in the 1860s, Richard F. Burton, ex-consul of Great Britain at Santos, declared that "the Mineira lives in the semi-seclusion system which crossed the Atlantic from Iberia. . . . In none but the most civilized families do the mistress and daughters of the house sit down to the table with the stranger; among the less educated the deshabille is too pronounced to admit of reception without an almost total toilette."[8] Was the condition of women in the interior deteriorating over time? How important were so-called Iberian traditions? Did some foreign travelers merely observe only particular classes of women? Was the situation far more complex than either Englishman suspected?

The whole question of foreign influences on the changing roles and lives of women in Latin America deserves prolonged study. Upper-class women could be influenced by trends and novelties among the European elites, from fashion to

[7]Robert Walsh, *Notices of Brazil in 1828 and 1829*, 2 vols. (London: Frederick Westley and A. H. Davis, 1830), 2:27–28.
[8]Richard F. Burton, *The Highlands of Brazil: With a Full Account of the Gold and Diamond Mines*, 2 vols. (London: Tinsley Brothers, 1869), 1:408.

literature. They would first go out to festivities and to the theater and eventually enter the universities and the professions. Lower-class women might receive other stimuli from abroad. By the end of the nineteenth century a new form of foreign influence was apparent among certain urban sectors in such countries as Argentina, Brazil, and Chile—along with European immigrants came radical social and economic views. European anarchists and foreign-born and native socialists influenced the nascent labor movement, in which women participated. Women were employed in increasing numbers in developing industries, especially textiles. Their pay, like that of children, was far below the meager wages allotted men. But women remained slower to organize than men. Not only did women receive worse treatment and lower pay in the factories, but they were also subject to abusive treatment and to sexual and other forms of exploitation by owners, supervisors, and foremen (selection 14).

Once education was accepted as desirable for women, more of them could express their views on their economic, political, and social situation. In the nineteenth century, education was seen as a means of improving women's performance as wives and mothers; but it also brought important personal gains for some women. The proliferation of women's writings in the late nineteenth and twentieth centuries is little short of revolutionary, and yet this phenomenon has been virtually ignored in historical studies on Latin America. Schoolteachers not only served as agents of literacy, but also as instigators of change and as disseminators of new ideas, including, finally, that of the vote for women. For many years teaching was one of the few genteel occupations open to a "lady." The profession became increasingly feminized by the late nineteenth century. During the second half of that century, some schoolteachers edited newspapers which comprise one of the earliest forms of feminist literature in Latin America, as in the case of Brazil (selection 7). Their concerns, including suffrage, and arguments were often similar to those expressed by feminists in the mid-twentieth century.

Educated professional women led the twentieth-century women's suffrage movements. Foreign influences and ideas affected their activities, for the movement received its inspiration from the United States and Europe. Women's suffrage was a middle class movement for political rights, for a

juridical change to give the vote to women who met the same qualifications as men. It was not an attempt to revolutionize the role of women in society or that society itself (selections 10 and 11). Leaders of the suffrage movements in different countries were often lawyers or members of government bureaucracies. Law has traditionally served as a path to political success and membership in the elite, and some women have also followed this route.

Starting with Ecuador in 1929 and then Brazil in 1932, Latin American countries slowly granted women the vote. Women in Uruguay, Cuba, and El Salvador received the vote in the 1930s. The Dominican Republic, Guatemala, Panama, Argentina, Venezuela, Chile, and Costa Rica gave women this right in the 1940s. In the 1950s, women in Haiti, Bolivia, Mexico, Honduras, Nicaragua, Peru, and Colombia received the vote. And, finally, in 1962 Paraguay became the last of the Latin American nations to grant women the vote.

Although suffrage would eventually help end most of the legal restrictions under which women labored, it led to few immediate gains, and we may well question why. Certainly voting forms only one aspect of political participation and is a far more passive act than election to office. Very few Latin American women ever ran for any political position. Many continued to feel that public decision-making and participation in politics were family tasks best left to men. Even those women involved in public life rarely reached the command echelons of government and remained apart in what have been considered feminine areas of concern, such as education, health, social welfare, and the arts.

In politics as in other areas, male and female perceptions of their respective roles and behavior patterns affected women's activities. Women as a group generally were believed to be a conservative element in Latin American politics. APRA (Alianza Popular Revolucionaria de América), once the foremost revolutionary party in Peru, for years took an official stand against universal suffrage, fearful that only women from the most conservative strata of society would qualify as electors. Even after the vote for women became a reality in Peru, this supposedly progressive party segregated women into a women's division, telling them to organize the feminine vote, not participate in policy making. The eventual disenchantment of Magda Portal, leader of the women's forces in APRA, surfaced after

years of dedicated party service in the form of a novel about the party and the types of women involved in it (selection 12). Women who achieved any power were often judged by harsher standards than were men and were resented and attacked for ambitions considered unseemly in a woman. This certainly was the case with Eva Perón, the most powerful woman in Latin American history. She never held elective office but instead achieved her influence and strength in the traditional manner based on family connections, although hers stemmed from her relationship with a powerful man rather than from birth into an important family (selection 13).

Although changes in womens' position and activities often came slowly, and not merely in the political sector, the effects of growing urbanization and the erosion of the traditional patriarchal system would become apparent in the twentieth century. Increasing numbers of women in the cities found employment outside the home, not only in the classroom, but also in factories, commercial establishments and offices, and in government bureaucracies (selection 15). Even though women holding professional positions suffer from inequities in salary and treatment, they enjoy many benefits denied that mass of urban women living in slums or performing menial tasks. Domestic service continues to be one of the major categories of employment for women in Latin America. The "liberation" of upper- and middle-class women with their growing interests outside the family and home is partly based on the labor of the lower-class women who cook for their families, clean their homes, run their errands, and take care of their children. Very few comfortably situated Latin American women, whether they pursue careers or not, can imagine life without their maids.

In rural areas also, lower-class women live hard lives full of toil and frequent subordination (selection 18). In a few fields, however, some rural women have achieved prominence. For example, in different regions market women dominate commerce in local produce grown or raised on a small scale. Within Latin America, market women have been especially important among several groups with strong African or Indian roots, such as the Indian market women of Peru and Bolivia; the middlemen, or rather "middlewomen," traders in agricultural produce of Jamaica, who are often known by the old English term "higglers"; and the striking women of the Isthmus of Tehuante-

pec in Mexico who dominate the markets and petty commerce of their region. As industrial products supplant handicrafts and new commercial patterns penetrate the countryside, however, such women may become less economically independent than they have been.

In Latin America, sexual and economic roles have been closely entwined. Lower-class women, whether factory workers in the late nineteenth century, Indian peasants, or shantytown dwellers in the mid-twentieth century, encounter both sexual and economic exploitation. They are both poor and female. The lives of slum dwellers, whose complexion is often markedly darker than that of the upper class, are never easy. Women have to feed themselves and their children by resorting to various means to earn their sustenance. Carolina Maria de Jesús supported herself and three children in a São Paulo *favela*, or squatter settlement, by collecting paper and scraps outside the *favela*, and kept her pride and self respect (selection 17). Other women earned their livelihood as prostitutes, as did Fernanda Fuentes in a San Juan slum, maintaining her independence in her own way (selection 16).

The importance of class should not be underestimated when studying women in Latin America. The stereotype of the guarded, pure female was never universally valid. Actual behavior varied according to class. Throughout the centuries, concubinage and certain kinds of personal freedom existed within the lower classes. For many of these women, legal marriage was an unattained or unattainable component of social status. Yet, if the slum and peasant women of today are frequently ignored, how much less is known of their historical counterparts?

The historic double standard of morality for men and women, with its associated values, is rarely absolute or unmodified by time, place, or class. Female honor is closely related to family honor and both are connected with the social hierarchy. In nineteenth-century Cuba, for example, when the social distance between partners who had eloped exceeded the tolerated maximum, considerations of family prestige prevailed over those of a daughter's virginity, and no marriage was permitted.[9]

[9]Verena Martínez-Alier, "Elopement and Seduction in Nineteenth-Century Cuba," *Past and Present*, no. 55 (May 1972), 91–129.

Then there is the frequently cited and debated concept of *machismo*. According to Octavio Paz, a leading Mexican poet and literary figure, *machismo* is more than a cult of virility, for it combines courage and intransigence with an aggressive maleness. Paz has projected the picture of an aggressive male protagonist, alone and withdrawn, constantly preoccupied with the image he is conveying. Together with this masculine desire not to open himself up but to break open his opponent, Paz depicts the Mexican concept of the passivity of women, who are seen as submissive and open by nature.[10]

How did concepts such as that of *machismo*, or its opposite, *marianismo*, evolve? Both Iberian and indigenous cultures produced sharp definitions of femininity and masculinity, with a consequent polarization in socialization, division of labor, and education between men and women. Sexism remains an elusive, complex intellectual and social issue in Latin America, where so many women have been reluctant to abandon traditional models of femininity, perhaps as they feel that such models give them access to power. Even feminists today manifest a desire to preserve femininity and respectability while attempting to gain additional rights.

In Latin America, the family has long served as a center of socialization, kinship, and control and transmission of property. Changes in family structure have definitely occurred over time. Class, slavery, and urban poverty all affected family structure. However, our recognition of the importance of the family does not approach our knowledge of its historical evolution. The development of indigenous and black families over the centuries is much less understood than that of white families. The high incidence of informal unions in Latin America ever since the colonial period permits the existence of households headed by women. But such contemporary households have received far more scholarly attention than those of other periods.

Although many political convulsions in Latin America have not drastically modified the lives of the region's women, major social revolutions may be expected to affect them more strongly. Certainly women participated actively in the Mexican Revolution and in revolutionary movements in Cuba. Yet it is very questionable whether the Mexican Revolution, which broke

[10]Octavio Paz, *The Labyrinth of Solitude: Life and Thought in Mexico*, trans. Lysander Kemp (New York: Grove Press, 1961).

out in 1910, became a revolution in the status of women. Mexican women were not even permitted to vote in national elections until 1952. The relationship of social revolutions to the changing role of women is most complicated. The improvements in women's position in revolutionary Cuba—or what some claim has been accomplished (selection 19)—deserve comparison with the changes in women's status and activities which occurred in Mexico and other countries. Revolution, education, growing urbanization and industrialization, the work of Latin American feminists themselves, various foreign influences—all these and many other factors have promoted changes in the varied lives and roles of Latin American women.

We must continue to ask questions and to probe ever more deeply into the complex subject of women in Latin America and to study their heritage. The salient features of their current behavior stem directly from the past. Many valuable studies on Latin American women can and should be written which will not only illuminate the history of these women but also provide insights into the lives and roles of women in other societies.

I Colonial Period

1 / Hardships and Bravery in the Conquest of the Río de la Plata

Spanish explorations along the southern part of the Atlantic coast of South America in the early sixteenth century yielded no treasures or evidence of high civilizations, only hostile Indians in a land of grassy plains. The Pacific coast would prove far more attractive. But Spain wished to assert her military claims to the Río de la Plata to prevent the Portuguese from doing so and because this area provided a tempting avenue for foreigners to penetrate the riches of the Andes. In 1535 the largest expedition ever mounted in Spain's conquest of the New World set sail for the Río de la Plata under Pedro de Mendoza, one of the leading noblemen of the court. This expedition, representing an attempt at settlement, not just exploration and conquest, included women. Mendoza planted his colony along the right bank of the estuary, erecting a collection of straw thatched huts surrounded by sod breastworks. But the location chosen for Buenos Aires provided little of the necessities for Spanish colonization, least of all a settled Indian population. When carefully laid plans to secure food supplies from Spain failed, starvation haunted the colony. Increasing Indian attacks and hunger forced most of the Spanish to sail up the Paraná River in 1537, in search of a better site, which they found among the sedentary, friendly Guaraní Indians, the only agrarian people in the area. Asunción, some nine hundred river miles from the sea, would become the earliest permanent Spanish settlement in the Río de la Plata region. Buenos Aires, abandoned in 1541, would be refounded in 1580.

Isabel de Guevara accompanied her husband on Pedro de Mendoza's expedition to the Río de la Plata and sur-

vived the fighting and suffering in Buenos Aires. Years later, in Asunción, she petitioned the crown to reward her and her husband for her services and the hardships borne without recompense. In her letter of July 2, 1556,* she described the starvation the Spanish had endured in Buenos Aires, the hard physical labor performed by the women, both their own traditional tasks and work the men were too enfeebled to do, and the difficult voyage to Asunción, where the women planted and gathered the first crops by themselves. According to her account, it was the women who had saved the colony.

Isabel de Guevara

VERY HIGH AND POWERFUL PRINCESS,
 To this province of the River Plate with the first Governor of it, Don Pedro de Mendoza, there came certain women, amongst whom fortune so willed it that I should be one, and that the fleet should arrive at the port of Buenos Aires with fifteen hundred men, and that they all should be in want of food.
 So great was the famine that at the end of three months a thousand perished. This famine was so great that not even in Jerusalem it could have been equalled, nor can it be compared to any other. The men became so weak that the poor women had to do all their work; they had to wash their clothes, and care for them when sick, to cook the little food they had; stand sentinel, care for the watch-fires and prepare the crossbows when the Indians attacked, and even fire the petronels; to give the alarm, crying out with all our strength, to drill and put the soldiers in good order, for at that time we women, as we did not require so much food, had not fallen into the same state of weakness as the men. Your Highness will understand that had it not been for the care and the solicitude that we had for them they would have all died, and if it were not for the honour of the men, there is much more that I could write your Highness truthfully. In the face of such terrible trials, the few that remained alive determined to ascend the river, weak as they were, and

*From Robert B. Cuninghame Graham, *The Conquest of the River Plate* (Garden City: Doubleday, Page and Company, 1924), pp. 281–284.

although winter was coming on, in two brigantines,* and the worn-out women cared for and looked after them and cooked their food, bringing the wood for firing into the vessels on their backs, and cheering them with virile exhortations, beseeching them not to allow themselves to die, for they would soon be in a country where there was food, and carrying them upon their shoulders into the brigantines with as much love as if they had been their own sons, and thus we came to a tribe of Indians who are called Timbues, who have good fishings. Then we bestirred ourselves to find out nice ways of cooking, so that the fish should not disgust them, for they had to eat it without bread and were all very weak. Then they determined to ascend the Parana in search of food, and in this journey the unlucky women endured so many hardships that God ordained that they should survive miraculously, for the men's lives were in their hands, for all the service of the ship they took so much to heart that each one was affronted if she thought she did less work than all the rest, so they all handled and reefed the sail, steered and hove the lead at the bows, and took the oars from the hands of the soldiers who could row no more; they also baled the vessel, and they put before the soldiers that they should not lose heart, for that hardships were the lot of men; certain it is they were not rewarded for their work, nor forced to do it, only love impelled them.

Thus they arrived at this city of Asuncion, which, though it is now fertile and full of food, was then in wretchedness, so that it became necessary that the women should return to their labours, making plantations with their own hands, digging, weeding, and sowing and gathering in the crops without the help of anyone, until the soldiers recovered from their weakness and commenced to rule the country and to acquire Indians as their servants, and so get the land into the state in which it is.

I have wished to write and bring all this before your Highness, so that you may comprehend the ingratitude that has been shown me in this country, for at present most of it has been

*The brigantine of the conquistadores appears to have been a sort of sailing barge or roughly-built half-decked boat. When the word "brigantine" is used, it is always applied to a vessel built by the conquerors themselves. Such were the "brigantines" that Cortés constructed on the lakes of Mexico.

granted either to the older or the new (colonists) without the least remembrance either of me or of my hardships, and they have left me without assigning me a single Indian as my servant. I would much like to have been free to go and put before your Highness all the services that I have done you and all the injuries that they are doing me; but this is not in my hands, for I am married to a gentleman of Seville who is called Pedro de Esquivel, whose services to your Highness have caused mine to be forgotten. Three times I have saved his life with the knife at his throat, as your Highness will know.

Therefore I beseech that you will order that a perpetual Repartimiento shall be granted me, and as a payment for my services that some employment be given to my husband, according to his quality, for he on his part merits it.

May our Lord increase your royal life and state for many years.

From this city of Asuncion and July the second, 1556.

Your servant, Doña Isabel de Guevara,
Kisses your royal hands.

2 / Life and Sufferings of an Intellectual in Colonial Mexico

The first half of the sixteenth century, a period of conquest and expansion, had witnessed great Spanish deeds and accomplishments. But the children of Spanish conquerors who had traversed continents found their own horizons often limited to the villages and towns of their birth. Compared with the sixteenth century, the seventeenth proved a period of stability and orthodoxy, especially in colonies suffering from economic depression, reduced silver production, and declining Indian populations.

Mexico remained the leading intellectual center of Spain's empire in America. And in seventeenth-century Mexico one of the outstanding intellectuals and the finest lyrical poet of the colonial period, Sister Juana Inés de la Cruz, lived and died (1651–1695). In that society the only choices open to a respectable upper-class woman were marriage or the nunnery.

Juana Inés de la Cruz, who had shone brilliantly at the Viceroy's court in Mexico City, sought the freedom to study and to pursue her intellectual interests by entering a convent. But she lived among people who doubted the wisdom of so much learning in a woman. Intellectual curiosity in one of her sex was considered not only indecorous but also sinful. Torn between her love of knowledge and the need for salvation in a century in which religious values were of the greatest importance throughout the European-dominated world, Sister Juana suffered both internally and externally. Rebuked by the Bishop of Puebla for her interest in secular learning and her alleged neglect of religious literature, she replied in a letter of March 1, 1691, part

of which is given below.* She described the way in which she began to read at the age of three, her passion for knowledge, the reasons she entered a convent, the endless questing of her mind, including the performance of scientific experiments using kitchen materials, and her inner discord over the effects of her intelligence on her salvation, as well as defending the right of women to education and intellectual activity.

Three years later in February 1694, the disapproval surrounding her and the relentless pressure upon her finally led Sister Juana Inés de la Cruz to renounce all her beloved books and possessions, which were sold and the proceeds distributed to charity. She then gave herself to excessive acts of penance, self-flagellation, and mortification of the flesh. In her weakened condition she nursed the sick sisters of her convent when Mexico City suffered another of its periodic epidemic diseases. She also became ill and died on April 17, 1695, at the age of forty-three.

Sor Juana Inés de la Cruz

I was not yet three years old when my mother sent an older sister of mine to be taught to read at a school of the kind called *Amigas*. Moved by affection and by a mischievous spirit, I followed her; and seeing her receive instruction, such a strong desire to learn to read burned in me that I tried to deceive the teacher, telling her that *my mother wanted her to give me lessons*. She did not believe me, since it was incredible; but to humor me she acquiesced. I continued to come and she to teach me, but no longer in jest as experience had shown her I was in earnest; and I learned to read so quickly that I already knew how by the time my mother learned anything about it from the teacher, who had kept it secret in order to break the pleasant news to her and receive her reward all at once. I had concealed it from my mother for fear that I would be whipped for doing what I did without permission. The lady who taught me still lives—God keep her—and can testify to this.

*From Sor Juana, *Carta atenagórica. Respuesta a Sor Filotea*, edited and notes by E. Abreu Gómez (México: Ediciones Botas, 1934), pp. 54–57, 60–70.

I remember that in those days, although I had the healthy appetite of most children of that age, I would not eat *cheese* because I heard that it made one dull-witted, and the desire to learn was stronger in me than the desire to eat, so powerful in children. Later, at the age of six or seven, when I already knew how to read and write, as well as to sew and do other women's tasks, I heard that in Mexico City there were a university and schools in which the sciences were taught. No sooner had I heard this than I began to plague my mother with insistent and inopportune pleas that she let me put on men's clothing and go to Mexico City and live with some relatives there and attend the university. She would not do it, and quite rightly, too, but I satisfied my desire by reading many different kinds of books that belonged to my grandfather, and neither punishments nor rebukes could stop me. Hence when I came to Mexico City men wondered not so much at my intelligence as at my memory and knowledge, at an age when it seemed I scarcely had had time to learn to talk correctly.

I began to study Latin, in which I had barely twenty lessons; and so intense was my application that although women (especially in the flower of their youth) cherish the natural adornment of their hair, I would cut off four or six fingers' length of mine, making a rule that if I had not mastered a certain subject by the time it grew back, I would cut it off again . . . for it did not seem right to me that a head so empty of knowledge, which is the most desirable adornment of all, should be crowned with hair. I became a nun, for although I knew that the religious state imposed obligations (I speak of incidentals and not of the fundamentals) most repugnant to my temperament, nevertheless, in view of my total disinclination to marriage, it was the least unbecoming and the most proper condition that I could choose to ensure my salvation. To achieve this (which is the most important goal) I had to repress my wayward spirit, which wished to live alone, without any obligatory occupation that might interfere with the freedom of my studies or any conventional bustle that might disturb the restful quiet of my books. That made me waver somewhat in my decision, until, having been told by learned persons that it was temptation, with divine favor I conquered and I entered the state which I so unworthily occupy. I thought that I had fled from myself, but— wretched me!—I brought myself with me and so brought my

greatest enemy, that thirst for learning which Heaven gave me, I know not whether as a favor or as a chastisement, for repress it as I might with all the exercise that religion offers, it would burst forth like gunpowder; and it was verified in me that *privatio est causa appetitus* [deprivation is the cause of appetite].

 I renewed or rather continued (for I never truly ceased) my labors (which were my rest in all the free time left after meeting my duties) of reading and more reading, of studying and more studying, with no other teacher than the books themselves. You will readily see how difficult it is to study from these lifeless letters, lacking the living voice and explanation of a teacher, but I joyfully endured all this labor for love of learning. Ah, if it had been for love of God, as was fitting, how worthy it would have been! True, I sought to exalt it as much as possible and to direct it to His service, because the goal to which I aspired was to study theology, since it seemed a notable defect to me, as a Catholic, not to know all that can be learned in this life through natural means about the Divine Mysteries; and since I was a nun, and not a lay person, it seemed to me an obligation of my state to study literature. . . . So I reasoned, and convinced myself, although it could very well be that I was only justifying what I already wanted to do, considering as an obligation what was just my own desire. Hence, as I have said, I continued directing the steps of my studying toward the heights of Sacred Theology; it seemed to me that in order to arrive there I must climb the stairway of the human sciences and arts; for how should anyone understand the language of the Queen of Sciences without knowing that of her handmaidens?

 How, without Logic, could I know the general and particular rules by which the Sacred Scripture was written? How, without Rhetoric, should I understand its figures, tropes, and turns of speech? How, without Physics, might I penetrate so many questions of the nature of animals, of sacrifices, that have so many symbolic meanings, some declared and others hidden? How might I know whether the healing of Saul by the sound of David's harp proceeded from the natural force and virtue of music or from a supernatural power that God placed in David? How, without Arithmetic, should one understand the computation of years, days, months, hours, and other mysterious matters, such as those of Daniel and others for which intelligence is needed to understand the nature, concordances, and properties

of numbers? . . . How, without Architecture, should one comprehend the great Temple of Solomon, where God Himself was the master architect who drew up the specifications and the plan ·and the Wise King was but the foreman who executed it, where there was not a base without its mystery, not a column without its symbol, not a cornice without an allusion or architrave without significance, and so on in all its parts, so that even the smallest fillet not only served to embellish but also symbolized greater things? Without extensive knowledge of the rules and facts of History, how should one understand the Historical Books? . . . How, without ample knowledge of both branches of the Law, could one understand the Legal Books? Without vast erudition, how should one comprehend the many points of profane history mentioned in Sacred Scripture, so many pagan customs, rites, modes of speech? Without much reading of the Church Fathers, how could one understand the obscure teaching of the Prophets? . . .

At one time my enemies persuaded a very saintly and guileless prelate who believed that study was a matter for the Inquisition to forbid me to study. I obeyed her (for the three months or so that she had power over me) and read no books; but as for the absolute ban on study, this was not in my power to obey, and so I could not do it, for although I did not study in books, I studied everything that God created, and all this universal machine served me as a textbook. I saw nothing without reflecting upon it; I heard nothing without thinking about it. This was true of even the smallest and most material things, for since there is no creature, however lowly, in which one does not recognize the *me fecit Deus* [God made me], so there is no object that will not arouse thought, if one considers it as one should. Thus I looked at and wondered about everything, so that even the people I spoke to, and what they said to me, aroused a thousand speculations in me. How did such a variety of temperaments and intellects come about, since we are all of the same species? What could be the hidden traits and qualities that caused these differences? If I saw a figure I would consider the proportion of its lines and measure it in my mind and reduce it to other figures. Sometimes I walked about in the front part of a dormitory of ours (a very spacious room), and I noticed that although the lines of its two sides were parallel and the ceiling was level, the lines seemed to run toward each other and the

ceiling seemed to be lower at a distance than it was close by; from this I inferred that visual lines run straight but not parallel, forming a pyramidal figure. And I speculated whether this could be the reason that caused the ancients to doubt that the world was a sphere. Because although it appeared spherical, this might be an optical illusion, presenting concavities where they perhaps did not exist. . . .

This habit is so strong in me that I see nothing without reflecting upon it. I noticed two little girls playing with a top and had hardly seen the movement and the object when I began, with this madness of mine, to consider the easy motion of the spherical form and how the impulse, once given, continued independently of its cause, for the top danced at a distance from the girl's hand which was the motive cause. Not content with this, I had some flour brought and strewn on the floor, in order to learn whether the top's motion on it described perfect circles or not; and I discovered that they were only spiral lines that gradually lost their circular character as the impulse diminished. Other children were playing at pins (which is the most infantile game known to children). I began to study the figures they formed, and seeing that three pins formed a triangle, I set about joining one to the other, remembering that this is said to have been the figure of the mysterious ring of Solomon, in which were depicted some shadowy hints and representations of the most Sacred Trinity, by virtue of which it worked many miracles; it is said that David's harp had the same figure and that for this reason its sound healed Saul; the harps we use today have almost the same shape.

But what could I tell you, my lady, of the secrets of nature that I discovered while cooking? I observe that an egg binds and fries in butter or oil but breaks up in sugar syrup; that to keep sugar fluid it is sufficient to pour on it a bit of water containing a quince or some other sour fruit; that the yolk and white of the same egg are so opposed that each one separately will mix with sugar, but not both together. I shall not weary you further with such trifles, which I mention only to give you an adequate notion of my character and which, I am sure, will make you laugh; but, my lady, what can we women know except kitchen philosophy? Lupercio Leonardo aptly said: "It is possible to philosophize while preparing dinner." And I often say, observing these trifles: "If Aristotle had been a cook, he would have written much more." . . .

If these, my lady, were merits (for I see similar accomplishments celebrated in men) they have not been meritorious in me, because I labor through necessity; if my activities are faults, for the same reason I believe I am faultless. Nevertheless, I always doubt myself, and not in one matter nor another do I trust my judgment. . . .

Although I had no need of examples, I have nevertheless been aided by the many that I have read about, in both divine and profane writings. For I see a Deborah giving laws, both military and political, and governing a people in which there were so many learned men. I see that sage Queen of Sheba, so learned that she dared to test with enigmas the wisdom of the wisest of men, and suffered no reproof for it but instead was made the judge of unbelievers. I observe so many illustrious women. Some are adorned with the gift of prophecy, like Abigail; others, with that of persuasion, like Esther; others with piety, like Rahab; others with perseverance, like Anna, mother of Samuel; and an infinite number of others, endowed with still other kinds of graces and virtues.

If I turn my gaze to the pagans, I first encounter the Sibyls, chosen by God to prophesy the principal mysteries of our faith, and in verses so learned and elegant that they arouse our wonder. I see a woman like Minerva, daughter of the first Jupiter and teacher of all the wisdom of Athens, adored as a goddess. I see a Bola Argentaria, who aided her husband Lucan to write the great "Battle of Pharsalia." I see a Zenobia, Queen of Palmyra, as wise as she was brave. An Aretea, a most learned woman, daughter of Aristippus. A Nicostrata, inventor of Latin letters and most learned in Greek. An Aspasia of Miletus, who taught philosophy and rhetoric and was teacher of the philosopher Pericles. A Hypatia, who taught astronomy and studied for a long time in Alexandria. A Leontia, of Greek birth, who wrote against the philosopher Theophrastus and convinced him. A Jucia, a Corinna, a Cornelia, and finally all that multitude of women who have won renown whether Greeks, Muses, or Pythonesses; all these were nothing more than learned women, regarded and venerated as such by the ancients. Not to mention an infinite number of others of whom the books are full, such as the Egyptian Catherine, who studied and overcame in debate all the wisdom of the wisest sages of Egypt. I see a Gertrude study, write, and teach. And there is no need to seek examples so far afield, for I see a holy mother of my own order, Saint Paula,

learned in Hebrew, Greek, and Latin, and most skillful in interpreting the Scriptures. In fact, her biographer, the great Saint Jerome, declared himself unequal to his task. He said, in his usual serious, forceful way: "If all the members of my body were tongues, they would not be enough to proclaim the wisdom and virtue of Paula." He bestowed the same praise on two daughters of Saint Paula, the widow Blesilla and the illustrious virgin Eustoquia, who for her learning won the name "Prodigy of the World." The Roman Fabiola was also most learned in the Sacred Scripture. Proba Falconia, a Roman lady, wrote an elegant work in Virgilian measures about the mysteries of our sacred faith. It is well known that our Queen Isabel, wife of Alfonso XII, wrote on astronomy. And without mentioning others whom I omit so as not to copy what others have said (which is a vice I have always abominated), in our own time flourishes the great Christina Alexandra, Queen of Sweden, as learned as she is brave and magnanimous, and there are also the excellent Duchess of Abeyro and the Countess of Vallambrosa.

3 / An Indian Baker
in Guadalajara

Although the lives of Indian women are far more difficult to trace than those of white urban women, they too left historical tracks. Indian women played a major role in the economic life of the Spanish colonies, especially in food production and distribution. In the urban areas, some had stalls in the markets and sold everything from food to used clothing. The elite of women traders owned small shops and businesses, supplying urban dwellers with bread, prepared foods, groceries, candy, and general articles of necessity. Other Indian women labored as maids, cooks, wet nurses, laundresses, and street vendors. These hardworking women, struggling to help sustain their families and themselves, became an indispensable element in the economy.

Cecilia Catalina, an Indian baker, lived in Guadalajara, the seat of the Audiencia of Nueva Galicia. Located some three hundred miles northwest of Mexico City in an agricultural, commercial, and cattle-raising region, Guadalajara served as the gateway to several mining areas. Upon the death of Friar Joseph Pescador y Escobar, a church canon, Cecilia Catalina and several others sought legal recourse for payment of small debts owed them by his estate. Her petition, dated June 6, 1691, had to be written for her, but she knew whom to address and how to obtain a legal solution to her problem.*

*Utah Genealogical Society, Archivo del Antiguo Obispado de Michoacán, Inventarios y Cuentas Testamentarias de D. Joseph Pescador, Section 1, leg 19, reel 778782.

33

Cecilia Catalina

Cecilia Catalina, Indian, baker, resident of this city [Guadalajara]. As the law entitles me, I appear before Your Excellency and state: I was in charge of providing Don Joseph Pescador y Escobar, canon of this holy church, deceased, with the bread he needed for his sustenance and that of his family, and my responsibility was such that the day I did not bake bread I bought it for him with my own money, which resulted in his owing me twenty-four pesos. Your Excellency should order that they be paid me from the choicest part of his belongings, not only because this is a legitimate debt and destined for personal sustenance, and as such takes precedence over any other, but also because I am a poor woman and in need, and burdened with daughters for whose maintenance I have nothing but my personal work.

I ask and beg Your Excellency to order that the said twenty-four pesos which the Canon owed me be paid to me, this debt arising from the bread I provided him for his sustenance, as I have said. If Your Excellency so orders I would receive a great benefit and gift of mercy. I swear by God and the Cross that those pesos are owed to me. And because I do not know how to sign my name, I asked a witness, Juan Joseph Sánchez, to do so for me.

4 / Indian Revolt in Peru

Various Indian revolts, large and small, punctuated the long centuries of Spanish rule in the Americas. Before Spanish rule was firmly established, Indians rose against their new masters in different regions during the sixteenth century. The eighteenth century knew another wave of revolts as tax burdens on the lower classes increased.

In 1779, José Gabriel Condorcanqui, who took the name of his early ancestor the Inca ruler Túpac Amaru, raised the standard of revolt in Peru. His action sparked the greatest native rebellion in the Viceroyalty of Peru since the sixteenth century. This well-educated and respected Indian chieftain, one of the more privileged members of Indian society, hoped to relieve the oppressions suffered by his people, although he would not succeed. The revolt by José Gabriel Túpac Amaru and his associates was never an organized rebellion conducted simultaneously in various theaters under unified direction, but rather was a series of episodes, campaigns, and insurrections covering much of what are now the Andean nations of Peru and Bolivia. Túpac Amaru phrased the aims of his revolt in the language of administrative reform, without denying crown or church. Even though he never formally offered his followers the promise of an independent Peruvian Indian state, others did so in his name after his death.

During this struggle, José Gabriel Túpac Amaru's chief aid and advisor remained his wife, Micaela Bastidas Puyucahua, whom he had married in 1760 when he was sixteen. A humane and shrewd commander, she played a major role in their rebellion, often counseling more active measures than those pursued by Túpac Amaru. The following selection, a letter from Micaela to her husband which combines harsh reproaches with the tenderness of a loving wife, reflects her realization of the blunders and tactical errors which would cost

their rebellion dearly.* The siege of Cuzco in January 1781 would fail. Soon afterwards, Micaela Bastidas, José Gabriel Túpac Amaru, their sons, and a number of captains were seized by treachery and executed by the Spanish. Micaela Bastidas was condemned to have her tongue cut out and then be garroted in the presence of her husband, the last to die.

Micaela Bastidas Puyucahua

DEAR CHEPE:

You are causing me grief and sorrow. While you saunter through the villages, even very carelessly delaying two days in Yauri, our soldiers rightly grow tired and are leaving for their homes.

I do not have any patience left to endure all this. I am capable of giving myself up to the enemy and letting them take my life, because I see how liglitly you view this grave matter that threatens the lives of all. We are in the midst of enemies and we have no security. And for your sake all my sons are in danger, as well as all our people.

I have warned you sufficient times against dallying in those villages where there is nothing to be done. But you continue to saunter without considering that the soldiers lack food supplies even though they are given money; and their pay will run out soon. Then they will all depart, leaving us helpless, and we will pay with our lives because they (as you must have learned) only follow self-interest and want to get all they can out of us. Now the soldiers are already beginning to desert, as Vargas and Oré spread the rumor that the Spaniards of Lampa joined by those of other provinces and of Arequipa are going to surround you; the soldiers are terrified and seek to flee, fearing the punishment that might befall them. Thus we will lose all the people I have gathered and prepared for the descent on Cuzco, and the Cuzco forces will unite with the troops from Lima who have already been on the march against us for many days.

I must caution you about all this, though it pains me.

*From Francisco A. Loáyza, ed., *Martíres y heroínas* (Lima: Imprensa D. Miranda, 1945), pp. 48–51.

But if you wish to ruin us, you can just sleep. You were so careless that you walked alone through the streets of the town of Yauri, and even went to the extreme of climbing the church tower, when you should not commit such extreme actions under present conditions. These actions only dishonor and even defame you and do you little justice.

I believed that you were occupied day and night in arranging these affairs, instead of showing an unconcern that robs me of my life. I am only a shadow of myself and beside myself with anxiety, and so I beg you to get on with this business.

You made me a promise, but from now on I shall not place any faith in your promises, for you did not keep your word.

I do not care about my own life, only about those of our poor family, who need all my help. Thus, if the enemy comes from Paruro, as I suggested in my last letter, I am prepared to march out to meet them with our forces, leaving Fernando in a designated place, for the Indians are not capable of moving by themselves in these perilous times.

I gave you plenty of warnings to march on Cuzco immediately, but you took them all lightly, allowing the enemy sufficient time to prepare, as they have done, placing cannon on Picchu mountain, plus other trickery so dangerous that you are no longer in a position to attack them. God keep you many years.

Tungasuca, December 6, 1780.

I must also tell you that the Indians of Quispicanchi are worn out and weary from serving so long as guards. Well, God must want me to suffer for my sins.

Your wife.

After I finished this letter, a messenger arrived with the news that the enemy from Paruro are in Archos. I shall march out to meet them though it cost me my life.

5 / A Slave in Northeastern Brazil

The institution of slavery deeply affected the lives of men and women, slave and free, across the New World. In each colonial empire, slavery became a prominent, and to many people, essential system of economic and social relations. Although slavery's relative severity in different countries has been long debated, the institution was never a mild one for the African slaves and their descendants.

Not all slaves lived similar lives or received the same treatment. Slave activities, legal rights, and actual living conditions differed from region to region, country to country, and from one time period to another. The situation of house slaves can be contrasted with that of field slaves, and the position of urban slaves with that of rural slaves. Yet, in all areas, slave women were oppressed differently from slave men. Not only did they endure the indignities and cruelties to which male slaves were subjected, but they suffered others too. Their children could be sold from them at any time, and, due to their servile status, slave women found it difficult to defend themselves from sexual abuse by their owners.

Any letter or other item written by a female slave in Latin America remains an extremely rare document. In fact, the slave herself could hardly be considered typical. The following letter of supplication—poorly spelled in the original—was written on December 6, 1770, by Esperança Garcia, a female house slave in Brazil's Northeast.* Even a century later, very few Brazilian slaves could read or write. Brazil's first national census, in 1872, indicated that only 958 male slaves and 445 female slaves out of a total slave population of 1,511,806 were literate, as

*From Luiz R. B. Mott, "Uma escrava no Piauí escreve uma carta," *Mensário do Arquivo Nacional*, X (May 1979), 8–9.

compared to almost 20 percent of the free population.

Esperança Garcia belonged to one of the former Jesuit estates taken over by the royal government following the expulsion of that order from Portugal and the Portuguese empire in 1759–1760. As she relates, the harsh administrator of one group of government estates and cattle ranches, who apparently also used state slave labor for his personal gain, removed her from her home to serve as his cook. Kept from her husband, she fled several times. Finally, this slave woman dared to write directly to the governor of Piauí protesting her treatment and begging official intervention. Perhaps slaves in poor, isolated Piauí had some rights denied slaves elsewhere. Certainly Esperança Garcia's letter demonstrates her strong family ties and illustrates the physical punishments to which slaves were subjected, the significance of slave family life, and the importance of religion in colonial society.

Esperança Garcia

I am a slave of Your Excellency under the control of Captain Antonio Vieira de Couto and am a married woman. As soon as the captain became Procurator here, he removed me from Algodões estate, where I lived with my husband, to make me his household cook. And I have had a very hard time in his house.

Firstly, great showers of blows fell on one of my children, who is just a very small child, causing blood to pour from his mouth. As for myself, I cannot describe how I am just a mass of beatings. Once when whipped I fell from the plantation house; only through the mercy of God was I saved.

Secondly, I and the others here have not been to confession for three years. One of my children plus two others need to be baptized.

I beg Your Excellency for the love of God and for your own merit to cast your eyes upon me and order the Procurator to return me to the plantation from which he took me so that I may live with my husband and baptize my daughter.

Your Excellency's slave,

Esperança Garcia

II Nineteenth Century

6 / Mexican Women at Midcentury

Economic chaos, political turmoil, and heavy loss of life accompanied the wars for independence in much of Latin America, including Mexico. That country remained politically turbulent and economically retarded for decades after independence. In one of the best travel accounts depicting political, social, and economic conditions in mid-nineteenth-century Latin America, and one of the very few by a woman, Fanny Calderón de la Barca vividly described not only the elite's political dissensions and Mexico's instability, but also the country's poverty, terrain, festivals, society, convents, mines, haciendas, and banditry.

Born Frances Erskine Inglis in Edinburgh on December 23, 1804, into a distinguished family, Fanny received a good education and enjoyed periods of travel in Italy. After her family suffered various reverses and sorrows in Europe, different members, including Fanny, emigrated to the United States where the women became schoolmistresses. In 1838 this intelligent, spirited, and sophisticated Scotswoman married Angel Calderón de la Barca, Spain's minister plenipotentiary in the United States. In October 1839 they left New York en route to Mexico, as Calderón had received an important new assignment as Spain's first envoy to independent Mexico. While their sojourn in Mexico, from 1839 to 1842, embraced a politically chaotic period, Mexican family life was far less disturbed. Fanny Calderón de la Barca sympathetically described the circumscribed lives of upper-class women in Mexico, including their personal modesty and warmth and the negligible education they received.*

*From Fanny Calderón de la Barca, *Life in Mexico*, edited and annotated by Howard T. Fisher & Marion Hall Fisher (Garden City: Doubleday & Company, 1966), pp. 286–291. Reprinted by permission of Doubleday & Company.

43

Fanny Calderón de la Barca

You ask me how the Mexican women are educated. In answering you, I must put aside a few brilliant exceptions, and speak *en masse*—the most difficult thing in the world, for these exceptions are always rising up before me like accusing angels, and I begin to think of individuals when I should keep to generalities.

Generally speaking, then, the Mexican señoras and señoritas write, read, and play a little—sew, and take care of their houses and children. When I say they read, I mean they know how to read; when I say they write, I do not mean that they can always spell; and when I say they play, I do not assert that they have generally a knowledge of music. Example is better than precept. The adjoining letter will show better than a thousand homilies how the first-rate young ladies are educated. I believe it is little better in Spain. In fact, if we compare the education of women in Mexico with that of girls in England or in the United States, we should be inclined to dismiss the subject as nonexistent. It is not a comparison, but a contrast.

Belonging to countries where the lowest of the lower classes can generally write and read, we should naturally consider a country where the *highest of the higher* classes can do no more, as totally without education. But we must, in justice, compare the women of Mexico with those of the mother-country; and when we consider the acquirements of the fair in old Castile, we shall be apt to be less severe upon their *far niente* descendants.

In the first place, the climate inclines everyone to indolence, both physically and morally. One cannot pore over a book when the blue sky is constantly smiling in at the open windows; then, out of doors, after ten o'clock, the sun gives us due warning of our tropical latitude and, even though the breeze is so fresh and pleasant, one has no inclination to walk or ride far. Whatever be the cause, I am convinced that it is impossible to take the same exercise with the mind or with the body in this country, as in Europe or in the northern states.

Then as to schools, there are none that can deserve the name, and no governesses—and their mothers are naturally

content with seeing their children equal themselves. Young girls can have no emulation, for they never meet. They have no public diversion, and no private amusement. There are a few good foreign masters, most of whom have come to Mexico for the purpose of making their fortune—by teaching, or marriage, or both—and whose object naturally is to make the most money in the shortest possible time, that they may return home and enjoy it. The children generally appear to have an extraordinary disposition for music and drawing, yet there are few girls who are proficients in either, especially in the former.

When very young they occasionally attend the miserable schools where boys and girls learn to read in common, or any other accomplishment that the old woman can teach them; but at ten in this precocious country they are already considered too old to render it safe for them to attend these promiscuous assemblages, and a master or two is got in for drawing or music until at fourteen their education is complete. I greatly shocked a lady in this city the other day by asking her if her daughter went to school. "Good heavens!" said she, "she is near eleven years old!"

It frequently happens and is remarkable that the least well-informed girls are the children of the cleverest men who, keeping to the customs of their forefathers, are content if they confess regularly, attend church constantly, and can embroider and sing a little. Nothing more seems to be required of them. Where there are more extended ideas, it is chiefly amongst some few families who have travelled in Europe, and have seen the superiority of women and the different education of women in foreign countries. Of these the fathers occasionally devote a short portion of their time to the instruction of their daughters, perhaps during their leisure evening moments, but it may easily be supposed how very little influence such a desultory system of things can have upon the minds of the children.

I do not think there are three married women, or as many girls above fourteen in all Mexico, who, with the exception of their mass book on Sundays and fête days, ever open a book in the whole course of the year. They thus greatly simplify the system of education in the United States, where parties are frequently divided [and feelings] run high between the advocates for solid learning and those for superficial accomplishments—seeming to think that nothing can amalgamate the solid beef of science with the sweet sauce of *les beaux arts*.

Here the road lies in a direct line, by which—leaving science on the right and art on the left—the blissful path of ignorance is steadily pursued. But in Spain the path is flowery; here it is bleak and arid as the plains of Apam. It is not all work and no play, but no work and no play, and the Mexican *Jenny* is a very dull girl indeed. It is the greater pity, [in] that they have a great aptitude for imitation. Their talent for imitation is an Indian gift; [the Indians] in their turn probably inherit it from their Chinese ancestors, as they may also their mode of torturing the feet to make them small, and their occasionally obliquely cut eyes.

But if a Mexican girl is ignorant she rarely shows it. They have generally *de grandes dispositions* for music and various other accomplishments—and the greatest possible tact, never by any chance wandering out of their depth or by word or look betraying their ignorance or that they are not well-informed on the subject under discussion.

The Mexican women are never graceful, yet they are rarely awkward, and always self-possessed. Their mode of walking, owing to the tightness of their shoes and the want of habit, is a mixture of tottering and waddling. In a large society they are extremely quiet, but when off ceremony their voices are generally loud and high—and most speak through their nose.

They have plenty of natural talent, and where it has been thoroughly cultivated, no women can surpass them. Of what is called literary society, there is of course none—

No bustling Botherbys have they to show 'em
That charming passage in the last new poem.

There is a little annual lying beside me called *Calendario de las Señoritas Mejicanas* of which the preface by Galván, the editor is very amusing:

To none—he says—better than to Mexican ladies, can I dedicate this mark of attention (*obsequio*). Their graceful attractions well deserve any trouble that may have been taken to please them. Their bodies are graceful as the palms of the desert; their hair, black as ebony or golden as the rays of the sun, gracefully waves over their delicate shoulders; their glances are like the peaceful light of the moon. The Mexican ladies are not so white as the Europeans, but their whiteness is more agreeable

to our eyes. Their words are soft, leading our hearts by gentleness, in the same manner as in their moments of just indignation they appall and confound us. Who can resist the magic of their song, always sweet, always gentle, and always natural? Let us leave to foreign ladies (*las ultramarinas*) these affected and scientific manners of singing; here nature surpasses art, as happens in everything, notwithstanding the cavillings of the learned.

And what shall I say of their souls? I shall say that in Europe the minds are more cultivated, but in Mexico the hearts are more amiable. Here they are not only sentimental, but tender; not only soft, but virtuous; the body of a child is not more sensitive (*no es más sensible el cuerpo de un niño*), nor a rosebud softer. I have seen souls as beautiful as the borders of the rainbow, and purer than the drops of dew. Their passions are seldom tempestuous, and even then they are kindled and extinguished easily; but generally they emit a peaceful light, like the morning star, Venus. Modesty is painted in their eyes, and modesty is the greatest and most irresistible fascination of their souls. In short, the Mexican ladies, by their manifold virtues, are destined to serve as our support whilst we travel through the sad desert of life.

Well do these attractions merit that we should try to please them; and in effect a new form, new lustre, and new graces have been given to the *Almanac of the Mexican Ladies*, whom the editor submissively entreats to receive with benevolence this small tribute due to their enchantments and their virtues!

There are in Mexico a few families of the old school, people of high rank but who mingle very little in society—who are little known to the generality of foreigners, and who keep their daughters entirely at home that they may not be contaminated by bad example. These select few, rich without any ostentation, are certainly doing everything that is in their power to remedy the evils occasioned by the want of proper schools, or of competent instructresses for their daughters. Being nearly all allied by birth, or connected by marriage, they form a sort of *clan*; and it is sufficient to belong to one or other of these families to be hospitably received by all. They meet together frequently, without ceremony, and whatever elements of good exist in Mexico are to be found amongst them. The fathers are

generally men of talent and learning, and the mothers women of the highest respectability to whose name no suspicion can be attached.

But, indeed, it is long before a stranger even suspects the state of morals in this country, for—whatever be the private conduct of individuals—the most perfect decorum prevails in their outward behaviour. But indolence is the mother of vice, and not only to little children might Doctor Watts have asserted that

> Satan finds some mischief still,
> For idle hands to do.

They are besides extremely *leal* to each other, and, with proper *esprit de corps*, rarely gossip to strangers concerning the errors of their neighbours' ways—indeed, if such a thing is hinted at, deny all knowledge of the fact. Besides, so long as outward decency is preserved, and the person most interested takes no notice, habit has rendered them perfectly indifferent as to the *liaisons* existing amongst their particular friends. They who live in a house of glass [should] beware of throwing stones at their neighbours. I have heard ladies, who I believe were honourable exceptions to these remarks, declare in a whisper their disgust at the conduct of so-and-so, who had *affichéed* herself so publicly with such a one—but lament the impossibility of breaking with her on account of her having such a *méchante langue*. This cowardice seems incomprehensible unless it may arise from the fact that the few who would wish to be severe, perhaps on account of their young daughters, would find their visiting list diminished to half-a-dozen in consequence. As long as a woman attends church regularly, is a patroness of charitable institutions, and gives no scandal by her outward behaviour, she may do pretty much as she pleases. As for flirtations in public, they are unknown.

I must, however, confess that this indulgence on the part of women of unimpeachable reputation is sometimes carried too far. I was lately at a marriage feast given to celebrate the wedding of the sister of the lady of Don Lucas Alamán with a Spaniard. The fête was given at the hacienda of the Conde de Peñasco, celebrated for his love of *les beaux arts*, his gallery, &c. His first wife having died some time ago, he has recently

married a young lady—very handsome—of low birth and doubtful reputation. This new countess was looking very splendid, dressed in rose colour, with a profusion of diamonds. After dinner we adjourned to another room, where I admired the beauty of a little child who was playing about on the floor. "Yes, she is very pretty. I have a little girl just that age," said the countess, "and a boy a year older."

"Indeed!" said I, rather astonished, seeing that she has been married about six months.

"Yes," said she. "My little girl is very pretty, quite French—not in the least Mexican—and indeed I myself am much more Spanish in my feeling than Mexican."

I was rather surprised, but concluded she had been a widow, and some time after she rose up made the inquiry of an old New Orleans lady (sister of the last vice-queen) who was sitting near me if the *condesa* had been a widow.

"Oh, no!" said she, "she was never married before. She alludes to the children she had before the count became acquainted with her!"

Amiable naïveté! And yet Mme Alamán, one of the most prudish women in Mexico, was actually *faisant la cour* to this woman, and loading her with attentions and caresses. Don Lucas was *aux petits soins* with her. *Ainsi va le monde au Mexique.* I must say, however, that this was a singular instance.

The Mexicans, particularly the women, have the most *cariñoso* tone of voice, and there are no women more affectionate and caressing in their manners. In fact, a foreigner, especially if he be an Englishman and a shy man, and accustomed to the coldness and reserve of his fair countrywomen, need only live a few years here and understand the language, and become accustomed to their peculiar style of beauty, to find the Mexican señoritas perfectly irresistible.

And that this is so may be judged of by the many instances of Englishmen married to the women of this country, who—whatever they may be in their conduct towards their own countrymen—almost invariably make excellent wives to foreigners, particularly to Englishmen. But when an Englishman marries here, he ought to settle here, for it is very rare that a *Mexicaine* can live happily out of her own country. They miss the climate—they miss that warmth of manner, that universal cordiality by which they are surrounded here. They miss the *laissez-*

aller and absence of all etiquette in habits, toilet, &c. They miss their *cigars*. They find themselves surrounded by women so differently educated as to be doubly strangers to them, strangers in feeling as well as in country and in language. A very few instances there are of girls married very young, taken to Europe, and introduced into good society, who have acquired European ways of thinking, and even prefer other countries to their own; but this is so rare as scarcely to form an exception. They are true patriots, and the visible horizon bounds all their wishes. In England especially they are most completely out of their native element. A language nearly impossible for them to acquire, a religion which they consider heretical, outward coldness covering inward warmth, a climate where there is a perpetual war between sun and fog, universal order [and] neatness, etiquette carried to excess, what to them must appear an insupportable stiffness and order in the article of the toilet—*rebozos* unknown and cigars undreamt of except by the masculine gender—the whole must form a contrast to them the most disagreeable and insupportable imaginable. They feel like exiles from paradise, and live but in hopes of a speedy return.

7 / The Early Feminist Press in Brazil

In the last half of the nineteenth century a number of newspapers edited by women appeared in the cities of south-central Brazil. Unlike the more common fashion journals, some of these now completely unknown newspapers preached women's rights. Several of the most outspoken were edited by Francisca Senhorinha da Motta Diniz, a forthright and persistent school teacher from Minas Gerais. In Brazil as elsewhere, teaching for many years provided one of the few genteel occupations open to a lady. At the same time, school teachers could serve as agents of change and as disseminators of new ideas. A key area constantly stressed by these newspapers was the need for improved education for women. Francisca Senhorinha da Motta Diniz wrote tirelessly about the necessity of educating women for their own benefit and for that of society. While she still emphasized the importance of a well educated mother in raising children, she looked beyond the family. Girls should aspire to high positions, just like boys.

Through her newspapers, Francisca S. da M. Diniz endeavored to awaken Brazilian women to their condition, needs, and potential. The first selection printed below, from her earliest newspaper, *The Feminine Sex*, which appeared in 1873, clearly illustrates the inferior position of married women in nineteenth-century Brazil.* Like other feminists, D. Francisca believed in progress and remained optimistic and confident, convinced of her cause's importance and eventual success, which she described in the florid prose of the period. In her later newspapers, she spoke more directly of equal rights for women,

*From *O Sexo Feminino* (Campanha), Oct. 25, 1873, pp. 1–2.

51

including the vote, long before an organized women's suffrage movement emerged in Brazil. She even called her last newspaper, a selection from which is given below, *The 15th of November* [the date the republic was established] *of the Female Sex.**

Francisca Senhorinha da Motta Diniz

What Do We Want?

It is quite natural that more than one of those backward souls who form part of our present-day society have asked this question. It is very probable that those who are unconcerned or pessimistic or willfully blind have asked the same question. We will try hard to answer them.

It is definitely a verifiable fact that men have overlooked the need to enlighten women's minds; instead, they remain content to adorn their bodies and flatter their vanity.

It cannot be denied that women (with few exceptions) live in complete ignorance of their rights, unaware even of those due them under our nation's laws—particularly that their public consent is necessary for the conveyance of *real estate*. How many married women are ignorant of the fact that a husband cannot dispose of any piece of the couple's property in any way without the wife's special consent? How many married women are deceived in such matters by husbands who force them to sign those legal documents on which they *automatically scrawl* their names? How many married women write out in their own hand the words dooming all the savings their parents suffered to accumulate but which their wastrel husbands pledged to repay *debts* that were not even contracted for the couple's benefit?

The state of crass and supine ignorance in which women languish, always deceived by their husbands, allows them so often to fool themselves into thinking they are *rich* when in fact some day they will awake to the *sad reality* of not

*O Quinze de Novembro do Sexo Feminino (Rio de Janeiro), April 6, 1890, pp. 1–2.

owning anything, of being *poor*, the *poorest possible*, because their husbands have squandered their inheritance, wasted it, handed it over to *creditors* who *legally* claim their money. Only then will such women see the abyss in front of their eyes! Is it not very strange in such cases, after all this has happened, those husbands climax their previous knaveries by abandoning their wives and children?

Many husbands perceive that their wives lack sufficient training to take over their affairs in their absence and carry on as they would do. Other husbands *praise* such ignorance, and give thanks for their luck in having wives who understand nothing about those affairs in which men say women *should not meddle!*

How many parents labor unceasingly under the harshest conditions to amass a dowry for their daughter and then deliver her body and soul to a *son-in-law* who will soon squander this dowry? After all, he secured the dowry through a marriage which he viewed not as an *end* in itself but just as a means of obtaining a fortune *without working*. Although the true purpose of marriage has always been the legitimization of the *union of man and woman* so that they will live together as one and love each other as Christ loved his church, in this corrupt, immoral, and irreligious society, *marriage is a means of making one's fortune*. Marriage is the goal of the rascal who does not want to work and who acts like some strange kind of acrobat turning *somersaults* to snare a dowry, no matter if the woman attached to it is pretty or ugly, young or old—all will do. With the social goal of marriage thus perverted, love of family, children, and homeland easily disappears.

Girls must be prepared for *reverses of fortune*. They must receive *education and instruction*, so that whether married, single, or widowed, they will know their rights and will be able to judge the *intentions and heart* of men requesting their hand in marriage.

To summarize the thesis of this article: We want our emancipation and the regeneration of our customs; we want to regain our lost rights; we want true *education*, which has not been granted us, so that we can educate our children; we want pure *instruction* so we can know our rights and use them appropriately; we want to become familiar with our family affairs so that we can administer them if ever obliged to. In short, we want to

understand what we do, the *why* and *wherefore* of matters; we want to be our husbands' companions, not their slaves; we want to know how things are done outside the home. What we do not want is to continue to be *deceived*.

EQUALITY OF RIGHTS

We believe, with the strong faith noble causes inspire, that an ideal state will soon be here, when educated women free from traditional prejudices and superstitions will banish from their education the oppression and false beliefs besetting them and will fully develop their physical, moral, and intellectual attributes. Then, linked arm and arm with virtuous, honest, and just men in the garden of spiritual civilization women will climb the steps of light to have their ephemeral physical beauty crowned with the immortal diadem of true beauty, of science and creativity. In the full light of the new era of redemption we shall battle for the restoration of equal rights and our cause—the Emancipation of Women. . . .

We women do not wish to play the role of ornaments in the palaces of the stronger sex. Nor do we wish to continue in the semislavery in which we languish, mutilated in our personalities through laws decreed by men. This is no different from the old days of slave labor when the enslaved could not protest their enslavement.

We are not daunted by such hypocrisy as men's treating us like queens only to give us the scepter of the kitchen, or the procreation machine, etc. We are considered nothing but objects of indispensable necessity! We are cactus flowers and nothing more.

Women's emancipation through education is the bright torch which can dispel the darkness and bring us to the august temple of science and to a proper life in a civilized society. . . .

In short, we want women to be fully aware of their own worth and of what they can achieve with their bodies as well as through their moral beauty and the force of their intellects. We want the lords of the stronger sex to know that although under their laws they can execute us for our political ideas, as they did such ill-fated women as Charlotte Corday and many

others, they owe us the justice of equal rights. And that includes the right to vote and to be elected to office.

By right we should not be denied expression in parliament. We should not continue to be mutilated in our moral and mental personality. The right to vote is an attribute of humanity for it stems from the power of speech. Women are human beings too.

We Brazilian, Italian, French, and other women of diverse nationalities do not request the vote under the restrictions currently imposed on Englishwomen, but with the full rights of republican citizens. We live in a generous and marveous country recognized as a world leader in liberal ideas and in the ability to throw off old prejudices.

What we ask is a right never demanded before and, therefore, ignored. But it was never deleted from natural law.

Women must publicly plead their cause, which is the cause of right, justice, and humanity. No one should forget that women as mothers represent the sanctity of infinite love. As daughters they represent angelic tenderness. As wives, immortal fidelity. As sisters, the purest dedication and friendship. Moreover, these qualities the Supreme Creator bestowed on them prove their superiority, not their inferiority, and show that equality of action should be put into practice by those men who proclaim the principle of equality. . . .

Our ideas are not utopian, but instead great and noble, and they will induce humanity to advance toward justice.

This is our political program.

8 / Girlhood in
Minas Gerais

"Helena Morley" grew up in Diamantina, an isolated, economically depressed town in the old diamond mining district of the central, interior Brazilian state of Minas Gerais in the 1890s, the turbulent decade following the overthrow of the empire in 1889. Between the ages of twelve and fifteen, this Brazilian schoolgirl kept a diary. Within Brazil, the *mineiros*, the inhabitants of Minas Gerais, have a reputation for shrewdness and thrift and for more restraint in their relations with outsiders than Brazilians from other areas. Minas Gerais was long known as a traditional region which preserved patriarchal family customs. "Helena Morley" and her parents' social activities and relationships were largely limited to their numerous relatives. She enjoyed days full of work as well as play and continually showed an independence of spirit in dealing with those around her.

Through the diary of this outspoken, good-natured, lively schoolgirl, we gain insights into the lives of women and girls in Minas Gerais, including ways by which women could earn money or support themselves, the importance of the Church in their lives, family relationships, marriage, and race relations. While some women sold local produce and food, from eggs to candies, others taught school. Teaching provided one of the few respectable ways for non-lower-class women to earn a sufficient income to be independent and also help their families. The important role played by the Normal School in promoting change for many women must be recognized. Through the following selections from the diary "Helena Morley" kept from 1893 to 1895, we learn a great deal not only about her life but

also about the activities of different women and the society in which they lived.*

Alice Brant (pseud. Helena Morley)

Thursday, January 5th, 1893

Today is the best day of the week.

On Thursdays [school holiday] mama wakes us up at daybreak and we tidy up the house and leave very early for the Beco do Moinho [Mill Lane]. We go down the lane, which is very narrow, and come out on the bridge. It's the best spot in Diamantina and it's always deserted. We never meet anyone there; that's why mama chose it.

Mama sends for Emídio from the *chácara*,** and puts the big tin basin of laundry on top of his head and the ball of soft soap on top of that. Renato takes pots and pans and things to eat in the little cart and we start off. Mama, Luizinha, and I go down under the bridge to wash the clothes. Emídio goes to look for firewood. Renato fishes for *lambaris*;† I never saw as many as there are there. He just has to put on the bait, drop in the hook, and he immediately pulls out either a *lambari* or a shad. Nhonhô spreads birdlime on a twig and stays a little way off watching for birds. When he catches one he runs out and cleans off the poor little thing's feet with oil and puts it in the cage. Then he puts more birdlime on the twigs and after a little while another bird arrives, a linnet, or a sparrow.

We wash the clothes and spread them out to bleach and then mama makes our lunch, *tutu*†† with rice and pork cracklings.

*From Alice Brant, *The Diary of "Helena Morley,"* trans. Elizabeth Bishop (New York: Farrar, Straus & Cudahy, 1957), pp. 3–4, 8–9, 13–14, 19–20, 35–36, 95–97, 183–186, 224–225. Reprinted by permission of Farrar, Straus and Giroux.

**House on edge of town with garden.
†*Lambaris*: tiny fish.
††Small balls of black beans.

After we've finished washing the clothes and eating our lunch, mama keeps a lookout on the road to see if anyone is coming and we go in the river to take baths and wash our hair.

After that we beat the clothes on the stones and rinse them and hang them on the bushes to dry. Then we go to look for berries and birds' nests and cocoons, and little round stones to play jackstones with.

When we go home Renato fills the cart with firewood and puts the pots and pans on top, and Emídio takes another bundle of wood on his head, on top of the basin with the clothes folded up in it.

Now that the mines aren't producing diamonds any bigger than a mosquito's eye, what a big saving it would make for mama if we could go to the bridge every day, because Renato and Nhonhô sell everything they bring back on the same day. Or if only we could stay at the mine with papa, mama wouldn't have to work so hard. But our educations are such a burden to mama that it kills me to think of it. It's wonderful that Renato will be finishing his exams the day after tomorrow and we can go to Boa Vista for our vacation.*

Saturday, February 18th, 1893

It's three days today since I started going to School.** I've bought my books and I'm going to begin a new life. The Portuguese teacher advised all the girls to form the habit of writing something every day, a letter or whatever happens to them.

I went to see my English aunts and there I met Marianna. She was my school's most famous pupil and I've always heard my aunt speak about her with admiration. She encouraged me and she said that the secret of being a good pupil is to pay attention and take notes on everything.

Aunt Madge said that my old teacher, Dona Joaquininha, told her that I was the most intelligent pupil in her school, but that I was lazy and I missed several days. That's true,

*Where the father is mining, six or seven miles away. They go on foot.

**The "Normal School," for training grade-school teachers. Equivalent to high school in the United States.

because last year we went to visit papa in Boa Vista a good many times. I don't know whether I'm intelligent or not. Grandma, papa, and Aunt Madge think so; but I only know that I don't like to study and sit still and pay attention. But anyway, I like to have them say I'm intelligent. It's better than if they said I were stupid, which is what I'm afraid they're going to say when they see I'm not going to be what they hope for, in Normal School. Today I saw what's going to happen. Everything seemed very difficult and complicated. But what I can do easily is learn by heart. Even if I can't understand it, I memorize everything. But how am I going to memorize anything in the Portuguese lessons? Logical Analysis—where can I study that? Well, in a few days I'll know how things are going to turn out. It isn't going to be hard for me to write, because papa has been making me write almost every day. There are two things I like to do, to write and to read stories when I can find any. As far as stories and novels are concerned, papa has already put them away. He says that now they're only for vacations.

I'm going to go to bed and ask Our Lady to help me study and make me more intelligent, so I won't disappoint my father, grandma, and Aunt Madge.

Saturday, March 4th, 1893

I arrive at the *chácara*, look for grandma, and find her sitting in the garden watching the Negro women make tallow candles.

"Your blessing, grandma!"

"God bless you, child. I was just looking at that bunch of ripe *araçás** and wondering how you ever happened to leave them there to get so ripe."

"It's because the day before yesterday I just came at night and yesterday I couldn't come."

"So that's it. Did you have dinner with your Aunt Madge yesterday? I like you to do that. You can only benefit from the society of your Aunt Madge. What did she teach you yesterday?"

"So many things!"

"Tell me some of them."

Araçá: small fruit of the guava family.

"In the daytime she gives me lessons in manners and at night lessons in how to be economical."

"How's that? Tell me."

"She's always taking the opportunity of telling me about other people's bad manners and I see it's just in order to teach me. She talked about people who spit on the floor, scratch their heads in the parlor and interrupt other people when they're talking. She said that at dinner people shouldn't push their plates out of the way. We should drink the soup and sit there enduring it with the plates in front of us until the maid takes them away. And one shouldn't pick one's teeth at the table."

"You learn such a lot when you're with her! Now you must practise it."

"But grandma, how can I when I take my own plate off the stove and afterwards I wash it myself?"

"Well, when you grow up you can."

"By that time I'll have forgotten everything."

"And what about being economical?" grandma asked. "What did she teach you?"

"It's simply incredible! Not even Seu Herculano can beat Aunt Madge at being economical. She talked a lot about changing one's shoes before going out in the garden, and not sleeping in one's clothes and everything. But the best thing was about saving matches. She was going to take me home and before we left she called me into the pantry, took the lamp, put in a drop of kerosene, and said, 'If I put any more in it, Marciana leaves the lamp going as long as there's kerosene. So I put in just a little and she goes to sleep, and this lasts long enough.' Then she opened the box of matches and took out three and put them in a little box and said, 'If I put in one it might not light, and two might not light, either, but it wouldn't be possible for all three not to, so I leave three.' Then she locked up the pantry and we came home, talking all the way."

Grandma said, "See what an extraordinary woman your aunt is! That's how she lives so well on eighty *mil reis* from the school, runs the house, and supports her sisters, and you see how she keeps inviting people to dinner, too. That's her secret, child. Notice everything. Learn from her."

Palm Sunday, March 26th, 1893

Aunt Carlota bought a cow with a calf, to sell milk, and mama became one of her customers. Mornings she sends the milk to our house by the maid's little girl, Maria, a very smart little nigger. Everybody began to notice that the milk had a lot of water in it. Today mama said to the little girl, "Maria, tell Carlota that the milk is getting very watery. She should give more corn or beans to the cow to make the milk richer." The little girl said, "Watery? That cow's milk is so strong that Siá Carlota has to put water in it every day, to thin it."

Wednesday, May 30th, 1893

I like all the holy days of Diamantina, but when they're in the Church of the Rosário, which is right next to grandma's *chácara*, I like them even more. It seems as if the *festa* belonged to us. And this year it really did.

An ex-slave of grandma's named Júlia was drawn by lot to be the queen of the Rosário, and the king was a very exuberant Negro whom I didn't know. Poor Júlia! She's been saving up her money for a long time to buy a little piece of land. She spent everything on the festival and now she's in debt.

Now I've seen how expensive it is for the poor Negroes to be king and queen for a day. First Júlia had to spend a lot for the dress and the crown. Then she had to give a dinner for all her court. The queen has a train-bearer who walks behind her holding her robe that has a long train. The train-bearer was a Negro from the *chácara*, too, and she helped with the dinner. I think that the enthusiasm of the blacks for such a short reign is wonderful. None of them refuses the honor, even knowing what it will cost!

What happened to Júlia's dinner was very sad. There's a gang of boys in Diamantina who make a game of stealing from people. They are boys from good families; Lauro Coelho [Rabbit] is one of them. They broke into the *chácara* a few days ago and did such awful things that I wished that I were a man so I could get revenge for grandma!

They jumped over the garden wall in the night and stole all the ripe fruit; they cut down the green fruit and left it

there. They pulled up all the vegetables, the beautiful cabbages, and threw them around the beds. They picked the pumpkins, cut them up in pieces, and threw them around. Iaiá was keeping one enormous pumpkin to see how big it would grow and to save the seeds, and they cut it in pieces. You should see what they did.

Grandma has her own way of taking things. First she says, "I never in my born days!" Then she adds, "But it could be worse." And didn't those wicked boys, those thieves, steal the suckling pig for poor Júlia's dinner! We think they boosted a little boy into the parlor through the window, which is low, and he stayed there hiding until the room was empty for a minute. The pig was a beauty! Full of *farofa*,* with toothpicks decorated with frilled tissue-paper, and olives and slices of lemon on his sides and a rose in his mouth.

Poor Júlia almost cried!

Sunday, January 14th, 1894

Grandma is very intelligent. She never studied and I never saw her open a book; only her prayer book. She didn't come to town to live until she was old, but how well she understands everything! She's interested in everything I tell her; she looks at my notes, something mama never does. She talks to me about when she was a girl, and I love to hear her.

When she and grandpa began their life in Itaipava, they were very poor; they only had two slaves. They only had baize coats to keep out the cold. They lived in a thatched house. Grandpa made a living mining; one day he'd find a diamond, another day, a little gold. And they lived happily like that. At that time, mining was against the law. When the dragoons went by, grandma hid the gold and diamonds inside her lace-pillow and sat throwing the bobbins. The dragoons came and looked and went away. Afterwards, mining was licensed and there weren't any more such scares.

Grandpa was from Serro and he was a lieutenant. When there was a war in Serra da Mendanha,** grandpa went,

*Manioc flour browned in lard, with or without hard-boiled eggs, sausage, etc.

**Note in *M V de M*: "An allusion to the encounter between government forces and the liberals in Serro da Mendanha during the revolution of 1842."

against his will, because he was on one side and grandma's brothers were on the other. He was shot in the arm and grandma still has his blue uniform, with gilded buttons, all stained with blood. When the war was over he came back to Itaipava.

At the time grandpa started working the mines at Lomba, grandma made a novena to the Blessed Virgin and she listened to her. When grandpa began working the mine he found a virgin *calderão*.* They were such big diamonds that a slave named Tito, who was a trusted friend, fell on his knees and raised his hands to heaven, exclaiming, "My Lord and Heavenly Father, if this wealth endangers my soul, let it vanish!" Just then grandma arrived with grandpa's coffee, and she helped to pick up the diamonds; they were as big as grains of corn on top of the gravel.

Grandpa never wanted to leave that place. He sent his sons to be educated in Rio. The daughters only learned to read and write; but they all married in Lomba without ever coming to the city. The story of the wealth of Batista's daughters spread far and wide. Doctors** and rich farmers came from Diamantina, from Serro, and Montes Claros, to ask for my aunts in marriage, without ever having seen them, and it was grandpa who accepted them or rejected them, according to what he knew about them.

No girl would marry like that today. In spite of this I haven't seen anyone more happily married than mama and my aunts. Could it be because they weren't brought up in the city?

Tuesday, February 5th, 1895

When mama heard that Luizinha hadn't passed this year, she decided to put us both in the College of the Sisters of Charity. I was quite satisfied because I like anything new. Mama got our clothes ready and yesterday was the day we were supposed to enter. I know this scheme was Aunt Aurélia's idea, so that her daughters, who are entering there, too, would have

*Note in *M V de M*: "*Calderão*; a concentration of diamonds formed in the depressions in the bed of a river in diamond-bearing regions." A *calderão* is literally a big pot.

**A "doctor" is any man—doctor, lawyer, engineer, etc.—with a university degree.

company. I don't know why she wants to put those two girls in the College, they're so quiet. They just live to study and they never go out of the house. Of course if my uncle wanted them to become Sisters of Charity I could understand it. But he doesn't.

Since yesterday was the day we were supposed to enter, I decided beforehand to go around saying good-bye to my friends. I went from one house to the other, leaving them all dumfounded at mama's decision. I left Ester's and Ramalho's house to the last. There I had to change my mind completely, because Ester and Ramalho just wouldn't hear of my being shut up in the College. I was overjoyed to see how the two of them consider me so different from what my relatives do, even mama. Ester said to me, "Don't think of it! With all the Sisters' rules and regulations you'll lose your gaiety and sociability; you won't have any charm, you'll turn into someone else. Don't be silly; put your foot down and don't go." When I told her that I had no hope of ever being able to study here outside, she said, "Do you think that any studious girl is worth as much as you are, even if you do waste your time? Don't change your nature or your ways a bit. Stay the way you are, don't go to the College." She kept me there for lunch and kept repeating the same advice, she and Ramalho, too.

When I left their house I went along the street thinking: "Ester is a good friend of mine and she studied at the Sisters' College. I know that my nature and my ways wouldn't change. Everybody is the way he's born. But perhaps I might lose all the joy in living I have and just mope like Luizinha and my cousins."

I resolved not to go but I didn't say anything to mama. We all went to the College and I left my clothes at home to get them later. The Sisters received us in the parlor. I let Luizinha and my cousins go in and then, without anyone's noticing, I went out the door and down Glória Street and waited for them away down the street. I could see by Uncle Conrado's face that he was furious with me, but he swallowed his wrath. Aunt Aurélia asked me how I could do such a thing! Mama only said, "It'll be your loss, daughter, when you see how studious your sister's going to be, with good manners and like a little saint, while you just fritter away your time outside."

But I'm going to follow Ester's advice. I'm going to begin the second year of Normal School and study. I shan't have to repeat it the way I did the first year.

Today we went to the College to visit Luizinha. We all came back so upset that we couldn't enjoy anything the rest of the day.

I never suspected that Luizinha, Beatriz, and Hortência, who are always so obedient, were capable of behaving the way they did. They wept and wailed all the time we were in the parlor. When the time came for them to go back to the convent the three of them made a spectacle of themselves. They didn't want to go and they had to be dragged off by force. Luizinha, usually so good and proper, yelled loud enough for the Sisters to hear her, "Helena, you were smart not to want to come here! It's like hell here!"

Uncle Conrado and Aunt Aurélia went home so sad at the sight they'd seen that they took mama to their house, to keep them company and distract them a little.

I've talked to mama about taking Luizinha out, because she's not going to get any happier no matter how long she stays. They told us about the life they lead at College and I felt sorry for them, *coitadinhas*.* They have to get up at dawn to go to mass, in all this cold, and spend an hour on their knees on the hard floor. When they come back from mass they get some watery coffee and *couscous* and begin studying. They say they can't endure the food. Cold baths and those nagging, unbearable Sisters . . . How wonderful I didn't go!

Thursday, February 14th, 1895

Thursday used to be the good day in our week, we got up happy and gay to go to the country. Now it's our saddest day.

I and mama came back from visiting Luizinha at the College so upset that we didn't talk to each other for fear of bursting into tears. I'm trying to persuade mama to take Luizinha out. Today I told her she doesn't have to go along with Aunt Aurélia in the education she's giving our cousins; that if they're there without Luizinha they'll finally get used to it, since they've always led very retired lives. But Luizinha, who was always at liberty, going back and forth between our house and grandma's, going to Boa Vista and on an excursion in the country,—she can't get used to prison. The change is too great.

Mama made some meat turn-overs and sent them to

*A term of pity, "poor little things."

Luizinha, who complains she can't stand the food at the College. Today mama asked her if she'd got the turn-overs and she said, "The Senhora sent me some? Now I see how they cheated me. The Sister put them in front of another girl and she and the girls near her ate them. I even thought: 'Those turn-overs look like the ones mama makes.'"

I can see clearly that mama isn't going to let Luizinha suffer like that. It's not just she; we're suffering too.

Wednesday, July 10th, 1895

Papa is much beloved in my family. Everybody likes him and says he's a very good man and a very good husband. I like hearing it but I'm always surprised at their just saying that papa's a good husband and never saying that mama's a good wife. Nevertheless, from the bottom of my heart I believe that only Our Lady could be better than mama.

I don't think anyone could be a better wife to papa or a better mother to us than she is. With papa leading a miner's life, most of the money he gets goes back into mining; there's not much left over for the house. We complain about things sometimes, but never a peep from mama. She never says a word that might upset my father; she just keeps telling him: "Don't be discouraged; to live is to suffer. God will help us." But I, being less patient, build castles in the air before I go to sleep, about being invisible and taking money from the rich and bringing it home. I've discovered it's a good way to get to sleep.

When I see mama getting up at five in the morning, going out in the yard in all this cold, struggling with wet, green wood to start the kitchen fire to have our coffee and porridge ready by six, I feel so sorry I could die. She begins then and goes without stopping until evening, when we sit on the sofa in the parlor. I sit holding mama's arm on one side and Luizinha's on the other, to keep warm. Renato and Nhonhô sit on the floor beside the stove, and mama tells stories of bygone days.

More than once she's told us the story of how I was born. She said she was already used to having babies because I was the third, and she didn't have the midwife and didn't want to call my father away from the mine. At that time they lived in Santo Antônio, in a little thatch-roofed house near the mine where papa was working. When she realized that I was about to be born, she went to her bedroom, prayed, and I was born.

Then she called Mama Tina, the slave who raised us, and sent her to the mine to get papa, who was just stopping work for the day. Papa came running, cut my navel-string, gave me a bath and put me in bed. When my navel-string fell off, he buried it in the gravel at the mine, according to mama's orders, to bring me luck. Mama always tells me: "Don't you see you're the only one in the family who's lucky?"

But this pleasant time never lasts very long. At half-past eight mama goes back to the kitchen to struggle with green fire-wood and get our porridge.

And yet nobody ever says mama's a good wife.

9 / A Poet in Bolivia

The Bolivian poet Adela Zamudio (1854–1928), born and educated in Cochabamba, remains virtually unknown beyond the borders of her isolated nation, with its tiny elite of largely European descent and its poverty-stricken Indian masses. Although her life is not well documented, we know that literature and education claimed her attention. She began writing at the age of sixteen and published verses in newspapers and magazines under the pseudonym Soledad (Solitude). In 1887 her father had her first book of poetry published in Buenos Aires. Much of Adela Zamudio's poetry concerned nature, morality, and personal emotions and sorrows, with serene and descriptive verses often edged in sentimentality or romanticism. In the following poem, however, she describes the disgrace of having been born a woman and the luck of men merely for having been born men.* Although some of her contemporaries thought this a humorous poem, her intention appears most serious.

Adela Zamudio

To Be Born a Man

How much work for her it is
to correct the stupid errors
of her husband, and at home!

Nacer hombre

¡Cuánto trabajo ella pasa
por corregir la torpeza
de su esposo, y en la casa!

*From José Macedonio Urquidi, *Bolivianas ilustres. Estudios Biográphicos y artísticos,* (La Paz: Arnó Hermanos, Escuela Typográfica Salesiana, 1919), 2:146.

(Permit me to act surprised.)	(Permitidme que me asombre.)
As inept as he is vain,	Tan inepto como fatuo,
he continues to be head of the household,	sigue él siendo la cabeza,
because he is a man!	¡Porque es hombre!
If she writes a few verses,	Si algunos versos escribe,
those verses must belong to some man;	de alguno esos versos son,
all she does is sign them.	que ella solo los suscribe.
(Permit me to act surprised.)	(Permitidme que me asombre.)
If that man is not a poet,	Si ese alguno no es poeta,
why is it supposed he wrote them?	¿Por que tal suposición?
Because he is a man!	¡Porque es hombre!
A woman of superior talent	Una mujer superior
does not vote in the elections,	en elecciones no vota,
and a low-level rascal does.	y vota el pillo peor.
(Permit me to act surprised.)	(Permitidme que me asombre.)
If he only learns to sign his name	Con tal que aprenda a firmar
an idiot is allowed to vote,	puede votar un idiota,
because he is a man!	¡Porque es hombre!
He gets depressed and drinks or gambles	El se abate y bebe o juega
after his luck has run out:	en un revés de la suerte:
she suffers, struggles and begs.	ella sufre, lucha y ruega.
(Permit me to act surprised.)	(Permitidme que me asombre.)
They call her the "weaker sex"	Que a ella se llame el "ser débil"
and they call him the "stronger sex,"	y a él se le llame el "ser fuerte"
because he is a man!	¡Porque es hombre!
She is supposed to be forgiving	Ella debe perdonar
if her husband is unfaithful,	siéndole su esposo infiel;
but he can take revenge on her.	pero él se puede vengar.
(Permit me to act surprised.)	(Permitidme que me asombre.)
Why in a similar case he can even kill her,	En un caso semejante hasta puede matar él,
because he is a man!	¡Porque es hombre!
Oh what a privileged mortal,	¡Oh, mortal privilegiado,
so perfect and faultless	que de perfecto y cabal
you enjoy such secure renown!	gozas seguro renombre!
In any case, for all this,	En todo caso, para esto,
it was sufficient for you	te ha bastado
to be born a man.	nacer hombre.

III Twentieth Century: Political Activities

10 / The Beginnings of the Women's Suffrage Movement in Brazil

The cause of women's suffrage has taken different forms in different Latin American countries. In Brazil, the women's suffrage campaign proved larger and better organized than most subsequent ones in Latin America, although it never became a mass movement. Brazilian women were not simply handed the vote by conservative male leaders who viewed them as a force for the preservation of the status quo.

The first serious efforts to achieve women's suffrage in Brazil—by inserting this right into the new republican constitution drafted in 1891—had been unsuccessful. Neither the handful of pioneer feminists who demanded the vote (see selection 7) nor their supporters in the Constituent Congress could counter male resistance or fears for the fate of the family and the home. But the suffrage issue could no longer be ignored.

By the late nineteenth century, increasing numbers of women were receiving education, although large segments of the population remained illiterate. The doors of Brazil's institutions of higher learning finally opened to women, as the early feminists had demanded. More middle class women found employment outside the home, especially in the classrooms, government offices, and commercial establishments. By 1920, they were competing for high level positions in government service.

The principal leader of the Brazilian women's suffrage movement was Bertha Lutz. Born in São Paulo in 1894 to a Swiss-Brazilian father, Adolfo Lutz, pioneer of tropical medicine in Brazil, and an English mother, she was educated first in Brazil and then in Europe. During her seven years of study in Europe, she closely followed the English suffrage campaign. In 1918,

shortly after her return to Brazil with a degree in biology from the Sorbonne, Bertha Lutz expressed her views on the status of women in her homeland and her hopes for the future in the following magazine article, laying out the major arguments which would be used by Brazilian suffragists.* In response to a column by the wife of the editor of a newsweekly contending that recent feminist achievements in the United States and England would exercise little influence in Brazil, Lutz argued that Brazilian women also merited equality and political responsibilities, but that change could occur only if women worked for it. Through their personal achievements, they could convince men of women's worthiness. Unlike many others, she felt that this was the time to organize, rather than just inform and educate.

Although the organization projected in Bertha Lutz's article could not be formed immediately, several women's organizations appeared in the next few years. She founded her own society in 1920, and two years later, immediately after her return from the United States where she had served as Brazil's official delegate to the first Pan American Conference of Women, it was transformed into the Federação Brasileira pelo Progresso Feminino. The Federation, which became the main suffrage organization in Brazil, affiliated with the International Woman's Suffrage Alliance and hosted the visit of the U.S. suffrage leader Carrie Chapman Catt to Brazil late in 1922. Bertha Lutz would maintain close ties with the international movement both before and after the achievement of women's suffrage in Brazil in 1932, and would continue to attend numerous women's conferences abroad, including the International Women's Year conference in Mexico City in 1975, the year before her death at the age of eighty-two.

Bertha Lutz

For some time I have been following with the greatest interest your columns in the *Revista da Semana*. The last one, that of December 14th, pleased me greatly. Ever since I learned of the

*From *Revista da Semana*, Dec. 23, 1918.

new electoral status of women in England.* I have been very curious as to whether you would have the courage to write what you did. If you had not, I intended to request that you publish a few lines of mine on the matter. Happily, you did it infinitely better than I would have. I am in complete agreement with your ideas and I congratulate and thank you wholeheartedly.

I am a Brazilian and during the past seven years I have been studying in Europe. It was with great sorrow that I observed upon my return home the situation you described concerning the lack of veneration and respect for women which one sees here in our capital city. The public treatment of women is painful for them and does little to honor our fellow countrymen. More respect, of course, is accorded a woman among the more cultured sectors; but this is superficial and barely conceals the toleration and indulgence with which she is treated, as though she were a spoiled child. In this regard, despite all the national progress achieved in recent years, we find ourselves lagging far behind the peoples who dominate the world today, and behind the new, regenerated France to which this terrible war gave birth.

Surely the greatest portion of the responsibility for this unfortunate state of affairs falls to men, in whose hands rest legislation, politics, and all public institutions. But we also are a bit to blame. You cited the words of one of our greatest contemporaries, President Wilson, concerning American women: "They have shown that they do not differ at all from us in every kind of practical endeavor in which they engage either on their own behalf or on that of the nation." These words should serve to guide us, for they reveal the secret to which emancipated women owe their equal footing with men. I was in Europe during the war, and I spent the tragic days preceding the victory in England and France. The women's war effort was admirable and heroic. Some were brokenhearted by the death of a son, husband, father, or brother, and each one was full of anxiety and horror, but with great simplicity and courage they all took the soldiers' places and carried out the hardest jobs of the absent menfolk. They brought a lively intelligence and an indomitable energy to those tasks, which until now were considered impossible for women. And this heroic example of sacrifices and will power secured that which all

*Parliament had just enfranchised women over thirty years of age who were householders, the wives of householders or university graduates.

the social and political arguments had failed to accomplish. Today they harvest the fruit of their dedication. Fortunately for our country and for ourselves, we have not been called upon to provide the same proof. But even so we feel that we are worthy of occupying the same position. But how can we obtain it? We should not resign ourselves to being the only subordinates in a world on which liberty smiles. We must become worthy of that position to which we aspire and we must prove that we merit it. Clearly, at present almost everything depends on men. But one of the greatest forces for emancipation and progress lies within our power: the education of women and men. We must educate women so that they can be intellectually equal and be self-disciplined. We must educate men so that they become aware that women are not toys created for their amusement, and so that, when observing their wives and sisters or remembering their mothers, they understand and are completely convinced of the dignity of women. For us to achieve this result and to demonstrate our equality, both individual and collective efforts are necessary. Practical demonstrations are infinitely more valuable than anything else; only they are truly convincing. You have provided the best example, demonstrating in your columns that the female spirit can rise to the level of large problems, understand new ideas, and express them with elegance and clarity. By achieving first place in a competition, Maria José* has also contributed greatly toward the success of our cause. Finally, all the normal school teachers and other women to whom the nation confides the education of its children prove that there are women of great worth in our country also. Such are the excellent examples which moved me to write this letter and to propose that we channel all these isolated efforts so that together they comprise a definitive proof of our equality. For this purpose I am proposing the establishment of a league of Brazilian women. I am not proposing an association of "suffragettes" who would break windows along the street, but, rather, of Brazilians who understand that a woman ought not to live parasitically based on her sex, taking advantage of man's animal instincts, but, rather, be

*In 1917, following a favorable legal ruling, Maria José de Castro Rebelo was permitted to enter the competition for a position in the Foreign Ministry and she secured first place; previously, women had not been allowed to seek such government service positions. The following year, Bertha Lutz successfully competed for a high position in the National Museum in Rio de Janeiro.

useful, educate herself and her children, and become capable of performing those political responsibilities which the future cannot fail to allot her. Thus, women shall cease to occupy a social position as humiliating for them as it is harmful to men. They shall cease being one of the heavy links that chain our country to the past, and instead, become valuable instruments in the progress of Brazil.

11 / The U.S. Suffrage Movement and Latin America

The whole question of foreign influences, from fashions in dress and literature to factory work and socialist doctrines, on the changing roles and activities of women in Latin America is most complex. Foreign influences and ideas also affected the activities of the twentieth-century suffragists, for the movement received its inspiration from the United States and Europe. The achievement of the vote by women in the United States and in several major European countries following the conclusion of World War I aided the cause in Latin America. Latin American suffragists would argue that if women in "advanced" nations could vote, so should they. Not only the examples given by those nations, but also the personal links established between some Latin American feminists and international suffrage leaders spurred the formation of formal women's rights organizations in several Latin American countries. Women's suffrage in Latin America was basically a middle-class movement for political rights, for a juridical change to give the vote to women who met the same qualifications as men, not an attempt to revolutionize the role of women in society or that society itself.

For many years both before and after women's suffrage was won in the United States, Carrie Chapman Catt, who as president of the National American Women's Suffrage Association had led the successful struggle for the ratification of the nineteenth amendment to the constitution in 1920, demonstrated a strong interest in women's rights throughout the world and headed the International Woman Suffrage Alliance. In 1922, four years after Bertha Lutz published her seminal article

78

(see selection 10), Carrie Chapman Catt embarked on a lecture tour of South America in her capacity as president of the Pan American Association for the Advancement of Women. Her first stop was Rio de Janeiro, where she spoke at a well-publicized women's congress called by Bertha Lutz's women's federation.

The following magazine articles written by Carrie Chapman Catt describing her 1922–1923 trip to South America contain many perceptive comments on the urban middle-class women she met, for most of those involved in women's rights were professional women, especially lawyers and writers.* In Brazil, for example, Bertha Lutz's lieutenants in the 1920s and 1930s included lawyers, doctors, and engineers, both in government service and in the private sector. Those occupying high-level public service positions possessed the necessary organizational skills and determination—as well as the personal contacts—to lead a successful women's suffrage campaign. But some female relatives of the political and social elite as well as upper middle class professional women played prominent roles in the Brazilian women's rights movement.

Although Carrie Chapman Catt strongly desired co-operation and interchange among women in the Americas, she was not unaware of some of their national and cultural distinctions. Yet her articles also indirectly demonstrate the difficulties in cross-cultural understanding, as well as show over-optimism as to when women in South America would gain the vote. Women's suffrage in Brazil would be delayed for another decade, until 1932, and in Chile until 1949.

Carrie Chapman Catt

SUMMING UP SOUTH AMERICA

When at the Baltimore Pan American Congress of Women, it was voted by the Latin American delegates to form a

*From Carrie Chapman Catt, "Summing Up South America," "Busy Women in Brazil," and "The Woman Question in Chile," *The Woman Citizen*, June 2, 1923, pp. 7–8, 26; March 24, 1923, pp. 9–10; April 21, 1923, pp. 9–10, 24, 26.

permanent Pan American Association, there was difficulty in finding officers who were able to give time enough to the task to secure constructive results. The delegates who came often represented no organizations of women and reported that little or no organization among women existed in their countries. As a Pan American Association must, if practical and effective, be a federation of national organizations, the proposed plan was contingent upon such organizations being formed where there were none, and upon the willingness of those already in existence to come into auxiliaryship. It was not at all certain that such an Association could be affected, or if so that it would operate in useful service to those concerned. It was clear that another Congress, this time a delegated one, must be held, and all the problems involved be thoroughly discussed by the women interested. I agreed to serve as tentative president for one year and to go to South America to make a survey of the prospects.

Women Pioneers

This brief explanation will account for my trip to South America. I was accompanied by Mrs. Van Lennep and Miss Babcock, of New York, and Miss Manus, of Holland. The letters I have sent from each country visited, have given some idea of what we found. This one is intended to be an abridged summary of the survey.

First, there is an unmistakable woman movement in South America, but it is in that state of individual effort which preceded the organized demand for various rights before 1848 in the United States, yet with a difference. The women of the United States established their own precedents and proved them good. These precedents all over the world are now established. Second, naturally these precedents reflect a tremendous influence upon the Latin countries. In consequence of these two facts women are admitted to universities in most of the South American countries, and women's colleges exist, although not of high standards of curricula. Girls go to the United States, France, or England to take degrees and governments assist girls to education along special lines in foreign countries in order to improve the quality of home teaching. Young women study law and a few profess to practice it. There are several women physicians in each country and we found women journalists

everywhere, although limited in the character of work done. Curious invasions of oldtime customs are seen, such as streetcar conductors and women hotel staffs in Chile and women bank clerks in Panama. The Y.W.C.A. has a branch in all the countries we visited and has led out in several directions quite new in South America and is finding approval among considerable numbers of young women. There are also small organizations espousing various reforms such as woman suffrage, social hygiene, abolition of regulation of prostitution, etc., etc. I note that nearly all recent North American men writers on South America comment hopefully upon the "rising feminist movement" there and doubtless base their conclusions upon such evidences as these. The facts call for a more fundamental analysis.

Just as Anglo-Saxon ideals and ideas dominated the constitutions and codes of law in the United States, Spanish ideals and traditions have dominated them in the Latin countries. The religion is Catholic, and Church and state are united in all of these countries but three. Most of them keep embassies or legations at the Vatican and the relation is very close and sympathetic. The Catholic Church permits no divorce. The Napoleonic Code with slight changes is in operation throughout South America and that means that the property of married women passes to the control of their husbands; wives must live where and how their husbands dictate; the children belong to the husband, and should a wife, tortured beyond endurance, escape and try to earn her living, the wages she earns may be claimed by a drunken and disloyal husband. One cannot imagine a more helpless human than a married woman whose husband has changed from protector and lover to a dissolute master. There is neither escape nor redress. Curiously, the woman who seeks relief through legal separation, which is sometimes permissible, is often cruelly punished by the increasing ostracism of public opinion while the guilty man suffers not at all.

The women of North America who in the early days strove to break through the wall of law and prejudice which "ringed them round" were Anglo-Saxon and of the same religion and class as those who had made the law and must amend it, if it were done. In South America it happens that the leaders of the so-called radical organizations, physicians, lawyers and many university girls—in other words, those who are leaders of the new movement—are rarely of strict Spanish origin, and their

Catholicism is, in public opinion, often blemished by a leaning toward some reform such as disunion, or trained nurses in hospitals, or more satisfactory adjustments of unhappy marriages, etc., which runs counter to the Church opinion. Often the father or grandfather was German, English, French or Italian. The women, therefore, who are agitating for change of conditions are usually not of the class which comprises the authorities of government. In more than one country I was told that the "aristocracy," drawing its inheritance from Spain, had not produced a single woman to take a college course, enter a profession or lead an organization.

Superficial observers hastily lay the responsibility upon the Church. I do not agree with this conclusion in the least.

More Social Immorality?

Social immorality is either more general or more open than in North America. Foreigners who live in the country and the women of the country talk of it freely. The general opinion is that most men of means keep mistresses and that all wives are familiar with this fact. Indeed, the man who doesn't do so is often regarded as queer. My impression is that the average South American woman would choose relief from the humiliation her husband's disloyalty causes her to all the opportunities, rights and liberty in the world. Under such conditions it follows that young women of the "protected classes" are not expected to go on the streets alone at any time and especially after dark. While a strict law exists in Buenos Aires permitting a woman insulted on the street to report the man offender to the nearest police—a law made possible by the protests of English and American women—the habit of "young men of good families" of speaking insultingly to women of all ages upon the street has not been corrected.

The young woman, therefore, who goes to college, takes a profession, enters business or joins a progressive movement, takes her reputation in her hands and risks her chances of matrimony, very precious in South America. The slightest transgression of the established habit of remaining silently in the back rooms of the house often arouses a suspicion of immorality which a woman may carry through a life-time. This form of intimidation has ever been the most effective weapon employed

by convention to prevent the normal expansion of woman's sphere. The women of all lands have had to pass through it and it required stanch souls to bear the world's scorn. There are such in South America.

The Bearing of Religion

In South America this bondage is riveted more tightly upon women because of the difference of religion. Yet to my mind the Church does not oppose, it merely waits for the women to make their demand. In North America it was the Quakers who, supported by their men, were the first social rebels and dared to speak and to advocate causes. In South America the only groups I found of such comradeship were the Socialists. These women dare and do and their men applaud, but because Socialists are reputed to be anti-religious as well as anti-state, this very act builds the walls of convention temporarily higher. Other women braving outworn custom are as isolated as the solitary snow-capped peak in a range of uncovered mountains. The blessing is that most of them are as serene.

Not all of these women have learned the lesson "In matters of principle go against the current, but in matters of custom, go with it," and have challenged the rightness of law and custom alike without distinction of what is fundamental. This fact has in the estimate of the conservative discredited all efforts of women to free themselves from the genuine bondage imposed by the established order.

In my opinion the association in international conference with women of other lands will give inestimable assistance to the movements now weak and struggling. There is far more sympathy and understanding than I expected to find in the circles of the most conservative, but these women are timid and unwilling to announce their views, lest they be classed with the women who are now under fire. A Pan American Association can only be useful if the conservative and radical will tolerantly unite to work for their common causes. This phase of the problem is far more difficult and delicate than the women of the United States, where all classes have long been accustomed to work together, are likely to understand.

If the Association is finally formed, it will be a conservative one, dealing chiefly with education, home culture and child welfare. All these are extremely important and are unques-

tionably the most fundamental of the reforms needed. I believe, however, that the new organization will endorse and work for the abolition of the Napoleonic Code. We interviewed four presidents of republics and congressional committees in the other two countries, their presidents being absent. I found a hearty approval of this movement, and on this reform, imperative before the woman movement can go far, I anticipate that conservative and radical will unite, and with the approval of the best in state and Church that this outworn and degrading code of past centuries will be replaced by more liberal laws. Already Uruguay has led the way. Woman suffrage may or may not be a long way off. Self-government is far less perfectly operative in South America and many of the republics have government by dictators at least part of the time. Revolutions occur frequently and elections are almost meaningless. Under these conditions, the vote is far less important to these women than individual liberation from code and custom.

A serious and perhaps unsurmountable obstacle to the successful operation of a Pan American permanent Association will be the cost of the journey for delegates who attend the Congresses. These meetings could in consequence not be held frequently; yet unfortunately it is only through frequency of meetings that such an association could be closely enough welded together to arouse that inspiration and loyalty which produces work and progress.

Unless the unforeseen prevents, a Congress will be held in May, 1924 at Rio Janeiro or Buenos Aires. For North American delegates the cost will be between $750 and $1,000. Whether this Congress will be followed by permanent organization or not, is still an open question, but the next Congress will in any event be so planned that it will prove helpful to the women of the Latin countries.

Two other questions remain—do the women of the Latin countries want the help of the women of North America, and can the women of North America give help if it is wanted? The answer to both questions is involved in many delicate considerations. It so happens that a turn in the political road of Pan Americanism in general has taken place at this moment and a very decided turn it is. Until 1920 the Monroe Doctrine was interpreted to mean that the United States intended to prevent any European militaristic nation from carrying out imperialistic policies on the two American continents. There was a promise in

the usual interpretation and the nations of South America felt a sense of protection since their own populations were small, while their immense territories and the richness of their undeveloped resources might easily arouse the greed of Europe. Events, however, chiefly connected with the acquisition of rights to build the Panama Canal and its fortification, the cases of Colombia, Panama, San Domingo, Haiti, Nicaragua and the perennial case of Mexico have aroused a very definite suspicion of the motives of the United States and the very definite accusation that imperialism has passed from Europe to the United States.

The Monroe Doctrine—Seamy Side

The most important newspaper in Argentina, *La Prensa*, declared editorially that the United States had much to gain from the Santiago Pan American Congress and that it had much to explain to South America. The newspapers throughout South America with noticeable unanimity reproduced this article. An Argentine writer quoted by *Current History* for February said:

"We do not desire to be nor could we continue being Pan Americanist. The famous Monroe Doctrine which appeared for a century to be our guarantee of political independence against European conquest has revealed itself gradually as a right of North America to intervene in our affairs."

This attitude of mind we heard over and over in every country. South American countries have their own differences, but on this point they seem in sympathetic agreement. The women as a whole are ill informed on political matters, but even they shared this view. Indeed, I heard more about the Monroe Doctrine in South America in four months than in a whole life time at home. Everyone knows about it and what they know is the South American interpretation. While many South American leaders among men are believers in Pan Americanism, the general opinion at this time is anti Pan Americanism and the very word is in some quarters anathema.

It was with a decided sigh of relief that these countries welcomed the League of Nations. The war swept away any probability there had been of military invasions from Europe and events connected with the Canal accentuated the suspicion that the menace had been transferred from Europe to the

United States. The League of Nations transferred the promise of protection from the United States to Europe.

Therefore, just at the moment when the women of the North are freed from the most grinding of the old limitations and desire with the purest and most philanthropic motives to extend a friendly hand of co-operation to the women of South and Central America, they find the situation "mussed up" by politics. If the outcome of the Santiago Congress* brings renewed confidence and a program of co-operation which follows common ideals instead of national advantage, the woman's movement will go forward fast and far. If, however, the distinguished gentlemen at Santiago make eloquent speeches of friendly intentions, but the results of the Congress indicate no co-operation in positive progress, the woman's Pan American movement may be swamped in the political morass created. In other words, South American women may not want the help of those of North America. South American women are sweetly charming, very kind and polite, and they will never say they want no help, but there would be a subtle resistance to co-operation.

On the other hand, the women of the North may not understand well enough to be really helpful, the situation in which the women of the Latin countries are placed. The road to emancipation in these countries may be a very different one from that the Northern women trod. Here there is poetry, sentiment and chilvalry in the relations of men toward good women despite all the hard facts seemingly to the contrary. There was no appreciable presence of these elements in the anti or pro woman forces of the North and they may produce results the cold logic of the North failed to do. It is clear that we cannot build the road over which the women of the South must pass. They must build their own and travel over it alone.

What then can we do for the Latin American women? Much; we can

Inspire them to aspiration,
Give them confidence,
Give them courage.

We will do well to adopt three don'ts:

Don't patronize,

*Written before the conclusion of that Congress.

Don't be superior,

Don't insist that ours is the only way.

These are three offenses of men in their relations with the Latin countries. In truth the Northern countries have builded a great civilization and the thought, method and institutions are similar in all of them. They belong to the same system. The Latins are different. Their thought, method and institutions belong to a different system. They should have the same freedom to develop their own system by their own method. Meanwhile South American civilization awaits the emancipation of women from the seventeenth century customs into the light and freedom of the twentieth century. In that evolution we may help, and in return receive the inspiration and the wholesome discipline of contact with a civilization quite different from our own. If we are able to work together, as I most earnestly pray we may, the women of North, Central and South America will together achieve much not only for the Western Hemisphere but for the entire world.

The Congress of 1924 may prove a crucial turning point in the woman movement, the Pan American movement, the peace movement, and the evolution of world civilization.

Busy Women in Brazil

Brazil has an undying organized woman suffrage movement. A group of women highly educated, of good families and actuated by noble aspirations will see that the movement does not swerve from the straight course leading to the enfranchisement of women.

Brazil sent Miss Bertha Lutz as official delegate to the Pan American Conference in Baltimore, held last April. It was there decided to organize a Pan American Association for the Advancement of Women, the object being to encourage and stimulate the organization of women in South and Central America and in Mexico. The plan adopted was that of federating existing organizations of women in support of the general improvement in the educational, civil, legal and political status of women. Constitutions were written and translated into Spanish and Portuguese, and I agreed to serve as acting president of the temporary Pan American organization for one year. In that

capacity I came to South America accompanied by Mrs. Anita Van Lennep and Miss Elizabeth Babcock of New York and Miss Rosa Manus of Holland. Our first stop was Brazil, where we remained for three busy weeks.

Miss Lutz had already organized a Brazilian Association for the Advancement of Women and formed three auxiliaries. Under the auspices of this Association a Brazilian Congress of Women was organized to receive us, and opened the day following our arrival. The Governors of nine of the twenty states which compose the Republic sent official delegates. Education, organization methods, child-welfare, laws for women, Pan Americanism and woman suffrage were subjects on the program.

The best of the sessions was unquestionably the suffrage evening when Senator Louro Mueller, state of St. Catharina, presided. He is mentioned as a possible president of Brazil and is widely influential. He frankly espoused the cause for the first time in an eloquent address. Senator Lopes Goncalves, who—as chairman of the committee to which the suffrage bill had been referred—had made a favorable report, also pledged his continued support. A prominent lawyer made a similar declaration and two women representatives of outlying states made earnest pleas for early action.

The significance of this evening was emphasized the next day by a unique suffrage experience. The Senate has a diplomatic committee whose function it is to receive "distinguished foreigners," meaning men. For the first time these words were interpreted to include women and we were invited to visit the Senate. The invitation was extended to the newly organized Brazilian Woman Suffrage Alliance, one result of the Congress. Vice-President Coimba and several senators received us and one senator who had graduated at the University of Pennsylvania addressed us in English, paying fulsome compliments to the United States, women in general and suffragists in particular. Then champagne and cakes were brought and speedy success to our cause was proposed and drunk. The fact that I and several others drank the toast in mineral water will not delay the victory.

A suffrage bill has passed both houses once, but to become a law it must pass three times and be signed by the President. It is now pending in the Senate for second passage with a firm belief on the part of its chief friends that it will pass. The Senate, however, adjourned on December 31 for its sum-

mer vacation (it is summer here now) and will not meet again until May, when it will be taken up.

We assisted at the organization of State Suffrage Alliances in the states of Rio—at Petropolis, and Sao Paulo—at its capital, the city of Sao Paulo. The capital of Brazil, Rio Janeiro, is a federal district similar to the District of Columbia, but differs in having the status of a state with representatives in the Congress. Thus the Brazilian Alliance for Woman Suffrage (Allianca Brasileira pelo Suffragio Feminino) begins its career with three state auxiliaries, and committees preparing for organization in several others, and with a bill in Congress supported by many influential political leaders.

The character of the women leaders offers the clearest assurance of ultimate success. Miss Bertha Lutz, a beautiful young woman, is the "propulsive force" at present. Her father, Dr. Lutz, is acknowledged to be the greatest of the many eminent Brazilian scientists and is manager of the world-famous Oswaldo Cruz Institute, wherein experimental medicine and research particularly directed to tropical diseases is conducted. Miss Lutz was educated at the Sorbonne, speaks four languages fluently and is herself a qualified naturalist. She is secretary of the National Museum, but this list of achievements does not tell the whole story. She has a winsome way of persuading people to do the right thing and is both fearless and perennially optimistic. She is president of the new Brazilian Association for the Advancement of Women and general secretary of the Allianca Brasileira pelo Suffragio Feminino. I am personally indebted to Miss Lutz for interpreting all my speeches, which those who knew both languages said was a brilliant display of memory and vocabulary.

The President of the Suffrage Alliance is Mme. Justo Chermont, whose husband introduced the suffrage bill in the Senate. She is a handsome, charming, intelligent, and exceedingly able woman. The presidents of the two outlying states are also noteworthy. Mme. Eneas Martins, president of the Petropolis branch, has seen much of the world and knows Brazilian politics thoroughly. Her husband served as Governor of the State of Para, was Minister of Foreign Affairs and Ambassador at several South American capitals. She is now a widow. She has founded a well-organized institute for the care of the poor and is enthusiastic, energetic and optimistic—three necessities in a leader.

The president of the Sao Paulo Alliance is Dr. Wal-

kyria Moreira da Silva, who represents an interesting bit in Brazilian history. Revolution freed Brazil from monarchy in 1888 and in 1889–1890 a Republican Assembly met to draft a republican constitution. Hon. Indio do Brazil introduced a motion to include woman suffrage in the constitution and a lively struggle followed, developing thirty-two supporters. Among them was the Hon. Moreira da Silva, the delegate from Sao Paulo. He not only earnestly supported the proposal to give women the vote at once, but when that failed succeeded in keeping the word male out of the constitution, which bases the right to vote upon "persons born or naturalized" in the country. It is therefore a controversial legal point as to whether women do not already possess the vote without further action. Signor da Silva made all his children promise to do their utmost to raise the status of women. One daughter is a Bachelor of Letters and a writer. Dr. Walkyria is a laywer in full practice and now becomes president of a suffrage association to carry out her father's aim. She is an eloquent speaker and in all regards is a remarkable young woman. She will be married soon and may come to the Rome Congress on her wedding trip. It is a temptation to give brief accounts of other women who are officers of the new associations, but space forbids. The new Association expects to send delegates to Rome, including its president.

Brazil contains curious contrasts in its women's movement. Very many women are held in almost harem restrictions, never going on the street alone and shopping only when escorted by their husbands. On the other hand, Brazil has many practicing women physicians, dentists and lawyers, many able women writers, sculptors, poets and painters, a famous young aviatrix, six civil engineers, several women engaged in the chemical service of the Department of Agriculture and several who are very notable in science. This advance column of women at home, coupled with the liberation of women the world around, is fast breaking down the outworn bondage and creating a new point of view in public opinion.

It was with genuine regret that we bade good-by to beautiful Brazil with its green mountains, blue skies and spreading sea; its splendid warm-hearted, hospitable men and women. They extended their greeting at Pernambuco, the first point reached in Brazil, through the Governor, who sent his chief of police on board to express them. They saw us off on the *Andes* at Santos and literally buried us in flowers. Indeed when we and our escorts came on board a passenger was overheard speaking

to another—"I say, has any one died on board?" But we felt more like brides than corpses and never said farewell with truer regret.

THE WOMAN QUESTION IN CHILE

Chile so much resembles California that the comparison is constantly in mind. The climate is superb, soft dry air with cool nights. Barren mountains with little vegetation form the background of every view, with sunny peaks in the distance. The markets are filled with delectable fruits raised by irrigation, for in parts of the country it does not rain during nine months of the year and not a great deal of the remaining three. Flowers, carefully watered, grow in every nook and cranny and roses are as plentiful and fine as in California. The comparison may be carried to all details, including the famed yellow poppies, and even to the same variety of evasive fleas. The vegetation is naturally covered with dust, and country roads are in bad condition, so that the traveler swallows much of the native soil reduced to the finest of dust. Yet were there better hotels, no spot in the world could be more fascinating as a vacation playground. The dry air has compensating attractions—there are no mosquitoes, and it is bracing.

It is very different country from the Argentine with its broad level prairies. Here agriculture is confined to valleys between mountain ranges or foot hills. It is sometimes called the "shoe-string" country because it is so long and narrow. The population is small—only four million and with a death rate so near the birth rate that the increase is not rapid, despite the fact that the streets where poorer classes live are swarming with children. The beautiful climate and the high death rate do not seem to square, but it is explained by the fact that the masses are of mixed blood with small knowledge of sanitation, and tuberculosis and other maladies, together with alcohol, are making havoc among them. Chile, like all the other countries in South America, is making earnest efforts to educate its people to understand the necessity of cleanliness and care, and is making progress. A compulsory primary educational law is just coming into enforcement.

The woman question in Chile has some curious phases. In the chief hotel the entire staff of the administration are women, and very efficient, while the "chambermaids" are all

men and inefficient. The trains have men motor drivers and
women collectors. The University has been co-educational for
many years and at present a thousand girls in its various depart-
ments are in attendance. Many women physicians are well estab-
lished, and although the hospitals still prefer the exclusive
services of men, they have their place there also.

A Council of Women was organized at the capitol,
Santiago, about three years ago, and exceeds all the other
important organizations in point of age. When it was organized
there were no organizations to federate, as is the normal Council
way, and it became a group of individuals with two auxiliary
provincial groups. It has taken an old house, once the home of a
luxuriant rich family, and has organized dormitories for out-of-
town girl students at the University. It holds classes of various
kinds and is attempting to educate the taste and mind of the
women. Our public meeting was held in the patio (an open
interior court found in every old-time house) and despite the
fact that "everybody" was reported to be at the seashore (for this
is the time which corresponds to the last days of our August) it
was well filled. The president is a university woman who studied
for her Doctor's degree at Columbia in New York and the
Sorbonne, Paris. She is now the directress of a girls' high school
and also has a post as professor of psychology at the University.
She is a woman of rare mind and able attainments—Señora Le-
barca de Hewet.

A Woman's Club has been organized at Santiago by
society women, with members all over the country—Señora
Delia Matte de Izquierdo, president. The first floor of an old
palace built some hundred and fifty years ago is its home. The
patio has been roofed over and thus furnishes an excellent hall
where lectures, concerts and classes are conducted. The mem-
bership seems restricted to the social set but attendance upon
classes and lectures is open to all women. A reception was given
us in this first of Chilean Women's Clubs and we met there some
truly remarkable women, writers, singers and musicians. "Rox-
ane," a contributor to newspapers and magazines, whose name is
known to every Chilean, we afterward saw in her own little
snuggery, where well up under a quaint old roof surrounded by
books and pictures, she writes her brilliant comments on people
and things. "Iris," a writer of books, is probably the best-known
woman author of Chile. She is the mother of four grown daugh-
ters and is beautiful, which never spoils a genuine woman. We
took tea with her at her home. "Iris" lives in a palace which

stands in the midst of a great and glorious garden all shut in by rose-covered walls. "Roxane" gets her impulses from the big conflicts in the world outside; "Iris" gets hers from the beauty of her surroundings and the unrest in her own soul—and these two are good friends and fellow directors of the Woman's Club. We were glad to meet there a relative of Rebecca Matte de Iniquez, by far the greatest sculptor of Chile. She lives in Florence, but some of the products of her chisel are in the Museum of Art. I do not recall ever having been so impressed by the power of marble as in her "Sorrow" at the cemetery and "He Must Die" at the museum—a genius, truly great, she is. This club is laying a firm foundation for a larger woman's movement yet to come.

A Liga de Dames Chilean (Catholic Women) is a recent development at Santiago, and followed the appearance of the Y.W.C.A., which in its comfortable home is doing much toward enlarging the life of girls. It has introduced the innovation of girls' camps, which at first shocked but were finally embraced by large numbers of girls. The new Catholic Liga is undertaking similar work among girls but is yet too new for one to make predictions as to its future. The president is Señora Amalia Errazuriz de Subercaseaux.

A woman suffrage association came into existence a few years ago, but after a brief life, internal disagreements brought it to an untimely end. From its ashes a new Partido Civico Feminino has been formed with Señora Ester La R. de Sanguesa as president. It publishes an excellent little paper, *Accion Feminina*, and is composed of very earnest-minded women who I predict will "carry on" with increasing effectiveness. It is a strong group with that vision which permits no pause.

These organizations are the important ones, but their activities are almost entirely confined to the two chief cities, Santiago and Valparaiso. The great territory, with its scattered population, which lies behind these cities, as well as that similarly disposed in all the other South American countries, is untouched by the woman movement and indeed is only slightly affected by the earnest desire on the part of governments to spread education.

In Chile the same union of church and state exists as in other South American countries, although there is a movement for disunion. Prostitution is "regulated" as throughout the continent, but Chile has put an end to the state lottery. The dissatisfied shrug their shoulders and say, "Yes, we have no lottery

now, so all the Chilean money goes to Argentina to support theirs." Nevertheless, there is a grim pride in the fact that the nation has thrown off the demoralizing influence of the lottery. One charitable institution stands unfinished for lack of money and offers daily temptation to resume the one-time method of gaining funds.

We visited the Chamber of Deputies, where we were received cordially by the Chairman or Speaker, and also the Senate, where the President of that body received us. Members, as in the Argentine, do not rise in debate. A beautiful Capitol building, somewhat resembling that at Washington, not only provides the usual halls for the two divisions of Congress but a third and larger hall where both houses congregate when joint meetings are necessary, as when the President delivers a message. It is in this hall that the Congress of the Pan American Union will sit. Painters and cleaners were everywhere at work putting the Congress hall from cellar to garret in apple-pie order ready for the coming visitors.

We had an hour's talk with the President of Chile, Don Arturo Alessandri, a man of the new time. He is a feminist earnestly advocating equality of educational privileges for women, a revision of the civil code and the eventual extension of the vote. He is a keen propagandist for Pan Americanism and the League of Nations, and he advocates many reforms, among which is the separation of Church and State, although he is himself a Catholic. He is in advance of his nation and his party, which now calls him a demagogue. Another generation will probably erect a monument to him.

All the South American republics have followed the example of the United States and extended universal suffrage to men. Among the electorate are so many illiterates, morons and appallingly ignorant that votes are to be had for bribery, and the party or candidate with the most money often wins. Thus the extension of ill-considered political rights has been followed here, as in the United States, by an evil which has become a serious menace to real liberty, and a problem difficult of solution is recognized. Here, as in the United States, women are told that their enfranchisement would only increase the evil and there-fore they must wait. Had the republics of the Western Hemi-sphere founded self-government upon the consent of the fit regardless of sex and set themselves to the problem of making all their people rise to the fixed requirements, their civilizations

would be a tremendous distance in advance of where they now stand.

Meanwhile women are far from satisfied, but they have no effectively large and united organization to conduct a campaign for betterment. All of the more intelligent women agree that a reform in the civil law should come first. The President has recommended it. The Partido Civico Feminino supports it, and some legal changes should be expected ere long. At present the woman upon marriage loses property, the right to wages, the right to her children and cannot testify in court or sign a legal paper. One interesting law has made an inroad upon this barricade against liberty of women. A working woman may have her own bank account and deposit her earnings therein until she has accumulated $150. After that the account becomes a "family account," which in practice means that it passes to the husband.

Although the women's organizations in Chile are few, small and timid, yet in some particulars they seem more normal and fundamental than in any other country visited. Time alone will offer proof as to the correctness of this diagnosis. In any event, Chile is a sturdy little country with a proud and growing people and has many women of remarkable gifts and many university girls who will be women soon.

We are greatly indebted to Señorita Graciela Mandujano, Chilean delegate to Baltimore last year, for our program at Chile and many attentions, including interpretation.

12 / The Place of Women in a Peruvian Reform Party

The liberal fear that women's suffrage in Latin America would result in conservative votes helped delay this suffrage for decades. And actual voting patterns in later years lent credence to the argument that women would be more influenced by the Church and conservatism than were men. The once revolutionary party of Peru, APRA, Víctor Raúl Haya de la Torre's Alianza Popular Revolucionaria de América, for years took an official stand against universal suffrage.

Even after the vote for women became a reality in Latin America, women were rarely found among the political decision makers. A large majority of the very small total number of women winning political office or bureaucratic appointment still found themselves in what have been considered feminine concerns such as education, health, social welfare, and the arts. In fact, many parties segregated women into women's divisions and told them to organize the feminine vote, not participate in policy making. This was the case even with supposedly progressive parties like APRA.

In the 1930s, Magda Portal, the leader of the women's forces in APRA took a stand against women's suffrage for fear that women who would qualify for the vote would support conservative positions (see the first selection below).* But her disenchantment surfaced after years of dedicated party service in the form of a novel published in 1956. Although she prefaced

*From Magda Portal, *El aprismo y la mujer* (Lima: Editorial Atahualpa, 1933), pp. 15–17.

this novel (see the second selection below)* with a denial of any similarities to actual deeds or people, she graphically portrayed the types of women in the party as well as her own role and feelings in the person of the chief character of the novel, María de la Luz.

Magda Portal

APRISMO AND THE WOMAN

Aprista women clearly understand the nature of the vote as exercised in a feudal–bourgeois democracy, where the lack of education and the presence of fraud and bribery have converted the ballot box into a sordid business benefiting the professional politicians. *Aprista* loyalists never forget the need to convert the vote into one more agent for the triumph of the economic and social claims of *Aprismo*. Under the circumstances women want limited voting rights. What type of women should have the right to vote? The educational level of the Peruvian woman, her prejudices, her willing dependency on male influence, and often, on that of the church, would convert the feminine vote into a means of strengthening conservative rather than revolutionary ideas. The experiences of other countries where political rights have been granted to all women, as in Spain, for example, show us that it is imperative to limit the right to vote until women are properly instructed and can fully respond to the need for social reform and economic justice.

Consequently, the *Aprista* woman, an industrious woman, a responsible woman, a woman who belongs to the working ranks in every way, realizes that the feminine vote should be limited. On the surface this represents a striking inequality vis-a-vis men, since all of the latter, regardless of their social situation, are permitted to vote, whereas women's votes are limited in accordance with their social and economic position. But under the modern concept of functional democracy,

*From Magda Portal, *La trampa* (Lima: Ediciones Raiz, 1956), pp. 87–92, 122.

not bourgeois democracy, the significant vote must be one of quality, not quantity. Thus, the vote of the woman who works, as compared with that of the woman who lives parasitically, is undeniably superior, for she is an element of production as well as a factor of social progress. The *Aprista* Party asks for a limited vote for women. This has not been achieved owing to the demagoguery surrounding the matter. But even Sánchez Cerro* and his henchmen, who dissolved the Constituent Congress and deported twenty-three *Aprista* representatives, included the female vote in municipal elections, a limited vote for women, in his new constitution, thus supporting once again, even though partially, *Aprista* principles.

Women in the Party

There are many types of women in the party: the poor wives of workers, women workers themselves, factory or mill employees, and the numerous domestic servants who labor more than ten hours per day. Then come the middle-class women, business employees, government bureaucrats, teachers, students, and poor professionals. These are the real loyalists who became party members in hopes of fulfilling their economic aspirations through the party. Many also joined for political reasons.

But there are other types of women outside the party who, nevertheless, occupy a dominant position within it. These are the wives, relatives, or friends of the leaders. The bulk of the membership appropriately view them as the "ladies," the aristocracy of the party.

María de la Luz knows how to deal with the loyalist women: without ceremony, without fuss, in a democratic fashion. She knows what they need and in her capacity as leader she sees to it that they receive the necessary training within the party to equip them for the struggle to obtain their rights.

With the ladies she feels a little uncomfortable. They require another type of treatment, more indulgent, more in accordance with their position. She speaks to them in friendly

*Luís Sánchez Cerro, who ruled Peru as a dictator from 1930 to 1933 and who outlawed APRA. Ed. note.

tones, but does not really consider them her friends. The ladies are more concerned about what time their husbands get out of their political meetings than about what is discussed in them. When the ladies arrive at party headquarters, everyone makes way for them. They come all decked out in their elegant clothes and costly jewels.

María de la Luz considers it rather offensive to wear such apparel and exhibit it before poorly dressed people. She prefers to wear her plainest clothes, and if she needs to cover her head, it is always with a beret.

Among the ladies, the most prominent are those most closely related to the leaders. The wife of the leader's physician is semi-educated, a schemer, with leadership aspirations. She would like to become a "somebody," but she is not happy in the company of the common people. She is not disposed to associate with her maid and let the maid call her "comrade." The physician's wife has special favors coming to her for hiding the leader when he was on the run. She now feels she should be justly compensated.

Another lady is a mystic. A mature woman, she caters to the leader's every wish. As she is related by marriage to a prominent leader, she has a very important position in the party. It would not be easy for her to relate to the loyalists. She lacks the common touch needed to identify herself with them.

The mystic speaks mildly on every topic, as she has dabbled in all political chores since her youth. But she feels herself weighted down with age and knows she was unsuccessful in avoiding a bitter and unwanted spinsterhood. Deep down in her heart she harbors a tremendous grudge against all younger women who are able to live their own lives.

It is easy to recognize the mystic by the tenseness of her mouth, her awkward expression, and the flush of hatred that passes over her face. When she is found out, she again puts on her mask of the humble smile and pious voice.

The woman professional is ambitious, intelligent, ill-trained, but talented in matters of union organization. She enters the party anxious to play a role, and she discovers that to obtain a leadership position, she needs to go through María de la Luz' training school. Therefore, she feels constrained because she thinks herself sufficiently qualified to play a leadership role.

A half dozen ladies comprise the core of the party aristocracy. Students, professionals, teachers, and women of high social rank back up these ladies and promote a sense of rivalry between them and the rest of the party women.

These ladies—many of them not officially enrolled in the party—are the ones who organize the musicals and benefit affairs, distribute gifts, and so forth. They are the party sponsors, who imitate the bourgeoisie and try to win the favor of the masses. They think this is the most important chore of the women in the party.

Another group serves as a counter-balance to these ladies. The members of this group, placing their confidence in the high position occupied by María de la Luz, believe that they will benefit most by serving and flattering her. They endeavor to get as close as possible to her, guessing her thoughts and catering to her wishes. They are humble and ready to carry out all her orders, so long as these emanate from the women's governing board, under the direct control of María de la Luz. Such women include members of the middle class, particularly students, women labor leaders, and wives of subordinate leaders. These women occupy confidential positions within the feminine organizations. They represent María de la Luz in neighborhood committees and serve as secretaries to the different sections comprising the women's training organization. They are useful, active workers but possessed by tremendous personal ambitions and plagued by petty jealousies among themselves. The undisputed authority María de la Luz enjoys has the effect of restraining any noticeable friction among this group of women.

The vast majority of the party women form another category. Obedient, mostly uneducated, they fall in step with the organization without question. Their participation, totally passive, resembles a sponge or hungry mouth which absorbs every word of the spiritual food spoken by the leaders. They are the ones who swell the big party demonstrations, accompany the dead and lay wreaths, and sing and applaud; they are the ones who visit the prisoners, or fall prisoners themselves, and endure the kind of oppression the ladies could never withstand. Prisons were not made for ladies, except for the more prominent ones, like María de la Luz. This amorphous group also includes the silent heroines, the anonymous ones, those who die of hunger,

the poor, the pursued, and the unyielding. The party erects no monuments to them. They are merely women.

These women are the retaining walls against the great avalanches of persecution. They carry weapons, messages, and compromising orders wrapped in their clothes. They ask for nothing now, but only for tomorrow when a new sun will rise to light the road for everyone.

María de la Luz is a little disturbed. The ladies involved her in a small intrigue with the leader and they came out winning. The leader likes gossip. She feels helpless when it comes to repelling low blows. She does not know how to fight on unfair grounds. She prefers not to defend herself. But she feels an uneasiness, as if her beautifully erected house of cards would come tumbling down.

The fact is María de la Luz does not understand women. Her dealings with them have always been on a superficial plane. As a rule, she has male friends. With men she feels much more comfortable, since she was their comrade during her student activist days.

Once at a party with friends—it was her birthday—when only two women were present along with a dozen men (poets, artists, writers, teachers), one of the participants, a doctor-poet, proposed that everyone present a toast. It was a delightful evening and they were happily reminiscing. When the person who suggested the toasts took his turn, he spoke the following words with special emphasis: "María de la Luz, may women speak ill of you." What an odd impression these words made on her as the rest of her friends applauded and continued to offer toasts.

It is true; the women do not like her. Could it be that her personality repels them? Is she really so different from the rest of the women that she cannot relate to members of her own sex? There is a tinge of jealousy in the group that surrounds her, as if she were usurping a position that does not belong to her.

The truth is that María de la Luz is not the exact equal of any of the party women; she feels either above or below them. Perhaps she is too much of an introvert; she ignores the frivolous manner which characterizes these women, or at least the majority of them.

The intrigue mounted against her created a minor storm among the party women. Her pride and astonishment

prevent her from explaining anything. She abstains, pained and disgusted. These are the rough stones along the road on which she must tread.

Among the women in the party the only real leader is María de la Luz. She is a founding member of the party, which she joined at its very inception. She occupies a lifetime position in the High Command. But the high-level political meetings always take place without her presence. Can one place trust in feminine discretion?

She is considered intelligent, capable, active, industrious, and loyal. But she is too intolerant, too gruff, too overbearing. She is inflexible and does not get along with the leaders' wives, because she does not view them as being on her level. She does not get along with the leaders because the presence of a woman among so many men produces a clash. Moreover, she always sits in judgment. When she appears at the meetings of the High Command, it is always on formal matters. And when she takes a position the majority of the members of the High Command oppose her. She remains alone. Many times she leaves the room as a sign of protest and they all breathe a sigh of relief.

María de la Luz is kept in the High Command because they need to have a woman there, so that no one can say the party excludes women. Besides, she cannot be replaced because the rest of the women lack the prestige and the strength of leadership she possesses. The majority of the outstanding party women are too "womanly," and this bothers the leader.

13 / The Most Powerful Woman in Latin America

In Latin America, where politics generally has been viewed as "man's work," a woman who achieved any power was often judged by harsher standards than were men, resented, and attacked for ambitions considered unseemly in a woman. This certainly was the case with Eva Perón, the most powerful woman in Latin American history.

Born in a provincial town in the interior of Argentina, Eva Duarte went to Buenos Aires, the nation's metropolis, as a young woman to become an actress. Like many other Argentine women from the interior who migrated to the capital, she was of relatively humble origin. Moreover, her illegitimate birth was never forgotten or forgiven by the country's social elite once she achieved power, and this influenced her attitudes toward the upper class. While Eva did not encounter great success as an actress in Buenos Aires, she found a better livelihood on the radio and in cabarets and circulated in the society of high-ranking army officers. In 1943 this attractive and intelligent woman met Juan Perón, an ambitious and capable army officer striving to improve his position within the government which had recently come to power. Eva became both his mistress and his very acute and able political assistant. Both before and after their marriage in 1945, her role was crucial in maintaining labor support for the Perón regime. And labor together with the armed forces comprised the major sources of the regime's strength.

Eva Perón never held elective office in Argentina. A woman by herself could not rule the nation and so she exerted her power through and with a man, Juan Perón. Her one attempt at political office, the vice-presidency, met with such hostility

from the armed forces that she retreated. The mere thought of the possibility of a female commander in chief was too much for the officers of the period.

No one ever seemed capable of speaking of Eva Perón in dispassionate terms. Those who benefited from her large charity foundation glorified her. Others vilified her. But certainly no one ignored Evita. Her ghostwritten autobiography, although composed in an overly theatrical style for mass propaganda, reflects part of her personality and activities. The autobiography, like the woman, has generated controversy and has been interpreted both as the propaganda of a cunning, ambitious woman, and, less often in later years, as the sincere testimony of a seeker of social justice and national regeneration. In this rather coy, ghostwritten, and adulatory autobiography, sections of which comprise the following selection, Evita revealed aspects of her life and feelings, although that life ran counter to some of her own statements as well as to existing stereotypes of the role of women.* She declared she was not a feminist who wanted to behave like a man; she enjoyed wearing lipstick and nice clothes, scorning women who did not. But she protested the absence of women from centers of power, ranging from atomic energy commissions to the Vatican. While she spoke of the sanctity of motherhood and the home, as had many others before her, she went on to propose salaries for housewives. Evita always claimed that all her actions were founded on love and praise for Perón and that she was the link between him and the people. Just as she had fought to bind labor to the Perón regime, so she mobilized feminine support for a government which gave women the vote in 1947, as well as a divorce law. Her death in July 1952 at the age of thirty-three would weaken Perón's own position. Following his overthrow in 1955, the divorce law was repealed and far fewer women were elected to office in Argentina.

Eva Perón

A GREAT FEELING

I have to look back on the course of my life to find the earliest reason for all that is happening to me now.

*From Eva Perón, *My Mission in Life*, trans. Ethel Cherry (New York: Vantage Press, 1953), pp. 5–6, 59–61, 185–190.

Perhaps I am wrong in saying "the earliest *reason*," since the truth is that all my life I have been prone to be driven and guided by my feelings.

Even today, in this rush of things that I must perform, I let myself be guided very often—in fact almost always—primarily by what I feel.

Reason, with me, often has to give way to emotion; and so, to explain the life I lead today, that is to say, what I am doing now out of motives that spring from the bottom of my heart, I have to go back and search through my earliest years for the first feelings that make sense, or at least explain, what to those severe critics is "an incomprehensible sacrifice," but which to me is neither sacrifice nor incomprehensible.

I have discovered a fundamental feeling in my heart which completely governs my spirit and my life. That feeling is my *indignation when confronted with injustice.*

Ever since I can remember, all injustice has hurt my soul as though something were stabbing it. Memories of injustices against which I rebelled at every age still rankle.

I remember very well how sad I was for many days when I first realized that there were poor and rich in the world; and the strange thing is that the fact of the existence of the poor did not hurt me so much as the knowledge that, at the same time, the rich existed.

EVA PERÓN AND "EVITA"

There is in my destiny nothing extraordinary, and even less that is due to chance.

I cannot say I think all that has happened to me is logical and reasonable, but I would not be sincere if I did not say that it all seems to me at least natural.

I have already set forth the principal causes of the mission which it has fallen to my lot to accomplish in my country. My explanation would not be complete, however, if I did not say something also about the circumstances which made me decide to bring myself into strict collaboration with General Perón after he became President of the Argentines.

Before starting on the subject, it is well to remember that Perón is not only President of the Republic; he is also the Leader of his people.

This is a fundamental condition, and is directly related to my decision to handle the role of wife to the President of the Republic in a manner different from any President's wife who had preceded me.

I could have followed in the old pattern. I want to make this very clear, because people have also wished to explain my "incomprehensible sacrifice" by arguing that the drawing rooms of the oligarchy would have been closed to me in any event.

Nothing is further than this from all reality, nor more removed from all common sense.

I might have been a President's wife like the others.

It is a simple and agreeable role: a holiday job, the task of receiving honors, of decking oneself out to go through the motions prescribed by social dictates. It is all very similar to what I was able to do previously, and I think more or less successfully, in the theater and in the cinema.

As for the hostility of the oligarchy, I can only smile.

And I wonder: why would the oligarchy have been able to reject me?

Because of my humble origin? Because of my artistic career?

But has that class of person ever bothered about these things here—or in any part of the world—when it was a case of the wife of a President?

The oligarchy has never been hostile to anyone who could be useful to it. Power and money were never bad antecedents to a genuine oligarch.

The truth is different. I, who had learned from Perón to choose unusual paths, did not wish to follow the old pattern of wife of the President.

Also, anyone who knows me a bit—I don't mean now, but from before, when I was a "simple Argentine girl"—knows that I could never have enacted the cold comedy of oligarchical drawing rooms.

I was not born for that. On the contrary, there was always in my soul an open repugnance for that kind of acting.

But also, I was not only the wife of the President of the Republic, I was also the wife of the Leader of the Argentines.

I had to have a double personality to correspond with Perón's double personality. One, Eva Perón, wife of the President,

whose work is simple and agreeable, a holiday job of receiving honors, of gala performances; the other, "Evita," wife of the Leader of a people who have placed all their faith in him, all their hope and all their love.

A few days of the year I act the part of Eva Perón; and I think I do better each time in that part, for it seems to me to be neither difficult nor disagreeable.

The immense majority of days I am, on the other hand, "Evita," a link stretched between the hopes of the people and the fulfilling hands of Perón, Argentina's first woman Peronista—and this indeed is a difficult role for me, and one in which I am never quite satisfied with myself.

There is no need for us to speak of Eva Perón.

What she does appears too lavishly in the newspapers and reviews everywhere.

On the other hand, it is interesting for us to talk about "Evita"; not because I feel at all vain about being she, but because those who understand "Evita" may find it easy afterward to understand her *descamisados*,* the people themselves, will never feel themselves more important than they are . . . and so will never turn into an oligarchy, which, in the eyes of a Peronista, is the worst thing that can happen.

FROM THE SUBLIME TO THE RIDICULOUS

I confess I was a little afraid the day I found myself facing the possibility of starting on the "feminist" path.

What could I, a humble woman of the people, do where other women, more prepared than I, had categorically failed?

Be ridiculous? Join the nucleus of women with a grudge against woman and against man, as has happened to innumerable feminist leaders?

I was not an old maid, nor even ugly enough for such a post . . . which, from the time of the English suffragettes down to today, generally belongs, almost exclusively, to women of this type . . . women whose first impulse undoubtedly had been to be like men.

And that is how they guided the movements they led!

*Lit., "the shirtless ones."

They seemed to be dominated by indignation at not having been born men, more than by the pride of being women.

They thought, too, that it was a misfortune to be a woman. They were resentful of women who did not want to stop being women. They were resentful of men because they would not let them be like them; the "feminists," the immense majority of feminists in the world, as far as I could see, continued to be a strange species of woman . . . which never seemed to me to be entirely womanly!

And I did not feel very much inclined to be like them.

One day the General gave me the explanation I needed.

"Don't you see that they have missed the way? They want to be men. It is as though to save the workers I had tried to make oligarchs of them. I would have remained without workers. And I do not think I should have managed to improve the oligarchy at all. Don't you see that this class of 'feminists' detests womanhood? Some of them do not even use makeup . . . because that, according to them, is womanly. Don't you see they want to be men? And if what the world requires is a woman's political and social movement . . . how little will the world gain if the women want to save it by imitating men! We have done too many strange things and made such a mess of everything that I do not know if the world can be arranged anew. Perhaps woman can save us, on condition that she does not imitate us."

I well remember that lesson of the General's.

His ideas never seemed to me so clear and bright.

That is how I felt.

I felt that the woman's movement in my country and all over the world had to fulfill a sublime mission . . . and everything I knew about feminism seemed to me ridiculous. For, not led by women but by those who aspired to be men, it ceased to be womanly and was nothing! Feminism had taken the step from the sublime to the ridiculous.

And that is the step I always try to avoid taking!

I WOULD LIKE TO SHOW THEM A WAY

The first thing I had to do in my country's woman's movement was to solve the old problem of woman's political rights.

For a century—the dark and painful century of selfish oligarchy and those who sold their country—politicians of every party had often promised woman the vote. Promises which were never made good, like all those they made to the people.

Perhaps that was lucky.

If women had begun to vote in the days of the oligarchy, the disillusion would have been too great . . . as great as the deceit of those elections in which all misconduct, all fraud and all lies were normal!

It was better for us to have no rights then. Now we have an advantage over men. We have not been mocked! We have not joined any strange political confabulation! The struggle for ambition has not touched us. And, above all, we are born to civic life under Perón's banner, whose elections are a model of integrity and honesty, as is admitted by even his most venomous adversaries, who surrender to the truth only when it is impossible to invent one more lie.

Today the Argentine woman may vote. I am not going to repeat the expression used by a politician who, on offering his fellow citizens an electoral law, stated too solemnly:

"Let the people know how to vote!"

No. I think the people always knew *how* to vote. The trouble is that it was not always possible for them to vote. The same thing happens with woman.

And she will know how to vote. Although it is not fundamental in the feminist movement, the vote is its most powerful instrument, and with it we women of all the world have to win all our rights . . . or, rather, the great right of being simply *women*, and thus being able to fulfill, totally and absolutely, the mission that, as women, we have to perform for humanity.

What I think we cannot ever forget is a thing Perón always repeats to the men: that the vote, that is to say, "politics," is not an end but a means.

I think that men, in their great majority, above all in the old political parties, never understood this properly. That is why they always failed. Our destiny as women depends on our not falling into the same error.

But I do not want to linger longer on this matter of woman's political rights.

I am more interested at present in woman herself.

I would like to show her a way.

Home or the Factory?

Every day thousands of women forsake the feminine camp and begin to live like men.

They work like them. They prefer, like them, the street to the home. They are not resigned to being either mothers or wives.

They substitute for men everywhere.

Is this "feminism"? I think, rather, that it must be the "masculinization" of our sex.

And I wonder if all this change has solved our problem.

But no. All the old ills continue rampant, and new ones, too, appear. The number of young women who look down upon the occupation of homemaking increases every day.

And yet that is what we were born for.

We feel that we are born for the home, and the home is too great a burden for our shoulders.

Then we give up the home . . . go out to find a solution . . . feel that the answer lies in obtaining economic independence and working somewhere. But that work makes us equal to men and—no! We are not like them! They can live alone; we cannot. We feel the need of company, of complete company. We feel the need of giving more than receiving. Can't we work for anything else than earning wages like men?

And, on the other hand, if we give up the work which makes us independent so as to form a home . . . we burn our boats once and for all.

No profession in the world has less chance of a come-back than our profession as women.

Even if we are chosen by a good man, our home will not always be what we dreamed of when we were single.

The entire nation ends at the door of our home, and other laws and other rights begin . . . the law and the rights of man—who very often is only a master, and also, at times, a dictator.

And nobody can interfere there.

The mother of a family is left out of all security measures. She is the only worker in the world without a salary, or a guarantee, or limited working hours, or free Sundays, or holidays, or any rest, or indemnity for dismissal, or strikes of any kind. All that, we learned as girls, belongs to the sphere of

love . . . but the trouble is that after marriage, love often flies out of the window, and then everything becomes "forced labor" . . . obligations without any rights! Free service in exchange for pain and sacrifice!

I do not say it is always like this. I should have no right to say anything, since *my* home is happy . . . if I did not see the suffering every day of so many women who live like that . . . with no outlook, with no rights, with no hope.

That is why every day there are fewer women to make homes.

Real homes, united and happy! And the world really needs more homes every day, and for them more women willing properly to fulfill their destiny and their mission. That is why the first objective of a feminine movement which wishes to improve things for women—which does not aim at changing them into men—should be the home.

We were born to make homes. Not for the street. Common sense shows us the answer. We must have in the home that which we go out to seek: our small economic independence—which would save us from becoming women with no outlook, with no rights and with no hope!

IV Twentieth Century: Economic and Sexual Roles

IV. Twentieth Century
Economic and
Sexual Roles

14 / Anarchists, Labor, and Equality for Women in São Paulo

By the end of the nineteenth century women were employed in increasing numbers in the developing industries of many Latin American countries, especially textiles. Their pay, like that of children, was far below the meager wages allotted men. Many of these women were foreign-born, as in São Paulo, with its large Italian population, and in Rio de Janeiro, the two major manufacturing centers of Brazil. At the same time, the activities of European anarchists in Brazil began to affect the nascent Brazilian labor movement as well as to worry members of the governing elite. As the anarchists themselves begrudgingly admitted, few native-born Brazilians could be found among their number.

In Brazil as elsewhere, Marxists and anarchists were among the first to call for the equality of women. Problems ensued, however, in the pursuit of some of their ideals; for example, when the companion of one member of the first anarchist circle in Rio in the 1890s put the doctrine of free love into practice by switching her affections to another member of the circle, her action broke up the group. The anarchist press, which consisted of vehemently written ephemeral journals of limited circulation and which suffered from police pressure and almost continual shortages of funds, opened its columns to articles by women on their conditions and problems. Women were slower to organize than men although they received worse treatment and lower pay in the factories and were subject to sexual and other forms of exploitation by owners, supervisors, and foremen.

In the following selection, from *Terra Livre*, the most important Brazilian anarchist newspaper, three seamstresses in São Paulo chastise their co-workers for their apathy, for the seamstresses did not even take part in general strikes although they often toiled a sixteen-hour day while some men worked just eight hours.* These three women appealed for support in the struggle against cruel employers and stressed the value of worker solidarity.

Tecla Fabbri, Teresa Cari, Maria Lopes

TO THE YOUNG SEAMSTRESSES
OF SÃO PAULO

COMRADES!
Because of the apathy dominating you which you have not yet shaken off, even in this city where we are so exploited, we resolve to make a new attempt to defend all of us. We hope you will not allow us to remain the only ones demanding our indisputable rights. In all fairness, you should recall that many times some friends have come to our defense in the newspaper columns of *Avanti!*, *La Battaglia*, and *Terra Livre*. But their words were not heard. We hope you will not abandon us also to cry out alone in this wilderness.

We must finally demonstrate that we are capable of demanding our due. If we maintain our solidarity, if you fight with us, if we are heard, we shall begin by exposing the greed of the blood-sucking employers.

The last general strike in this city clearly proved that the seamstresses are the most ignorant and backward group among the working classes. In that movement of worker solidarity all the skilled workers participated, from the mechanics to the cabinetmakers, from the iron workers to the carpenters, plus hat workers, masons, carriage makers, almost all the printers, factory workers in textile, clothing, and match plants, marble

*From *Terra Livre*, July 29, 1906, p. 2.

cutters, goldsmiths, and many others. In Jundiaí retail commerce made common cause with the strikers by shutting their doors. Here in São Paulo students demonstrated their sympathy and the law school had to be closed. And we, the seamstresses, what did we do?

We remained apathetic and unconcerned while strikers filled the city streets. We still went to our jobs, thereby showing that we had no feelings, that we had no blood in our veins. In the mass of strikers were our fathers, our brothers, our sweethearts, and we walked among them without realizing that they were demanding our rights also. Thus we demonstrated our lack of family affection and love!

Reflect, comrades, that we too must always maintain our solidarity with those struggling for the liberation of labor if we wish any aid from others in achieving our more than just demands.

Comrades! It is essential that we refuse to work night and day because that is disgraceful and inhuman. Since 1856 men in many places have attained the eight-hour day. But we members of the weaker sex have to work up to sixteen hours a day, double that of the stronger sex! Comrades, think about your futures; if you continue to allow yourselves to be weakened and the last drop of your blood drained off, then, after you have lost your physical energy, motherhood will be martyrdom and your children will be pale and sickly. . . .

You should speak about these matters not only with your families, but also with our inhuman employers, face to face. After all, their businesses grow and prosper day by day. Go at night to protest and give these thieves a caning if necessary! Come, without delay and energetically pull out the claws of those greedy exploiters! Do you have much to lose? What do they give us—those vultures—in payment for our toil? A ridiculous salary. A miserable pittance!

We too would like to have leisure time to read or study, for we have little education. If the current situation continues, through our lack of consciousness, we shall always be mere human machines manipulated at will by the greediest assassins and thieves.

How can anyone read a book if he or she leaves for work at seven o'clock in the morning and returns home at eleven o'clock at night? We have only eight hours left out of every

twenty-four, insufficient time to recuperate our strength and to overcome our exhaustion through sleep! We have no future. Our horizons are bleak. We are born to be exploited and to die in ignorance like animals.

We hope you will not abandon us, comrades, and that you will aid us to lay bare and oppose the employers' infamous outrages which must be ended. Yes! We count on the support of our sisters and comrades. The victory will be ours. Let us get to work!

Tecla Fabbri
Teresa Cari
Maria Lopes

15 / Women and Work
in Colombia

In the twentieth century, with increasing migration to cities throughout Latin America, the labor force grew. Larger numbers of women obtained paid positions outside the home. Some who managed to secure a certain amount of education could find employment in expanding areas such as commerce and government. However, few women received anything near the compensation or prestige granted men in similar occupations. And most women remained in the poorest paying jobs, such as domestic service, which continued to be an overwhelmingly female field.

In the following selection, Ofelia Uribe de Acosta, a leading Colombian feminist, considers the question of women and work in an urban setting, including the effects of urban migration on the family, the essential unappreciated activities of middle- and lower-class housewives, attitudes of Colombian society toward women working outside the home, the plight of the secretary, and abusive treatment of female workers.* She blames women's lack of self-confidence and of a sense of self-worth for much of their exploitation and urges them to join unions.

Ofelia Uribe de Acosta

First of all it is essential to fully clarify the question of woman's work. It is generally believed that a woman works when

*From Ofelia Uribe de Acosta, *Una voz insurgente* (Bogotá: Editorial Guadalupe, 1963), pp. 295–303, 310.

she is engaged in an activity outside the home for which she receives wages. In accord with this belief, the exhausting daily tasks performed by middle- and working-class women and by rural women within their homes have never been considered work in our country, but rather are called "occupations proper for women."

I do not refer to the wealthy upper class since they have numerous servants at their disposal, as well as modern conveniences which speed up and simplify home management. These women can pay for nurses and governesses highly skilled at raising and educating their children, as well as for house-keepers and cooks.

When the question of women's work was first brought up these ladies' husbands, who know nothing about the subject because they have never experienced the sufferings of others, cried out: "The breaking up of the home!" "The neglect of the children!" "The destruction of our wholesome customs!" These and similar lamentations stirred up the press in the capital. These men thought, as they always have due to their own selfish-ness, that it was harmful to encourage women to engage in some vital activity and thus lose their status as sex objects or expensive dolls.

The condition of other women is very different: their husbands are employees, day laborers or agriculture workers. When these men arrive home exhausted they want peace and quiet; a clean, comfortable home; and a good meal. Their wives, who have put up all day with the children's nonsense and mischief, who have mended clothes, swept and cleaned, done the shopping at the market with prodigious economy, and prepared the dinner, must remain on their feet, rendering to their lords and masters the multiple attentions and care that are their due. The men are the ones who supply the money for everything and they keep pointing this out. Their wives are parasites because they do not earn money, merely living with their children at the men's expense. Women share this errone-ous concept because they never stop to think that their work at home is worth as much as or more than that of their husbands.

Have women considered the value of this work which earns them no remuneration, no prestige, and, generally, no gratitude? Let us envisage for a moment the fate that would befall any of our men if they had to cope for just one day with

that infinite web of details, trifles, and small nothings that make up the world of the home directed and organized by women. Which of these men would be able to scale the heights and show off his glory at congresses and banquets, at social gatherings and cafes, without the help of that silent cog which unfailingly propels the chariot of male magnificence? Housewives are unsleeping workers who never receive a salary, or a vacation, or any kind of benefit because their efforts have never been valued. Our expression "women's work" reflects the low regard with which we view their activities. They never protest, nor think of freeing themselves from their burden. Since they are basically conformists they have resigned themselves and have accepted the burden imposed upon them by human and moral law.

Then one day the nation began to develop and industrialize. Men's jobs no longer sufficed to cover the needs of the home and to meet the spiralling cost of living and of educating their children, thus forcing women to leave the home in search of wages. Developing factories and industries continually required more workers who rushed from the countryside to the cities where modern communications, films, radio, television, and so forth undermined the foundations of rural life, giving rise to new sufferings, needs, and worries. Happiness took on a new meaning for these country people who crowded into the populous cities where they were exposed to the bourgeois pattern of keeping one or more mistresses, of drinking, gambling, and frequenting brothels, bars, and cafes. The husband's neglect of the home grew increaisngly common until it became the tolerated and accepted norm. Thus the wife, the only one upholding the ideals of the old-fashioned home, was left to bear by herself the burden of confronting increasingly unstable conditions. Driven by hunger such women desperately seek living space and bread for their children; they throw themselves into an exhausting double task, working by day to provide food and by night to take care of the home. I have seen them washing, darning, and ironing into the wee hours of the night. I know many who leave their children a sandwich and a coke for lunch and later return home to prepare dinner.

Despite the known horrors of this situation, some people still discuss whether or not women should work. Do they by any chance think that the question of eating or not eating is a matter for discussion? Where can people get social welfare, free

education, or housing? These can only be obtained at a high price, which is what motivates and forces women to seek work.

The only purpose of these remarks is to awaken women to a sense of their own worth and convince them that they should no longer sacrifice themselves with impunity before the altar of those clay gods who preach austerity and belt-tightening while themselves wallowing in self-gratification and licentiousness. In order to demand responsibility and morality from women, responsibility and morality must be instilled in men, starting with those who govern us, since they must reflect high moral standards.

Men cannot demand comfort, rest, and attention at home unless they cooperate with their wives who are also exhausted at night because they have worked all day. In these days when domestic service is coming to an end, it is good for the male to descend from his pedestal to help his mate with the tedious tasks proper to both, since marriage is not only a sacrament, but also a mutual contract.

Women's subservience and ignorance of the law have combined to work against them. They are ignorant of the rule: "Equal pay for equal work," which would place women's work on the same footing as men's. Since women are convinced they are inferior beings, they believe they should earn less. This undervaluing of themselves leads them to regard as a gift whatever miserable job they manage to obtain by pleading with men, the supreme arbiters and distributors of public and private employment. Under such circumstances, it is only natural that they should be exploited. They are also unaware that the first step a female worker must take when starting on a job is to join a union in order to obtain the protection to which she is entitled.

Unions are organizations devoted to the protection of the workers' interests, whereas those remaining outside the unions are totally unprotected. Unfortunately, the complex of prejudices affecting women has led them to believe that unionization characterizes only the lower levels of society and that joining a union shows poor taste and threatens their image as "distinguished" women. They do not know what the word "distinction" really means, and they merely ape others. To be distinguished means to be different from others because of individual qualities or characteristics not found in the ordinary people who comprise the anonymous mass. Distinction is not

demonstrated by jewels or fashionable clothes, but rather by that talent, ability, and morality which mark their possessors with a special stamp of greatness and dignity. Hence, the unions provide an excellent forum in which women can distinguish themselves through their activities for their own benefit and for that of their fellow workers. Let them free themselves of the bondage of prejudice, let them realize that they will gain nothing by marching side-by-side with any "great lady," nor lose anything by joining with the humblest. On the day they do so, they will have the opportunity to distinguish themselves through their own merit and worth, which will shine forth everywhere.

The greatest mistake working women commit is to remain isolated and powerless at a time when collective action is required. That is why women have always had starvation wages. . . .

As more husbands abandon their families, more women anxiously seek work. This places them in a precarious and subservient position. Management can fix whatever wages and hours it pleases, since demand exceeds supply a thousand-fold. . . .

In many of the most important companies and factories the manager's salary is kept confidential, but we know it is high, while the most highly skilled bilingual secretaries earn very little. The whole conduct of the business and the activities of the manager depend on these secretaries. They keep correspondence up to date, attend to all telephone calls, organize the daily paper work, and prepare contract and agreement forms. They know how to keep silent with amazing aplomb. They wait all day, often past six o'clock at night, for the latest order from the manager who is always so very busy at his club or conversing on the street or in cafes with friends.

A woman who spent her life as a secretary, Elvy Vernaza Isaacs, has written a book entitled *My Esteemed Bosses*. When I first read it I thought it could not possibly be true, but then I did some research. . . . I spoke with a distinguished fifty-year-old woman who had just retired from her position as secretary, which she had held for twenty-five years. From her I got complete confirmation of everything that Elvy Vernaza had said about her "esteemed bosses." This secretary said, "It is a raw book which reflects great inner bitterness, but it is a broad-based analysis of our society, which is corrupt to the core."

Nevertheless, nobody accepted this book as an accurate and constructive critique revealing the secret recesses where evil lurks and where universally deplored moral decay breeds. Prominent society women gave their verdict: "It is a dirty book unworthy of a woman." Secretaries felt insulted and degraded. Employers declared that the book's author was a liar who held a grudge. Such is our world, in which false virtue, dissimulation, and duplicity reign supreme. And it is the fault of women themselves, who are the first to cast stones at those who dare reveal why they remain exploited serfs. . . .

I believe that many years will elapse before women become assured of their own worth, so that a spirit of rebellion against a notoriously unjust state of affairs will be aroused within them. They must first free themselves from the web of myths and prejudices which renders them completely defenseless and creates a vicious circle.

It is my hope that when these few observations, perhaps the first that have been addressed to the working women of my country for the purpose of raising their morale, become known, new paths will open up for these women to follow, confident of their own abilities.

16 / A Prostitute in San Juan de Puerto Rico

In his studies of poverty and family life in Mexico, the late Oscar Lewis, a United States anthropologist, tape recorded long, intensive autobiographical interviews. While continuing to test and refine his concept of a culture of poverty he carried out whole family studies in an urban slum in San Juan, Puerto Rico, and also examined the problems of adjustment and changes in family life of migrants to New York City. Lewis' *La Vida* contains the autobiographies based on tape transcripts of Fernanda Fuentes, a black woman of forty, living with her sixth husband in an old San Juan slum, her children, their husbands and wives and former spouses, and other relatives. Several of the women had been "in the life," that is, prostitutes, including Fernanda Fuentes herself. According to Oscar Lewis, one-third of the households in that San Juan slum had a history of prostitution. He contends that for unskilled, often illiterate, women struggling for survival, prostitution presents a tempting economic alternative which does not necessarily ostracize them from their neighbors or represent a sharp break in their ordinary lives. Yet he feels that most people in the slums regard prostitution as a degrading occupation. Slum women who at times engaged in prostitution and who played active, forceful roles in their relations with specific men, with their children, and with those around them could be seen as refusing to accept what has been termed the traditionally submissive role of Puerto Rican women.

Fernanda Fuentes grew up both in a country town with her grandmother and in San Juan with her mother. At the age of fourteen, she went off with her first husband, living with

him for seven years and having four children before going "into the life." In the following selection she recounts her years as a prostitute.*

"Fernanda Fuentes"

I am as frank as I am ugly and I don't try to hide what I am because you can't cover up the sky with your hand. There is nothing good about me. I have a bad temper, why should I deny it? At times I become so angry no one dares come near me, so angry I cry, and in my rage I want to kill.

When I get into these rages, it makes no difference to me whether I kill or get killed. I never feel sorry or anything. I'm the kind of a woman that nobody can say anything to when she's drunk, because any little thing and I'm ready for a fight. If I have a husband and I'm drinking and he starts pestering me or being jealous without cause, or quarreling about any little thing my children do, I'd just as soon cut him with a razor, slash him with a bottle—anything. It makes no difference to me, see?

I often carry a razor because if someone tries to hit you, you have to defend yourself. When I was in the life, I kept a *Gem* blade in my mouth all the time. I could eat with it there, drink, talk and fight without anybody noticing it. I'd break off one corner of the blade to form a little handle and then I'd slip it between my lower gum and my cheek, with the cutting edge up. That way the edge doesn't touch your mouth, it's in the air, see? You can also hide a blade in your hair or you can slip it into the top of your stocking. The one place you should never carry a *Gem* is in your purse, because if you're arrested the cops will find it. When I know I'm going to get into a fight I have the *Gem* ready in my hand, hidden between my fingers. Then, when I get the chance, I quickly cut the cheek or lip.

I'm not afraid of anyone but God, and I'll never accept mistreatment from a man. I wasn't born for that. When I

*From Oscar Lewis, *La Vida: A Puerto Rican Family in the Culture of Poverty, San Juan and New York* (New York: Random House, 1966), pp. 26–27, 50–59. Copyright © 1965, 1966 by Oscar Lewis. Reprinted by permission of Random House, Inc.

live with a man I'm faithful to the last, but if I find out he's cheating on me, I swear I'll do the same to him. You can count on it, I'll put the horns on him. Revenge! Because my *mamá* told me never to let men dominate me. "If they do it to you, do it to them. Never give in. Don't bow down." And I have the heart to do it.

I would rather be a man than a woman. If God had made me a man I would have been the worst son of a great whore ever born. Not a woman would have escaped me. *Ave María!* I'd have a woman everywhere, and if they didn't give me what I wanted I'd kick my way in. That's why God made me a woman, a real bitch of a one. I'm forty now and I've had six husbands, and if I want I can have six more. I wipe my ass with men.

I may be Negro and I may be getting old and, if we face facts, I was a whore. All this I cannot deny, but no one can come to me and say, "Fernanda, you took my man away from me." I can sing out with the greatest pride that I have never, never taken away another woman's husband. I have always preferred men who are free. I may kid around with married men but it's all in the open. I'm no home breaker because I'd never do to another woman what I wouldn't want her to do to me. That's why I feel that I am worth more than most women here in La Esmeralda.

The truth is, I am really soft-hearted. I have lots of friends. The fights I have are only with my husbands. If someone lives with me, he won't die of hunger or need anything. If I have money I will give it to anyone near me who needs it, because I can't see them suffer. That's the kind of a heart I have. I feel compassion.

I've done favors for lots of people. Why, I've taken to the streets to get a few pesos for someone in need. I've made lots of money and I've spent it all What would I want to keep it for? We're not made of stone and we all must die, right? Suppose I save money in the bank and then I die. Who is going to enjoy that money? The government! No, I'd rather eat up my money myself before they come and take care of it for me.

Now my mother was dead and I hardly ever saw my husband. When Cristóbal came back from Panama, he was worse than ever. He almost never came home any more. Then I learned that he had set up housekeeping with another woman.

As I've already said, I have a very jealous nature and in these matters I go the whole way. When I heard that he was living under one roof with another woman, I left him. I left him because I didn't love him. We broke up lightly, without any quarrel. I just told him I didn't want to have anything more to do with him, that I wanted to be free. I was about twenty-one years old.

I said I'd take the eldest, Soledad, who was about seven or eight, and leave the other three children with him, because you can fit in anywhere with one child but not with four. Cruz was only eight months old at the time. Felícita and Simplicio were crazy about their father, so they didn't cry because I left them. Soledad was the only one who didn't want to stay with him. Well, Cristóbal was in the Army so he turned the three youngest children over to their godmother Elsa, his brother Pablo's wife.

I would go to see Felícita, Simplicio and Cruz twice a month at their godmother's house. I guess they stayed with her until Cristóbal married Hortensia, about a year after we had separated. Then Hortensia took the children. They all lived at Stop 27; Cristóbal had his own house by then.

Hortensia and I knew each other well because we had been neighbors. We used to visit each other and all. She's white and slender. When Cristóbal went to Panama he had a lot of mistresses but Hortensia wasn't one of those. He took up with her later. Hortensia and I get along well together. I don't bear her a grudge at all. I go to her house and she comes to mine.

When I left Cristóbal I went to Río Grande to my grandmother Clotilde, who was still alive at that time. I sent Soledad to school there. She was a good student. Soledad has always been the brightest among my children.

I had to leave my grandmother's house after a month because she kicked me out. It all came about because I had an abcess on my left breast and had to stay home one night when she went out. She went to a wake and I lay down with all my clothes on and Soledad beside me. Jamie, my grandmother's husband, who always treated me with respect, was also in the house.

When my grandmother returned she began yelling in front of a lot of people. She said I had been waiting for her to leave so I could screw with Jaime the minute her back was

turned. Maybe she was drunk when she said that, because, she drank like a fish. That very night—it must have been eleven or twelve o'clock—she told me to get out. I didn't talk back to her or argue or anything. I'm always respectful to my older relatives. That's why they're all so fond of me on both sides of the family.

When she told me to leave, I burst out crying and went to my aunt Sofía's house and told her what had happened. She said, "*Ay*, you know *mamá* is crazy. Come stay with me and don't go back there." My aunt was all alone at the time because her husband, Esteban, was in jail for killing two men in Trujillo Alto. He served a fifteen-year sentence for that.

Well, I lived a long time at my aunt's house and she treated me very well. She gave me a bed that night, and Soledad and I went to sleep. She supported me as long as I stayed with her. I helped her and Adela, my cousin, with the housework but she never let me look for a job. She worked as a school janitor and she sold lottery tickets.

She used to beat my cousin Adela and me even though we were both grown women with children. One day Adela and I went to the movies, leaving Soledad and Adela's baby at home. Well, Aunt Sofía took the children to the movies and she beat us right then and there. We got out of the movie and she ran after us to whip us with tamarind twigs, which are the worst kind. When she beat me I never said anything. I had great respect for her. When she came home from work angry, or when she got mad at the children, God Himself wouldn't have dared look her in the face.

I finally got bored living there. I've never liked Río Grande much anyway. It's a dead town. It's not like San Juan, where you hear noise and there's always something going on. So one day when I met a friend of mine called Leonor, who told me about a dance she was going to in Santurce, I said, "Oh, wait for me, I'll go with you." My aunt said that if I went to dance and to whore around, I'd better not come back to her house. So I told her I was going to Santurce to stay. I didn't dare go back after that except to visit.

Soledad and I went to stay with my *comadre* Gilda, who took in washing and did housework for a well-to-do family. We got along very well with each other. While she washed clothes I did the housework. Other times I'd wash and she'd do something else. She would always give me some of the money

she earned so I could go to the movies or play bingo.

When Soledad was about eight, I asked her, "Would you like to go stay with your father now?" She didn't want to but then I said, "You'll be better off there because I have to get a job now and I won't be able to look after you." She agreed to go, on condition that I visit her every Sunday.

I went on living with *comai* Gilda. Then I got myself an old man who gave me everything I needed. His name was Valentín. He's dead now. I met him at Stop 26 because he used to walk by there. He'd give me gifts and I would joke with him. We never went out together, but he helped me because he had hopes of getting me to go live with him. He gave me money, and I divided it half and half with *comai* Gilda. This went on for about a month, but then I investigated and I learned he was married. I told him I was interested only in men who were free.

After I stopped seeing the old man I just had to get a job as a servant so I could help out with the expenses. I had been with Gilda for about a year. One day I was sitting reading the paper when I said, "*Ay, comadre*, I really feel like getting myself a job." And she answered, "I'm not asking you to leave. You don't have to work as long as I can take in washing. We can help each other." But I told her, "If I get a job we can really help each other."

Finally I went to work with a family living at Stop 19. This job didn't turn out well because the lady of the house was as angry as they make them. She wanted me to work seven days a week for fifteen dollars a month. I stayed only a week. After that I worked in a lot of houses.

I worked and worked but I saw that I never got ahead. I needed a lot of things that I couldn't afford to get. So I thought about what I could do to improve my situation and I decided to become a whore. Before that, it had never occurred to me. I had known several whores, but none of them had ever advised me to take up the profession. Gilda, my own *comadre*,* had been a whore once, but she never suggested that I should be one. Gilda is very discreet about her affairs. She's a woman whom everybody thinks well of, and if she peddled her wares late at night, who was to know it? By the time I moved in with her, her whoring was a thing of the past. She gave it up because she had a

*Godmother, co-godparent, or intimate friend.

little girl who was being brought up in the country and she didn't want to set her daughter a bad example.

I have a cousin called Virginia who was a whore too. She was my aunt Amparo's daughter. She used to come to Río Grande, but my grandmother Clotilde never wanted us to be friendly with her. "Don't talk to her," Clotilde would say. "She's a whore and she might advise you to do wrong and even take you with her." But Virginia never gave us any bad advice; on the contrary, her advice was always good. She had been a whore for a long time and she works at it even now. She has had a million men. She's way ahead of me and she's still in the profession.

I believe that I am now being punished because my grandmother forbade us to talk to Virginia or to any other whore. She didn't mind speaking with whores herself, but if one of those women bought candy for us she wouldn't let us take it. I don't know if my grandmother ever found out I was in the profession. After I left Río Grande, I didn't go back for a long time. What did I care about Río Grande? And knowing my grandmother, I thought, "She would probably treat me the way she treated Virginia." So I didn't go.

Before taking up the profession, whenever I saw whores I'd think, "I wonder what the hell those women are doing?" Once I was talking to somebody, I don't remember who, and I asked, "What are those women doing?" She told me, "They're peddling their wares." I said then, "Oh, so that's what whoring is like." And I thought, "I wonder why they do it? What is it like? What do they think about? How do they spend the money they get?" I asked all those questions, you see, but I had never thought of becoming a whore myself.

Well, what happened was that I started to work as kitchen help in a bar called El Molino in front of the Capitol. They've put up some buildings there now, but at that time there were a lot of wooden shacks and this bar was in one of them. They paid me twenty-five dollars a month. There were some whores in the bar but I didn't know much about it. I thought they led a gay life because they always seemed to be so happy. Then they gave me a job as waitress in that same bar. I did pretty well the first day, even though I didn't much know English. I got plenty of tips.

Well, I was a grown woman already and a free one to boot, so when a sailor I met there fell in love with me, I went out

with him. That's how I got my start in the whoring profession. I was twenty-four years old. I was working in the bar that night and this American sailor told the owner that he liked me. He asked if I was willing to go out with any man or if I was a virgin. The bar owner told him no, I was not a virgin.

This sailor came and asked me if I wanted a drink. We started to drink together and he asked me if I went out with men. I thought this over a while and I looked at a man near me and at the bar owner before I answered, "Yes. Yes, I do."

He asked me in English how much I charged. The bar owner wanted us to be able to speak to the customers in English, so he told me how to answer the question. The customers would ask, *"You focking?"* and then *"How much?"* and the whore would answer, *"Two dollars to the room and five for me, at short time."*

I went upstairs with that sailor because it was the Christmas season, see, and I needed money for presents for my children for the Day of the Three Kings. I slept with him, but I didn't take off my clothes because I was ashamed. I just lowered my *panties* and I didn't look him in the face. He wanted to kiss me and I wouldn't let him. He gave me ten dollars, but he told the bar owner what had happened. Then the owner said to me, "Look, if you want to be a whore, you can't be that modest. And you need the money, Nanda. What you earn at the bar is a mere trifle. You're a new girl, so you have a better chance to get clients than the rest of the girls here. Try to be freer and more lively." He said, "Take a few drinks and that will give you courage."

He sent one of the other girls to give me advice. Her name was Josefina; she's in the States now. She told me, "When you're in a room with a *gringo*, kiss him, caress him and all that. And be sure to ask him to pay in advance or you mightn't get your money." I listened to her and said, "All right, I'll do it that way."

After that when I liked the looks of a customer I'd go and drink with him. All this was new to me, so I drank a lot and when we went upstairs he'd have to carry me. You understand that a whore is ashamed to be with a man she doesn't know. She has to be at least a bit high before she can go to bed with him. Well, I drank to get over the embarrassment and I kept it up after I stopped being a whore.

By the third day I no longer felt any shame. I'd take off my clothes right away, and I felt fine. I was gay. It didn't bother me a bit. Some women feel sad and ashamed, but not me.

Being in the profession is easier than being married. As long as you're a whore, nobody can interfere with you. You live alone, so there's nobody to tell you what to do or not to do. A whore can go anywhere, go to the movies as often as she likes, dance whenever she wants to and stay out as late as she pleases. If you want to take a holiday for a week or two, there's nobody to prevent it, unless you take up with a pimp.

If it weren't for the pimps, whoring would be a ball. The minute a whore gets herself a pimp, she isn't free to do what she likes any more. She must work only where he allows her to. If she stays too long with a customer, her pimp falls on her and beats her up. And then he takes all the money she earns. He doesn't work but stays in bed and sleeps as long as he likes while his whore is out on the job. A whore who has a pimp leads a dog's life. We have a rhyme about pimps that goes:

This pimp has come to think	*Ese chulo se ha creido*
The sun doesn't shine for me.	*Que a mí no me alumbre el sol.*
Four candles and a street lamp,	*A mí me están alumbrando*
That's all the light I see.	*Cuatro velas y un farol.*

I don't know why some women take up with pimps. To have a man of their own maybe, a man who can back them up and defend them if anybody tries to take advantage of them. That's the only thing a pimp can do well. But I say it isn't her pimp a whore loves, it's money. We had a couplet that said:

When the sailors come	*Cuando vienen los marinos*
The pimp sleeps in the street.	*El chulo duerme al sereno.*

And, you know, that's the truth. The sailors pay, so the pimp has to sleep outside.

A whore really doesn't feel pleasure, except when she feels the money in her hands. It's like not having a sex life at all. All that matters is the pay.

I didn't hang around much with other women. When they were together they'd always talk about their pimps. A woman who has a pimp must do whatever he asks. A pimp will force her to suck him or let him get into her ass whether she enjoys it or not. Almost every whore does it because many men like it that way. And people who don't want to have children do

it. As the old saying has it, "That's not the way to get a woman pregnant."

But sometimes it harms a woman to do it that way. Like a girl I know whom we call Pupa. One day a lot of *gringos* arrived in San Juan. I told her, "A lot of ships came in today, Pupa. Wait for me tonight so that we can go out together."

Well, this Pupa was so selfish she went on ahead instead of waiting for me. She wanted to get the pick of the customers. As it happened, I got there late and all I could make that night was four *gringos* at five dollars apiece. I asked, "Well, where's Pupa?" And they told me. "*Muchacha*, they had to take Pupa to the hospital. She was with a man who had a lamppost for a penis and he tore her insides." She liked to do it up her ass and that night they had to carry her out of the hotel with her intestines hanging out. She had to have an operation and now that girl has a strange way of walking.

Whores are kind-hearted in a way. If you live near a prostitute you'll never lack for anything. A whore will help her neighbor even if she happens to be an honest married woman. A whore won't allow anyone who is near her to suffer. When I worked in the hotel, after I left the profession, the girls I knew would bring food and coffee up to me. I'd wash their sheets and all that. I knew a lot of girls whom I had helped, because when I was a whore I had more money than I knew what to do with. So when I gave up whoring, they helped me.

As long as I was in that life, I never got pregnant. I never even had a miscarriage or an abortion. I can't explain it, because I never used any kind of contraceptive. I got sick once but I don't know who infected me. I went to the women's clinic in a sort of hospital or medical dispensary. The women's clinic was called *el detention*. The doctors treat you well there, not like whores but like respectable ladies. If a woman has a yellow discharge or something like that, they'll give her an injection of 800 cc. of penicillin every day. They tell me that now all whores get these injections whether they're sick or not.

One suffers a lot when one is in the life. I had to pay three dollars a night for a bed to sleep in, otherwise I had to sleep out in the street. Sometimes the owner of the bar would let me go up to sleep even if I had no money. But other times I would have to sit up at the bar until they closed at five or six in the morning.

The next day I'd go looking for customers right away. I worked in the daytime if I hadn't any customers the night before. I'd go anywhere I saw a lot of people together, and I worked until I earned at least five or ten dollars so I could pay for my lunch and laundry. I had to change clothes every day and it cost me a dollar each time I had a dress washed or cleaned. The lady who did my clothes wouldn't give me credit, even if I didn't have a thing to wear that day.

There were times when I earned as much as fifty or sixty dollars in one night, but what was the good of that? I had to spend it all on clothes and on lodging. When I had enough money, I would pay ahead for a room so I would have a place to sleep in case I went broke. And I'd buy clothes or a new pair of shoes almost every day. All kinds of good-quality clothes, see? A whore doesn't really have to work. She just dresses up and peddles her goods. She lives sort of like a woman of means who doesn't have to do any housework.

I went hungry at times, but when I had no money I could usually get food from schooner crews. I'd go to a schooner that had come from Santo Domingo or St. Thomas and ask the captain or anybody on board for a meal and they'd give it to me. The men who work on schooners are very nice, especially the captains. If a lady of the streets goes to them and asks for something, the captain won't let the men curse her or use bad language. I had a lot of friends among the crews of schooners and they always had respect for me.

I was with an American one night at El Molino when I got into trouble and they put me in jail. One of the other girls just walked over to me and said that she liked my American and was going to lay him. I said she should ask him which of the two he liked better, her or me. She asked him and he said he liked me best. At that she hauled out and hit me and we began to fight. I had never used a razor before, but that time I grabbed one and cut her. It was the merest scratch, just of bit of a cut on the arm, but someone sent for the cops and they arrested me.

Well, my mother was dead and I had no one to bail me out, so I had to stay in jail until my case came up in court. I talked with the judge and with a man called Abel who was the marshal of the court. So when the case was heard, the judge only sentenced me to fifteen days in jail.

I cried all the time. Imagine, I'd never been in jail

before, and I had to spend Christmas there. The very night I was jailed I thought of escaping through some steel drums I saw. But then I thought, "If I run away I will be killed or have to live as a fugitive. I'd better stay here." So I stayed. And the next day I felt better about it because the other girls there began to talk to me. They told me to be calm, not to mind too much spending Christmas there, because I had only a short sentence to serve. They begged me not to cry and I resigned myself to staying. During those fifteen days nobody visited me. But then, I didn't expect anyone to come.

In those days there were no beds in jail, only pallets made up on old doors which were laid on the floor. You can't say it wasn't clean though. We cleaned up the place very day. We would divide the work among us, scrubbing floors, cleaning out the toilets, washing the sink, cleaning the courtyard, planting, and so on. If a prisoner refused to follow orders she was put in solitary confinement. She would be locked up in a cell all by herself. Luckily I wasn't sent there. The guards treated us well. On weekdays we were given rice, beans and meat for dinner. On Sundays we would have chicken.

I've had only one fight with the police and that was much later, on account of my cousin Darío. He's my aunt Amparo's son. He's in jail now. When the cops came to arrest him, one of them tried to hit him and I got between them. The cop knocked me down and my daughter Soledad hit him. Then some more cops arrived and pushed me into the police wagon, but I escaped. They brought charges against me for having hit a policeman. And it was a big lie. It was my daugher who had hit him. She had bitten him too.

Well, they came to my house to arrest me. I stayed in jail a short time, about two weeks, and then I was bailed out. The day of the trial I was found not guilty because there was no evidence against me. The cop himself said he had nothing against me. I've never got into an argument with the police, see? All I had to do was to keep running when they were out arresting whores so they wouldn't put me in jail.

A whore's life is insecure. You're afraid all the time and you can't manage too well. Any time you are peddling your goods, you may suddenly find a cop beside you, to arrest you. You live scared. It's a dog's life. You have to be paying fines and serving jail sentences all the time. It's really terribly inconve-

nient. Sometimes I was fast asleep in a hotel and the owner of the place would wake me and tell me to beat it because the cops were on the way. And that night I'd have to stay out in the streets, hiding from the cops.

The truth is cops don't get along well with whores. They just won't let us alone. They'll arrest us without cause. They won't even let us earn a nickel in peace. They'll push the whores into the police wagon like dogs and treat them rough. If a whore curses a policeman, he'll charge her with assault and battery without her having lifted a finger.

Policemen are bullies. They like to hit people who aren't bothering them. A policeman will go into a bar on the sly and get drunk and then come out and bully you. There's no justice in the world. The really bad people are never caught, because they have money and can bribe the law and the police. So nobody does anything to them. But the poor souls who don't own anything, who don't do anything except get drunk—they get thrown into the cooler.

The lawyers are just as bad as the police. Thieves, every one of them. They fix up everything as between *compadre* and *compadre* and they get the rich off scot-free. But a poor client—why, after they eat up fifty or sixty dollars of his, they make him plead guilty. The lawyer tips the judge a wink and that's that! We used to be tried right out in the street. They'd say, "Did you disturb the peace? Well then, give me a quarter and you're free." Sometimes they said half a dollar or you had to leave something as a guarantee. They're all the same.

But we whores would get even with them. We had rhymes about them, which we'd sing. There was one that went like this:

When this judge reads my sentence
I will confess my guilt
And walking down the stairs
On his mother I will shit

Cuando este juez me sentencie
Yo me declaro culpable
Y bajando la escalera
Yo me le cago en la madre

When this judge reads my sentence
One question I'll ask him:
"Didn't you like the whores
When you were a pimp?"

Cuando este juez me sentencie,
Una pregunta le haré:
Que si cuando el era chulo,
¿No le gustaban las putas?

An honest whore is a rare thing. Most of them steal from the Americans. After making a big play for a *gringo* and all, they lift his billfold. They'll work out a plan with their pimp to take the American to their house and rob him there. I never did anything like that. And I never used heroin or marijuana or any kind of drug. My only vice is smoking cigarettes.

When I got out of jail that first time, I started drinking a lot. I went to La Marina, the dockyard section, to work in the Silver Cup Club. Whenever a ship came in, I didn't walk the streets but stayed in the Club, waiting for customers. I lived in a room right there at the Silver Cup and I didn't have to pay rent. They charged only two dollars for the bed. And every time I was with a man he paid me five dollars.

I earned twenty-five to thirty dollars a night. One night when I was at the Club an American wanted to screw me twice for five dollars. I refused and then he took my petticoat and my *panties* and hid them. He wouldn't give them to me, so the porters and a waiter came and bounced him out of the Club. That was the only time I had trouble with an American.

I liked Americans better than Puerto Ricans because Americans pay more. Puerto Ricans want to have a woman for only two dollars. But Americans never make any objection to paying five dollars or whatever you ask for. Most Americans are good. Some of them will step aside to let you pass on a narrow sidewalk, and there are Americans who will defend you if necessary.

But when the bad ones get drunk, they don't respect anybody. They'll start asking any woman to go with them as if she were a whore, even if she's a respectable housewife. And they start grabbing a person's ass even if she is a virgin or is married. And if they see a poor woman, many of them, at least a fourth of them, will ridicule her. But some Americans are respectful even when they're high and they like Puerto Rico because it's a gay place.

I finally had to give up the profession because there were days when I went hungry and I'd feel weak and angry all the time and without energy to do anything. I got thin as a skeleton. I couldn't go on like that. Besides, I think that prostitutes should go to work instead of earning their living by whoring. Nobody is forced to be a whore. A woman who has children to support may have to be a whore in order to earn

money for them, but most whores go into the profession because they enjoy it. To my mind, its plain laziness to get under a man for two or three dollars instead of taking a job.

When I see these women now, hanging around street corners, I feel sorry for them because they have no peace. I wish they would settle down and lead virtuous lives. Most whores could get other jobs if they wanted to, because everybody has the right to an honest job. Some of them are young women who could even work in a factory or as sales clerks.

People in general, most people, don't think it's right for a woman to take up whoring. Even the cops and the judges don't think well of the profession and they want to make an end of it. But they can't. I think they'll never be able to put an end to whoring. Suppose they tried to end it here in San Juan by arresting two or three whores. Why, by tomorrow there would be fifty more all over the place! Mary Magdalen, the saint, was once a whore and they say that's the way the profession started. If she hadn't been a whore there would be no prostitution.

17 / Life in a Brazilian Slum

To be both black and female has historically proved to be doubly disadvantageous in Brazil as in various other countries: black women continue to occupy the lowest positions in society. Carolina Maria de Jesús, a proud, observant woman from a São Paulo *favela*, or squatter settlement, supported herself and three children by collecting paper and scraps outside the *favela*. Despite her daily confrontations with the overwhelming reality of hunger, this strong-willed and intelligent woman maintained her sense of pride and self-respect. She continued to criticize many of her neighbors for succumbing to what she saw as the causes of dissolution among the *favelados*: alcohol, prostitution, theft, apathy, and begging. Her writing first provided her with a temporary escape into a private world and finally helped her turn her dream of leaving the *favela* into a reality. Her diary, published in 1960, became a best seller in Brazil. In the following excerpts from that diary, we can see her far from unsophisticated views of marriage, race relations and prejudice, hunger, and politicians.*

Carolina Maria de Jesús

Sunday, July 17, 1955

A marvelous day. The sky was blue without one cloud. The sun was warm. I got out of bed at 6:30 and went to get water. I only had one piece of bread and three cruzeiros. I gave

*From Carolina Maria de Jesús, *Child of the Dark: The Diary of Carolina Maria de Jesús*, trans. David St. Clair (New York: E. P. Dutton & Co., 1962), pp. 21–25, 49, 72–73, 126–127, 144–145. Copyright © 1962 by E. P. Dutton & Co., Inc. and Souvenir Press, Ltd. Reprinted by permission of the publishers, E. P. Dutton & Co., Inc.

a small piece to each child and put the beans, that I got yesterday from the Spiritist Center, on the fire. Then I went to wash clothes. When I returned from the river the beans were cooked. The children asked for bread. I gave the three cruzeiros to João to go and buy some. Today it was Nair Mathias who started an argument with my children. Silvia and her husband have begun an open-air spectacle. He is hitting her and I'm disgusted because the children are present. They heard words of the lowest kind. Oh, if I could move from here to a more decent neighborhood!

I went to Dona Florela to ask for a piece of garlic. I went to Dona Analia and got exactly what I expected:

"I don't have any!"

I went to collect my clothes. Dona Aparecida asked me:

"Are you pregnant?"

"No, Senhora," I replied gently.

I cursed her under my breath. If I am pregnant it's not your business. I can't stand these favela women, they want to know everything. Their tongues are like chicken feet. Scratching at everything. The rumor is circulating that I am pregnant! If I am, I don't know about it!

I went out at night to look for paper. When I was passing the São Paulo football stadium many people were coming out. All of them were white and only one black. And the black started to insult me:

"Are you looking for paper, auntie? Watch your step, auntie dear!"

I was ill and wanted to lie down, but I went on. I met several friends and stopped to talk to them. When I was going up Tiradentes Avenue I met some women. One of them asked me:

"Are your legs healed?"

After I was operated on, I got better, thanks to God. I could even dance at Carnival in my feather costume. Dr. José Torres Netto was who operated on me. A good doctor. And we spoke of politics. When a woman asked me what I thought of Carlos Lacerda, I replied truthfully:

"He is very intelligent, but he doesn't have an education. He is a slum politician. He likes intrigues, to agitate."

One woman said it was a pity, that the bullet that got the major didn't get Carlos Lacerda.

"But his day . . . it's coming," commented another.

Many people had gathered and I was the center of attention. I was embarrassed because I was looking for paper and dressed in rags. I didn't want to talk to anyone, because I had to collect paper. I needed the money. There was none in the house to buy bread. I worked until 11:30. When I returned home it was midnight. I warmed up some food, gave some to Vera Eunice, ate and laid down. When I awoke the rays of the sun were coming through the gaps of the shack.

July 18, 1955

I got up at 7. Happy and content. Weariness would be here soon enough. I went to the junk dealer and received 60 cruzeiros. I passed by Arnaldo, bought bread, milk, paid what I owed him, and still had enough to buy Vera some chocolate. I return to a Hell. I opened the door and threw the children outside. Dona Rosa, as soon as she saw my boy José Carlos, started to fight with him. She didn't want the boy to come near her shack. She ran out with a stick to hit him. A woman of 48 years fighting with a child! At times, after I leave, she comes to my window and throws a filled chamber pot onto the children. When I return I find the pillows dirty and the children fetid. She hates me. She says that the handsome and distinguished men men prefer me and that I make more money than she does.

Dona Cecilia appeared. She came to punish my children. I threw a right at her and she stepped back. I told her:

"There are women that say they know how to raise children, but some have children in jails listed as delinquents."

She went away. Then came that bitch Angel Mary. I said:

"I was fighting with the banknotes, now the small change is arriving. I don't go to anybody's door, and you people who come to my door only bore me. I never bother anyone's children or come to your shack shouting against your kids. And don't think that yours are saints; it's just that I tolerate them."

Dona Silvia came to complain about my children. That they were badly educated. I don't look for defects in children. Neither in mine nor in others. I know that a child is not born with sense. When I speak with a child I use pleasant words. What infuriates me is that the parents come to my door to disrupt my rare moments of inner tranquility. But when they upset me, I

write. I know how to dominate my impulses. I only had two years of schooling, but I got enough to form my character. The only thing that does not exist in the favela is friendship.

Then came the fishmonger Senhor Antonio Lira and he gave me some fish. I started preparing lunch. The women went away, leaving me in peace for today. They had put on their show. My door is actually a theater. All children throw stones, but my boys are the scapegoats. They gossip that I'm not married, but I'm happier than they are. They have husbands but they are forced to beg. They are supported by charity organizations.

My kids are not kept alive by the church's bread. I take on all kinds of work to keep them. And those women have to beg or even steal. At night when they are begging I peacefully sit in my shack listening to Viennese waltzes. While their husbands break the boards of the shack, I and my children sleep peacefully. I don't envy the married women of the favelas who lead lives like Indian slaves.

I never got married and I'm not unhappy. Those who wanted to marry me were mean and the conditions they imposed on me were horrible.

Take Maria José, better known as Zefa, who lives in shack number nine on "B" Street. She is an alcoholic and when she is pregnant she drinks to excess. The children are born and they die before they reach two months. She hates me because my children thrive and I have a radio. One day she asked to borrow my radio. I told her I wouldn't loan it, and as she didn't have any children, she could work and buy one. But it is well known that people who are given to the vice of drink never buy anything. Not even clothes. Drunks don't prosper. Sometimes she throws water on my children. She claims I never punish my kids. I'm not given to violence. José Carlos said:

"Don't be sad, Mama. Our Lady of Aparecida will help you, and when I grow up, I'll buy a brick house for you."

I went to collect paper and stayed away from the house an hour. When I returned I saw several people at the river bank. There was a man unconscious from alcohol and the worthless men of the favela were cleaning out his pockets. They stole his money and tore up his documents. It is 5 p.m. Now Senhor Heitor turns on the light. And I, I have to wash the children so they can go to bed, for I have to go out. I need money to pay the light bill. That's the way it is here. Person

doesn't use the lights but must pay for them. I left and went to collect paper. I walked fast because it was late. I met a woman complaining about her married life. I listened but said nothing. I tied up the sacks, put the tin cans that I found in another sack, and went home. When I arrived I turned on the radio to see what time it was. It was 11:55. I heated some food, read, undressed, and laid down. Sleep came soon.

May 20, 1958

Day was breaking when I got out of bed. Vera woke up and sang and asked me to sing with her. We sang. Then José Carlos and João joined in.

The morning was damp and foggy. The sun was rising but its heat didn't chase away the cold. I stayed thinking: there are seasons when the sun dominates. There's a season for the rain. There's a season for the wind. Now is the time for the cold. Among them there are no rivalries. Each one has a time.

I opened the window and watched the women passing by with their coats discolored and worn by time. It won't be long until these coats which they got from others, and which should be in a museum, will be replaced by others. The politicians must give us things. That includes me too, because I'm also a *favelado.* I'm one of the discarded. I'm in the garbage dump and those in the garbage dump either burn themselves or throw themselves into ruin.

The women that I see passing are going to church begging for bread for their children. Brother Luiz gives it to them while their husbands remain home under the blankets. Some because they can't find jobs. Others because they are sick. Others because they are drunk.

I don't bother myself about their men. If they give a ball and I don't show up, it's because I don't like to dance. I only get involved in fights when I think I can prevent a crime. I don't know what started this unfriendliness of mine. I have a hard cold look for both men and women. My smile and my soft smooth words I save for children.

There is a teen-ager named Julião who beats his father at times. When he hits his father it is with such sadism and pleasure. He thinks he is unconquerable. He beats the old man as if he were beating a drum. The father wants him to study law.

When Julião was arrested the father went with him with his eyes filled with tears. As if he was accompanying a saint in a procession. Julião is a rebel, but without a cause. They don't need to live in a favela; they have a home on Villa Maria hill.

Sometimes families move into the favela with children. In the beginning they are educated, friendly. Days later they use foul language, are mean and quarrelsome. They are diamonds turned to lead. They are transformed from objects that were in the living room to objects banished to the garbage dump.

For me the world instead of evolving is turning primitive. Those who don't know hunger will say: "Whoever wrote this is crazy." But who has gone hungry can say:

"Well, Dona Carolina. The basic necessities must be within reach of everyone."

How horrible it is to see a child eat and ask: "Is there more?" This word "more" keeps ringing in the mother's head as she looks in the pot and doesn't have any more.

When a politician tells us in his speeches that he is on the side of the people, that he is only in politics in order to improve our living conditions, asking for our votes, promising to freeze prices, he is well aware that by touching on these grave problems he will win at the polls. Afterward he divorces himself from the people. He looks at them with half-closed eyes, and with a pride that hurts us.

When I arrived from the Palace that is the city, my children ran to tell me that they had found some macaroni in the garbage. As the food supply was low I cooked some of the macaroni with beans. And my son João said to me:

"Uh, huh. You told me we weren't going to eat any more things from the garbage."

It was the first time I had failed to keep my word. I said:

"I had faith in President Kubitschek."

"You had faith, and now you don't have it any more?"

"No, my son, democracy is losing its followers. In our country everything is weakening. The money is weak. Democracy is weak and the politicians are very weak. Everything that is weak dies one day."

The politicians know that I am a poetess. And that a poet will even face death when he sees his people oppressed.

May 21, 1958

I spent a horrible night. I dreamt I lived in a decent house that had a bathroom, kitchen, pantry, and even a maid's room. I was going to celebrate the birthday of my daughter Vera Eunice. I went and bought some small pots that I had wanted for a long time. Because I was able to buy. I sat at the table to eat. The tablecloth was white as a lily. I ate a steak, bread and butter, fried potatoes, and a salad. When I reached for another steak I woke up. What bitter reality! I don't live in the city. I live in the favela. In the mud on the banks of the Tieté River. And with only nine cruzeiros. I don't even have sugar, because yesterday after I went out the children ate what little I had.

Who must be a leader is he who has the ability. He who has pity and friendship for the people. Those who govern our country are those who have money, who don't know what hunger is, or pain or poverty. If the majority revolt, what can the minority do? I am on the side of the poor, who are an arm. An undernourished arm. We must free the country of the profiteering politicians.

Yesterday I ate that macaroni from the garbage with fear of death, because in 1953 I sold scrap over there in Zinho. There was a pretty little black boy. He also went to sell scrap in Zinho. He was young and said that those who should look for paper were the old. One day I was collecting scrap when I stopped at Bom-Jardim Avenue. Someone had thrown meat into the garbage, and he was picking out the pieces. He told me:

"Take some, Carolina. It's still fit to eat."

He gave me some, and so as not to hurt his feelings, I accepted. I tried to convince him not to eat that meat, or the hard bread gnawed by the rats. He told me no, because it was two days since he had eaten. He made a fire and roasted the meat.. His hunger was so great that he couldn't wait for the meat to cook. He heated it and ate. So as not to remember that scene, I left thinking: I'm going to pretend I wasn't there. This can't be real in a rich country like mine. I was disgusted with that Social Service that had been created to readjust the maladjusted, but took no notice of we marginal people. I sold the scrap at Zinho and returned to São Paulo's back yard, the favela.

The next day I found that little black boy dead. His toes were spread apart. The space must have been eight inches

between them. He had blown up as if made out of rubber. His toes looked like a fan. He had no documents. He was buried like any other "Joe." Nobody tried to find out his name. The marginal people don't have names.

Once every four years the politicians change without solving the problem of hunger that has its headquarters in the favela and its branch offices in the workers' homes.

When I went to get water I saw a poor woman collapse near the pump because last night she slept without dinner. She was undernourished. The doctors that we have in politics know this.

Now I'm going to Dona Julita's house to work for her. I went looking for paper. Senhor Samuel weighed it. I got 12 cruzeiros. I went up Tiradentes Avenue looking for paper. I came to Brother Antonio Santana de Galvão Street, number 17, to work for Dona Julita. She told me not to fool with men because I might have another baby and that afterward men won't give anything to take care of the child. I smiled and thought: In relations with men, I've had some bitter experiences. Now I'm mature, reached a stage of life where my judgment has grown roots.

I found a sweet potato and a carrot in the garbage. When I got back to the favela my boys were gnawing on a piece of hard bread. I thought: for them to eat this bread, they need electric teeth.

I don't have any lard. I put meat on the fire with some tomatoes that I found at the Peixe canning factory. I put in the carrot and the sweet potato and water. As soon as it was boiling, I put in the macaroni that the boys found in the garbage. The *favelados* are the few who are convinced that in order to live, they must imitate the vultures. I don't see any help from the Social Service regarding the *favelados*. Tomorrow I'm not going to have bread. I'm going to cook a sweet potato.

June 16, 1958

José Carlos is feeling better. I gave him a garlic enema and some hortelã tea. I scoff at women's medicine but I had to give it to him because actually you've got to arrange things the best you can. Due to the cost of living we have to return to the primitive, wash in tubs, cook with wood.

I wrote plays and showed them to directors of circuses. They told me:

"It's a shame you're black."

They were forgetting that I adore my black skin and my kinky hair. The Negro hair is more educated than the white man's hair. Because with Negro hair, where you put it, it stays. It's obedient. The hair of the white, just give one quick movement, and it's out of place. It won't obey. If reincarnation exists I want to come back black.

One day a white told me:

"If the blacks had arrived on earth after the whites, then the whites would have complained and rightly so. But neither the white nor the black knows its origin."

The white man says he is superior. But what superiority does he show? If the Negro drinks *pinga,** the white drinks. The sickness that hits the black hits the white. If the white feels hunger, so does the Negro. Nature hasn't picked any favorites.

September 20, 1958

I went to the store and took 44 cruzeiros with me. I bought a kilo of sugar, one of beans, and two eggs. I had two cruzeiros left over. A woman who was shopping spent 43 cruzeiros. And Senhor Eduardo said: "As far as spending money goes, you two are equal."

I said:

"She's white. She's allowed to spend more."

And she said:

"Color is not important."

Then we started to talk about prejudice. She told me that in the United States they don't want Negroes in the schools.

I kept thinking: North Americans are considered the most civilized. And they have not yet realized that discriminating against the blacks is like trying to discriminate against the sun. Man cannot fight against the products of Nature. God made all the races at the same time. If he had created Negroes after the whites, the whites should have done something about it then.

**Pinga:* a white fiery liquor made from sugar cane.

December 8, 1958

In the morning the priest came to say Mass. Yesterday he came in the church car and told the *favelados* that they must have children. I thought: why is it that the poor have to have children—is it that the children of the poor have to be workers?

In my humble opinion who should have children are the rich, who could give brick houses to their children. And they could eat what they wanted.

When the church car comes to the favela, then all sorts of arguments start about religion. The women said that the priest told them that they should have children and when they needed bread they could go to the church and get some.

For Senhor Priest, the children of the poor are raised only on bread. They don't wear clothes or need shoes.

V Twentieth Century: Change and Nonchange

18 / A Mexican Peasant Woman Remembers

In the following selection a Mexican peasant woman called Esperanza, whose life Oscar Lewis recorded, recalls her childhood and youth in a non-Spanish-speaking Indian village in the State of Morelos prior to the outbreak of the Mexican Revolution in 1910, the first major social revolution in Latin America, as well as telling something of her life during the Revolution.* Although that prolonged upheaval had a tremendous impact on many individuals and institutions in Mexico, we may well question whether it was a revolution for women, especially for women in rural areas. From the following autobiographical account we can gain valuable insights into the relationships between men and women in Esperanza's village and culture, including their sexual relationships, the subordination of women, the frequent death of children, and the hard life of Indian peasant women.

"Esperanza"

YOUTH AND MARRIAGE

I must have been about seventeen when I got married. I can't tell because my mother said that she gave my baptismal

*From Oscar Lewis, *Pedro Martínez: A Mexican Peasant and His Family* (New York: Random House, 1964), pp. 48, 51–53, 92–94, 111–112, 115–116. Copyright © 1964 by Oscar Lewis. Reprinted by permission of Random House, Inc.

certificate to my grandma and they threw it away. So that's why I never really knew when I was born. That's why I never celebrated my birthday or even thought about celebrating it.

My *papá* was a field hand. I was a month and a half old when he left us. My mother was married before to Carlos Zúñiga and had four children with him. Three of them died. The only one who lived was my half-brother Emigdio. It was he who supported us. My *mamá* was a very poor woman and had to live with others—we had no house of our own. The only thing she worked at was gleaning the fields. I was little and she carried me everywhere. She said I nursed for three years. My brother borrowed some land and they gave him permission to put up a little house on it.

My poor little mother, always suffering want. My *mamá* would tell me about what went on in the past. My brother took the place of my father; little as he was, he worked in the fields. He didn't even have a shirt and would go naked with my mother to plant the corn. They left me tied under a tree while they worked.

In the house, my brother scolded me and my mother beat me, and I never talked back. Actually, my mother hit me little because I was the only child. One time she sent me to the plaza to buy some liver but I took a long time for they did not serve me. When I returned home I explained what had happened but my mother began to beat me right off. I said to my *mamá*, "You hit me so much that I would rather go to my godmother." My *madrina* liked me a lot and gave me many things.

Then my mother hit me more, hard with a rope. I went running out into the street looking for my godmother's house. My mother came after me and threw a stone at me. Possibly she just wanted to frighten me, for it fell to one side. Later my brother came and defended me. "Why do you hit her so much?" he said to my *mamá*.

I had no liberty whatsoever in my house. In truth I never went anywhere. Many times people wanted to hire me to take care of their children, but my brother would never allow it.

Two other boys from the *barrio* of San Martín asked for me before I married Pedro. I couldn't have been more than fourteen at the time. My brother was already married and had children. I had no idea of getting married, but my mother said, "Better get married. Look, your brother is married and if I die

you'll be left all alone." It never entered my mind that my mother could die and then I thought that if she did I would go to live with my godmother. When the men asked for me she said, "Get married . . . get married! You won't have to work hard, they have a little money." But I kept telling her I didn't want to get married.

I knew nothing of evil things at that time because I had not gone to school and I never went out to visit others for my brother would not allow it. I had heard girls speak of sweethearts but my brother had advised me not to talk to boys or be alone in isolated places because boys might do bad things to me. I respected my brother very much.

I knew no vice. I saw infants and wondered how they had come into the world. I imagined women had to be split apart to take out the babies. Not until I married did I learn about these things. I began to have my monthly period at about fifteen. Like a fool, as soon as it happened I told my mother about it. She said to me, "That's how it is. Now you must be careful. Don't bathe when you are this way, nor eat 'cold' foods. Also, be careful your brother doesn't see a stain on your dress. He is a man but he knows about these things and it always makes one ashamed." I never kept to a diet when I was a girl. Many times one cannot because of poverty. There may be only tomatoes in the house and one has to eat them even though they are "cold."

Some people say a girl is not a virgin if she has her period. They say if a girl doesn't marry, the period never comes. But that is not true because I got it before I married.

I lived around the corner from Pedro's house. I didn't know it, but he was already asking for me. My *mamá* said, "I'll see what the girl says." My brother was of the same opinion. "Whatever the girl says. Even if I have to go on supporting her . . . even if I like the boy, if she doesn't want to marry him, she doesn't get married!"

Fifteen days went by and Pedro's *mamá* came to find out the answer. As I didn't want to get married, they didn't give her any at all. After that my poor little mother-in-law kept coming back and coming back, hoping to get a definite answer. My brother had a talk with Pedro and said, "I like the boy. He is a hard worker."

As a matter of fact he was. Pedro was always working on the *haciendas*. So they kept telling me, "Get married . . . get

married." After Pedro's mother died, they kept insisting even harder.

Then my *mamá* would say to me, "Poor boy, what a pity! All alone . . . nobody to make his *tortillas* for him." She and my brother kept insisting so much, I finally said to them, "If you want me to marry, I will marry."

Pedro never visited me when we were engaged. He only came to the house when my brother sent for him. My brother was very strict and would say, "I don't want that young man here because it may happen that the engagement will be broken and if people see him coming here there will be talk."

I never had any conversation with Pedro before we were married. When he came to the house my mother would talk to him. I would go into the *corral* and wouldn't return until he had gone. Once I was grinding corn when he came and I couldn't go to the *corral*. That time we almost ate together but we didn't talk to each other. What could I have talked about?

After Pedro had asked for my hand I was always afraid of him. Once my *mamá* sent me to sell some eggs and when I went out I saw Pedro standing at the street corner. He saw me also but we did not speak to one another. Because of my fear, I ran all the way to the market place. After I sold the eggs, I came home more afraid than before. First, I tried to hide in a doorway and then I passed by him at a run. I felt cold through and through and had a feeling down my back as if he already had his arms around me. I looked back but there he was, still sitting at the corner.

We were married on the feast day of Saint Peter, in the month of May. Pedro bought me the dress I wore. It was rose color. It was the first dress I had ever worn because I had only worn blouses and skirts. Pedro had on a new shirt and white pants. After the wedding, my godmother took us to the *barrio* fiesta. Pedro gave me fifty *centavos* to buy myself something but I didn't buy anything. What was there to buy?

When we arrived at Pedro's house after the fiesta, my aunt and Pedro's aunt began to make the evening meal. I was inside the house and Pedro was walking around outside. They called to us when the meal was ready but neither he nor I ate much. I wished my mother were at my side.

I remember the night we married, I was very scared. Pedro still bothers me sometimes when he says jokingly, "Why

were you so frightened that night?" To tell the truth, I don't really know what was the matter with me. Chills came over me and I began to tremble. I was very afraid for never, never had we spoken to one another.

A few days before the wedding, my mother gave me advice. "Now that you are going to marry, you must change your character. Here you have one character but there you must have the character of your husband. If he scolds you, do not answer. If he beats you, bear it, because if not, your husband is going to ask what kind of upbringing we gave you." And that is the way I have always been. Whenever Pedro hit me I only sat down and cried. He hit me many times.

After we ate, my aunt went away. Pedro's aunt went to bed and so did he. I was standing near the table and didn't want to go to bed. Pedro called to me but I didn't pay attention to him. His aunt also said, "Go on, go to bed," but I didn't want to. The light was on, and we could all see each other. He had gone to bed with his clothes on. He has always done that. I also always go to bed with my clothes on.

The aunt told me that for this I had got married and that I should go to bed. Then they put out the candle and I finally had to go to bed. I was very afraid and ashamed. Pedro covered me with the blanket and then began to embrace me and to touch my breasts. Then he was opening my legs and went on top of me. I didn't know what men did to one and I said to myself, "Maybe it has to be like this." I felt like crying or going to my mother, but I remembered that they were the ones who had married me. Then I said, "If I die, I'll die. I have to go through it even though he kills me." And I closed my eyes and waited.

Pedro knew how these things were done because he already had a daughter with a married woman. I don't remember that I bled, but it hurt a lot. I didn't cry because there were others there and I was ashamed to be heard. Pedro did it three times that night.

The next day when I got up, how ashamed I felt! Two weeks later I was still afraid but, little by little, one picks up confidence. I didn't talk about these things to anyone, not even my *mamá*. I told only Pedro's cousin what my husband was doing to me. I said, "All men do is play with a person! What do they have to get married for?" She said, "That's how men are and you have to let him, otherwise he will roam the streets at night."

After about two months I was feeling pleasure and I began to love my husband.

THE REVOLUTION

I was not afraid when the Revolution began because I didn't know what it was like. After I saw what it was, I was very much afraid. I saw how the federal troops would catch the men and kill them. They carried off animals, mules, chickens, clothes. The women who came with the soldiers were the ones who took away everything.

The government soldiers, and the rebel soldiers too, violated the young girls and the married women. They came every night and the women would give great shrieks when they were taken away. Afterward, at daybreak, the women would be back in their houses. They wouldn't tell what happened to them and I didn't ask because then people would say, "Why do you want to know? If you want to know, let them take you out tonight!"

For greater safety, we would sleep in the *corral*. Our house was very exposed because the street is one of the main entrances to the village and the soldiers would pass that way. Pedro took us to a relative's house further into the village. There the soldiers never entered. The *zapatistas** were well liked in the village, because although it is true they sometimes carried off young girls, they left the majority of women in peace. And after all, everyone knew what kind of girls they took. The ones who liked that sort of thing!

Sometimes the *zapatistas* would come down to the village and send someone from house to house to ask for *tortillas*. At other times, the government troops did the same thing. We always gave them whatever they asked for. After all, what else could we do? But the government men were the ones who behaved the worst and did us most harm.

One time the government called all the women together in the village plaza. I was in bed. My baby had been born

*Followers of Emiliano Zapata (1880–1919), peasant leader of revolutionary forces in the southern states of Morelos, Guerrero, and Puebla. Ed. note.

a month before. Sick as I was, they made me get up and go. When they had us all there, they told us to go and grind corn and make *tortillas* for the soldiers and then come to sleep with them that night. We ground the corn and delivered the *tortillas* and went off into the hills. Sleep with the soldiers! Not for anything would we have stayed for that!

My mother remained in the village with my brother because he had corn and beans to guard. Sometimes Pedro would leave me with my mother and he would go back to the hills and come down at night. One day my mother died. She died at three o'clock one afternoon and we buried her at six o'clock because they were saying, "The government is coming." We didn't make a coffin for her, poor thing. We just wrapped her in a *petate*,* put a board on either side of her and buried her. Pedro was angry when he came home that night and learned that I had already buried her.

I didn't feel my mother's death, probably on account of it being a time of revolution. Since we were always on the run from the government, I didn't grieve so much over her. After my *mamá* was gone, Pedro took me with him to the hills.

There was no work here any more and Pedro had nothing to do. There was no way to earn money for food. But I didn't want him to go as a *zapatista*. I would say to him, "Even if we don't eat, Pedro." He would answer, "What are we going to live on? If one works, the government grabs him and kills him." That's why when someone cried, "Here comes the government!" Pedro would take his *sarape* and make for the hills.

One day Pedro appeared, carrying his rifle. He told me, "Well, I've done it. I've joined up." He had become a *zapatista* because they offered to give him food. I got very angry but he said at least he would have something to eat and furthermore they would pay him. Then he told me he would have to go to Mexico City with the rebels and he promised to send me money.

He went with the *zapatistas* and left me without a *centavo*. There I was with nothing and I had two children to support, the girl of two years and the boy of two months. Also, I had in my care Pedro's cousin who was about eight years old. I cried in anguish because I didn't know what to do.

My brother was angry with Pedro. He said Pedro was

*Sleeping mat.

lazy and didn't want to work. Pedro had planted corn seed but he didn't want to go to the hills to take care of it. My brother said, "Just as soon as he returns I'll tell him to take back his children and I will support you."

I would leave Pedro's little cousin to rock the baby and go to my brother's house to grind corn. I made the *tortillas* in my brother's house and then I would go running back to see about the children. My sister-in-law would let me have six or seven *tortillas*. I wouldn't eat until after I had divided it with the children.

That way the time went by, eating only a few *tortillas* a day. I had some china plates and I went to sell them. They would give me a handful of corn for each plate. I sold my grinding stone for three *pesos*, but at that time corn cost one peso and a half a *cuartillo** so the money lasted no time at all.

My brother became angrier with Pedro. "When he comes back give him his children, and you come here." I would say, "How can I leave him? I don't know where he is but he has gone to get money."

At last Pedro sent me sixty *pesos* with Pablo Fuentes. But where to buy corn? No one in the village would sell any. A neighbor woman told me to go to Yautepec where they had corn. We went together early the next morning. I had an infant in my arms and so did she. On the road we met the government troops marching to Azteca, but they didn't harm us.

We reached Yautepec and went to the house of an aunt of mine. She said to us, "Ah, my little ones, what have you come here for? Why did it occur to you there would be corn here? Here there is nothing."

The next day we returned to Azteca without a single grain of corn. I continued living all alone in my house. My neighbor, seeing me alone, began to talk to me of love. He would say things . . . that I should sleep with him and he would help me get food. I told him, "You are old enough for me to respect you as a father and you should stop saying such things to me." Then he asked me not to tell Pedro, but I said I was going to.

I never did tell Pedro, to avoid a fight and also because he might think that maybe out of necessity I had paid attention to that old man. And why start bad feeling with one's neighbors?

*Pint.

I did tell my brother, though. He said, "Don't pay any attention to him. He is an old man. I will talk to him. He thinks because we are alone we don't know how to behave ourselves."

It was a dreadful time. We suffered a lot. I no longer had clothing and I wore a soldier's khaki shirt. For Pedro I had to make a shirt of some heavy unbleached muslin.

Then Pedro got sick and I had a very hard time. I had to sell everything I owned, a few little turkey hens and another grinding stone. When we get sick we always have to sell everything.

Three Years in Guerrero

We went to Guerrero because Pedro was a *zapatista*. We could not come back to our village for they would have taken him prisoner and killed him. We went to Guerrero through Jojutla by way of Tlaltizapán. When we crossed the El Estudiante river, he threw away his rifle so the Guerrero authorities wouldn't arrest him. My cousin Domingo was with us. We had a black horse that belonged to him. Who knows where he got it from . . . it was the time of the Revolution. Domingo was a *zapatista*, too.

We crossed the river and then we were in Guerrero. "Now where are we going to stay?" Pedro asked me. I said, "You know best."

We arrived at Santa Fe. There were some women there grinding corn. They said they were from Guanajuato. They asked us to take them to Buena Vista on the horse. Domingo said, "Let's go have a look." So we took the women to Buena Vista and once we were there Pedro and Domingo decided to stay. So we did.

In Buena Vista we went to *señor* Bernardo Cantara. "If you want to work for me," he said, "I won't look any further for *peones*." He asked them whether they wanted to be a plowman or a field hand. Pedro chose plowman.

Later on, when the rainy season was close, Pedro said, "Now we will cut palm leaves to make our house." We were well off in Buena Vista because the men were paid and in addition were given corn. We had no problems there. They built two

huts, one for Domingo and his wife, and one for us and our two children.

We continued working, but Domingo could not stand the work and soon left. We stayed on quite a while . . . three seasons. Then, *don* Bernardo gave Pedro a little plot of land to plant.

I ground corn and later on washed clothes for *don* Bernardo's family. I would take my two children along so they could be at my side in the master's house. We had another boy, Manuel, but he had died of smallpox in Azteca. Then María and Gonzalo also died on me and I was left alone. The girl died of a sickness. She got very thin and as it was the time of the Revolution, there was no doctor to go to and she died without medicine. The boy died of a scorpion sting.

And so I remained all alone. *Don* Bernardo's wife saw me there so sad and crying, and would call to me from her house. She would say that everyone had gone to work and that I should come to be with her. That's how I began to make *tortillas* for them. I always grieved over the death of my children but as there were other people there in the house I had to act as if nothing was wrong.

In the afternoon, the *señora* would take me to the gully to bathe. We would also bring the men their dinner. The death of the children affected Pedro, but it is not the same as with a woman. He cried a little but the grief soon passed. I believe men don't feel, or they feel very little. I feel deeply. Three months went by after their death and I was still crying and crying. I kept remembering how they were. I couldn't get out of my mind the way they walked, the clothing they had . . . I even wanted to sleep in the cemetery and stay there all the time looking at the bit of earth that covered them. And he, when he saw that I was crying, would scold me and that made me angrier and more resentful.

My daughter Conchita was born practically on the Buena Vista hill and was baptized there. *Don* Bernardo was her godfather. A woman took care of me there but I don't know whether she was a midwife or not. Anyway, she lived there and knew how to care for women who were going to give birth. The way she attended me was different from in Azteca. There in Guerrero they don't give massages or medicines for *los aires** during pregnancy, and they don't bathe the mother in the sweat-

*"Harmful winds."

house after the baby is born. The midwife takes no more interest in her and doesn't even come back.

I got on my feet about two weeks later and bathed in lukewarm water outside the house. And that was all. I received no other treatment.

I was like a new person after I started to have children again. I was no longer so lonely. I really missed those children who had died and that's why it made me so happy when Conchita was born. We loved her very much and it was as if she had been our first-born. We spoiled her a lot as it was five years before the following child was born.

We spoiled her, but we also beat her when she cried. She was very bad-tempered. She always wanted to be fed first. If she saw that we were going to eat before her, she would throw herself on the ground and thrash around in rage. That is why her father said she should be given her food first. It made us laugh; we didn't hit her for that. Her father would take her out for a walk so that I could eat without her seeing me. If she saw us eating, she would want to be fed also and it could have done her harm to be eating all day long.

Whenever Conchita got angry she would throw herself on the ground. She was a real crybaby. Later, when she was bigger, she would get mad because we didn't allow her to go everywhere she wanted.

We came back from Guerrero because Pedro did not want to stay there any longer. He said, "We have our own house in Azteca and that is where we belong."

I was sick, too. I think it was from "cold" as they did not bathe me in the *temazcal** after I had Conchita and I didn't always have "hot" food to eat. Pedro would go out to sell the tomatoes he had planted. He would leave me sick and alone. I was often hungry and would look at the tomatoes and feel like eating them. One time I got up out of bed, took two tomatoes roasted them on the hearth and ground them up in the mortar. Then I ate the tomatoes with *chile* peppers. Later on he arrived with the *tortillas*. "Have you eaten?" he asked me. I said that I hadn't, that I had only prepared a tomato with *chile* peppers for myself and that was all. He said that they were bad for me because they were "cold." "Cold" foods are bad for a "cold" illness.

My trouble was that my abdomen hurt me very much.

*Pre-Hispanic Indian steambath or sweathouse. Ed. note.

I was skin and bones and had fevers every day. Pedro had a lot of people look at me, but nobody cured me. He said to me, "As soon as I have the harvest in, we will go to Azteca. They will cure you there." That is the reason we went.

When we got to Azteca, he had a woman look at me. "It's because you are pregnant," she said. "That's why your belly is big." I was here for about five months and nothing changed. So then Pedro said, "The thing is that you are not pregnant at all." And he took me to another curer. This one said that I had "cold" in the belly and she really began to treat me. I was sick and that was the reason I wasn't having children. "It doesn't matter," Pedro said. "The important thing is for you to get cured." She gave me a medicine to take and smeared greases all over my body, oil of camomile, oil of rosemary, and others. There were five different ones that she used. Then, when I was better, my aunt Gloria said to me, "Silly girl, now that you are cured, you are going to have another baby."

"It doesn't matter," I said. Being sick, I couldn't go out anyway. I always had a fever.

I wanted to be cured as I never felt right. But I didn't want any more children. I have always had a horror of having children. The thought of being pregnant would frighten me and sometimes it would make me angry because I was the one who was going to suffer. I cried and cried every time I felt that I was pregnant, especially with the first child because I didn't know what was going to happen. Then I cried even in the daytime and when I was walking in the street.

At night, when my husband took me I became angry because of the danger he put me in. But when I didn't want Pedro to come near me he scolded, saying, "You don't want me because you have some other man." So I had to let him and then I would be pregnant again.

I know that what happens is God's will, so I say, if children come, good, if not, so much the better!

I was glad to be back in Azteca. The village was the same but a lot of people were missing because they had died of hunger. They swelled up and died. Almost none of my people were still living. My brother was alive but he was far away in Puebla. His wife had died and so had his children. I went around asking for my brother and they told me he had gone far

away. When he came back later, it was just to die . . . he was very sick by then.

The Revolution was almost over when we came back from Guerrero and Pedro began to work in the fields. He planted the *tlacolol** and hired himself out as a field hand and in the dry season he made rope.

Five and a half years after Conchita's birth, Rufina was born. It didn't matter to us whether the child was a boy or a girl. Pedro said that it was all the same to him. "Whatever the ladle brings." All children mean money, because when they begin to work, they earn.

But we always wanted our children to be born when the moon was full, so they would come out strong. Even a tree should be pruned in the full moon to have it bloom again.

*A type of agriculture in which planting is done with a primitive hoe on land which is steep, rocky, and wooded. Ed. note.

19 / Women in
Revolutionary Cuba

Vilma Espín, one of the highest ranking women in Cuba, heads the Federation of Cuban Women (FMC). Born in Santiago de Cuba, capital of Oriente Province, she graduated as an industrial chemical engineer in 1954 and then studied at Massachusetts Institute of Technology. On her way back to Cuba in 1956, she stopped in Mexico where she met Fidel Castro. Returning to Oriente Province, she worked with the underground 26th of July Movement, becoming one of its leaders. She later fought with the guerrilla forces of the Second Eastern Front.

After the revolutionary government came to power in January 1959, Vilma Espín became the leader of the new Federation of Cuban Women. In 1969 she was appointed director of industrial development in the .Ministry of Food Industries and, in 1971, president of the Institute of Child Care. She is also a member of the Central Committee of the Cuban Communist Party and the wife of Raúl Castro, Fidel's brother. In the following interview Vilma Espín discusses the position of women in revolutionary Cuba and the liberation of women.* Although some observers may view Cuban women as still largely limited to serving the nation in auxiliary roles and activities, with many basic attitudes remaining unmodified, she stresses the changes and benefits the revolution brought Cuban women.

*Prensa Latina Feature Service (ES-1847/1972), Havana.

Vilma Espín

Question: What role does feminism play in the struggle for the liberation of women? What is the FMC's position on feminist trends?

Vilma Espín: One of the social themes which has been debated throughout history is without doubt that of the woman and her role in society. However, in recent years, during which the revolutionary movement has gained ground throughout the world, the liberation of women is one of the questions that is being discussed by sociologists, psychologists, politicians, economists, that is all those who in one way or another have something to do with the development of society. We should also say that it is a problem which first and foremost, interests woman herself.

In my opinion, the liberation of women cannot be separated from the liberation of society in general. There can be no liberation for a social group constituting half of humankind, as long as exploitation of man by man continues, as long as the means of production are owned by an exploiting minority.

A woman cannot have any political, economic or social rights in a capitalist society where she suffers from class oppression and discrimination because of sex and race.

I mention this in order to answer your question on the role of feminism. Historically, the feminist movement has put forth partial solutions, struggling for political rights—as did the suffragettes—but in my opinion, it has not attacked the roots of the problem, which is the capitalist society.

Of course, the feminist movement as such was progressive in its time, at the start of this century, because it helped to create consciousness in the woman, to take her out of the narrow confines of the home. Even now it can play an agitating role, channel dissatisfactions, but its fundamental weakness is that it strays from the real road which is the struggle for the liberation of the peoples and confuses many women desirous of struggling for a better life.

This feminist movement is quite strong in the United States and in western European countries. There are dozens of groups that have different aims, many of them positive. Of course, the woman is attracted to them in societies that grow increasingly corrupt, where the use of drugs and juvenile delinquency constitute veritable terror for mothers, where the woman is discriminated against as a worker, receiving a lower

salary than men, with few possibilities of highly-qualified jobs or posts. Societies which in some cases are very economically and culturally developed but where truly backward laws exist discriminating against women.

We don't deny that sometimes through this way some women join the struggle, in the measure that they grow in consciousness, acquiring a political development. But unfortunately many feminist groups take away forces that could strengthen the genuinely revolutionary movement.

We even know of some capitalist countries where the ruling class stimulates those movements, they do not persecute them, they let them grow because to a certain extent these movements are playing into the hands of the so-called democracies. Let's not forget that women make up half of the electorate.

The problem of the liberation of women is a class problem and we can't speak of women's liberation as long as the oppressed classes do not free themselves from the exploitation of the oppressing classes. Women's struggle is intimately linked to the struggle of their peoples.

On the other hand, for the peoples who have succeeded in eliminating the exploitation of man by man, the women's problem is one of society in general, a society which must work to incorporate women into active life, into social production. In our country where since the triumph of the Revolution, a tenacious struggle is being waged to overcome underdevelopment, we are creating institutions, services, all the conditions to free women from domestic problems, although we still don't have all the resources we need to do this. We are also waging an intense ideological battle aimed both at women and at the rest of society to eliminate all vestiges of backwardness, the prejudices about women and the role they must play in society. Even in socialist countries with developed economies, where the woman already occupies an important place, there are still problems in the material and ideological aspects, which are being analyzed by society in general, while serious efforts are being made to find the proper solutions.

Question: Do you think that giving women jobs alone will allow women to occupy their rightful place as active and thinking social beings?

Vilma Espín: I mentioned the liberation of women as being a problem not only of women but of all society. Her incorporation into social work is essential for her incorporation into society. Women must play their rightful role in the world.

In Cuba the woman is aware that society needs her, that she is part of the productive forces fighting against underdevelopment to build the material base which will make it possible to create all the institutions, services and industries which will alleviate her domestic work load.

Moreover, work gives new perspectives to women, it broadens their horizons, it takes them out of the home and helps create a social consciousness, but, as is logical, just working itself will not solve all the problems. All society must be aware of this problem and be willing to solve it.

Question: What, in your opinion, have been some of the discriminatory practices against women that the Revolution has eliminated today? What are their roots? What is the way to eliminate them?

Vilma Espín: In all new societies vestiges of previous practices subsist for a long time. It is very difficult to change man's mentality, that's why we still have some vestiges of discrimination and prejudice towards the woman. In woman herself these vestiges have their roots in the centuries of colonial and imperialist exploitation to which we were subjected and to the place which woman occupied in that society: woman in the home and man in the street. Of course, woman in the home means that she was reduced to her role of mother and housewife, for which she did not need a high level of education, according to that idea. Ideas which, on the other hand, served the interests of the exploiting classes, which used the woman as cheap labor reserve whenever necessary.

Let us recall the two world wars when women were needed to work in factories to replace the male workers that went into the armies. Then all pre-established schemes were broken, the woman had to go out of the home and take a place in production.

We can say that the situation of the Cuban woman after the triumph of the Revolution is totally different and that during these thirteen years the political consciousness of men and women has grown and created a totally new situation, although, as I've said, there are still some prejudices. Perhaps the most deep-rooted are the ones referring to the fact of women working.

Not everyone understands the necessity for woman to work, to meet her social duties and raise her cultural and political level.

This is most frequent in the case of men, although there are women who do not understand the problem either.

Sometimes there are some expressions of discrimination in men who lead a certain branch of the economy, who do not consider the woman worker on a fully equal basis. Of course, this is a mental attitude and is not general, they're just manifestations of discrimination which sometimes are evident and other times are not.

However, the Revolution has systematically struggled against this, we can say, right from the start.

In February 1959 Fidel spoke of the exploitation and discrimination of women. The very fact that our organization was created with the aim of incorporating women into the revolutionary process, educating her culturally and politically, implies a struggle to eliminate these vestiges of the previous society.

Our Communist Party and the FMC and all the mass and political organizations have waged and are waging a systematic campaign, because evidently the elimination of even the most minimum discrimination requires a process of political and cultural education.

We have also taken other measures to incorporate women and to create the best conditions for them to change their status from housewife to full-fledged workers. The Party, the Cuban Workers' Federation, the Ministry of Labor and the FMC had made efforts to help women adapt to their new status of workers.

We should mention that this political work is also aimed at explaining the responsibilities that the human couple should assume in this stage of intense struggle for economic development. There is not only the social responsibility of sharing in the education of the children, but also the responsibility of facing all types of practical problems involved in incorporating women into social work.

This is something that the young people, especially the students, work on in common. Since we don't have all the resources we need to alleviate domestic tasks, the fact that the couple share them helps out.

The sharing of important social responsibilities such as the duty of working and of educating children, evidently tightens the bonds uniting the couple and gives a genuine and deep meaning to conjugal love.

Question: In 11 years of work, what have been the fundamental achievements of the FMC in the social order? What are the FMC's objectives in the future?

Vilma Espín: The work of our organization is eminently social and political since we are trying to prepare ideologically a social group that constitutes half the population and incorporate it in full into the revolutionary process so that it will occupy the role it rightfully has in the new society, be it in state administration or in all the other tasks regarding political, cultural, social and economic work in our country.

A truly important achievement of the FMC is the incorporation of women into work. Moreover, the qualitative change has been extraordinary. Women have taken jobs which before they couldn't have. They do so in better conditions since in general their educational and technical level has been raised and they are protected by a more just labor legislation.

Women in work have no limitations at all, except for the problems we mentioned before regarding child care centers, services, etc., which still are not enough to cover the growing demand. Even so, woman, without being part of a work center, fulfills her social duty through voluntary work in agriculture, industry or services. She has made an extraordinary contribution in voluntary work during these years.

Another important achievement has been in education, in educating adult women at the trimph of the Revolution and the possibilities the woman has today to study any career she wants. In this sense, the FMC is making a gigantic effort, creating special adult courses, directing specific plans for the training of organizational cadres, opening technical courses according to the needs of production, studying material on social research and attention, etc.

During 1961, in addition to taking part in the literacy campaign, the FMC had the responsibility of creating massive educational courses. The first thousand attendants for the nursery schools were trained in that year, as well as 17,000 peasant girls who learned to sew and received a general primary education. Thousands of women who had been servants in the homes of the bourgeoisie who had left the country took courses preparing them for administrative work. Later different technical courses were organized by the FMC in coordination with organizations that needed skilled labor. We also worked hard to help out the primary and secondary schools.

In regard to social work, we have developed vast plans in coordination with different ministries, including health education and projects, especially concerning the health of the child, pregnant women and new mothers, children with behavior problems, community services, recreation facilities, etc.

We can say that the FMC has achieved its objectives, the woman is an integral part of the process of transformation going on in our society.

In regard to future tasks we are trying to develop the plans we have today to the maximum, plans which are headed by our secretariats of Production, Social Work, Foreign Relations, Education, Ideological Orientation, Nursery Schools and the organizational and financial work of our organisms, because it should be known that the mass of women in our organization, in addition to doing voluntary work on all fronts, pay all the expenses of the FMC with their dues.

The FMC's work plan for 1972 is ambitious but realistic, since it was first debated at the local level and later passed by our ninth National Plenary.

This year we will also be doing many different tasks supporting the nursery schools, as well in the research plan of the Child Care Institute.

Question: What role does the FMC assign to the Latin American women in their present-day struggle for the liberation of other countries?

Vilma Espín: Latin America is now the scene of great transformations. The revolutionary movement is gaining ground. The triumph of the Popular Unity government in Chile, the interesting and deep-rooted process in Peru, the position taken by Panama in the struggle for sovereignty over the Canal, just to mention the most important processes, show us that the era of absolute U.S. domination in Latin America is beginning to decline. The struggle for the liberation of our sister peoples of Latin America is growing and in it we are feeling more and more the participation of women.

We are convinced that woman must, and will, play a very important role in the fight for full national independence. Moreover, in our great Latin American homeland there is a deep-seated historic tradition of women's struggles. In the battles for our first independence, together with the popular and internationalist armies of San Martin and Bolivar, women

were present. Outstanding fighters such as Colonel Juana Azurduy de Padilla who fought in the area then called Upper Peru; Manuela Saenz, the companion of Bolivar; Remedios Escalada de San Martin; and our own Ana Betancourt who in 1869 demanded that woman's rights be included in the new constitution; Mariana Grajales, the mother of the Maceo brothers, the heroes of our independence; Captains of the Liberating Army, Adela Azcuy and Rosa Castellanos, the Bayamesa, and many others who not only helped the combatants but were also combatants themselves.

Thus, with these examples which we have inherited and the awakening of consciousness on the part of the Latin American woman, we know that women will make their enormous renovating and patriotic force felt in the struggles for the liberation of their peoples and for their second and definitive independence.

Our people, our women, are following the development of these struggles and have expressed their full solidarity with them.

20 / A Poet in Argentina

 Somewhat as Juana Inés de la Cruz's poetry protested the position of women in colonial society, so does the poetry of Alfonsina Storni (1892–1938) voice some of the frustrations and longings of certain twentieth-century Latin American women. The daughter of Italian Swiss immigrants to Argentina, Alfonsina Storni was born in Sala Capriasca, in the Canton of Ticino, during an extended visit her parents paid to their native land. Alfonsina grew up in the interior of Argentina, where she taught school before moving to Buenos Aires, the huge national capital, and giving birth to a child. She supported herself and her infant son by working as a clerk and shop girl while continuing to write. Her first book of poetry appeared in 1916. Subsequent volumes won her several literary prizes and she secured various teaching positions. Through her talents and efforts, Alfonsina Storni made a name for herself in the male-dominated literary circles of Buenos Aires. In 1938, suffering from cancer, she committed suicide by walking into the sea at the resort of Mar del Plata.

 The following two poems, published in 1925 and 1919 respectively, reflect her understanding of the traditional position of Latin American women and the anguish and pain they could feel, as well as her need for freedom in relations with men.*

*From Alfonsina Storni, *Obra poética completa* (Buenos Aires: Ediciones Meridion, 1961), pp. 165–166, 232.

Alfonsina Storni

SHE WHO UNDERSTANDS

With her dark head fallen
 forward,
The beauteous woman, past her
 youth,
Kneels in suppliant fashion; and
 the dying Christ
From the rugged cross looks on
 her with pity.

In her eyes a burden of vast
 sadness,
In her womb the burden of an
 unborn child,
Before the white Christ bleeding
 there she prays:
—Lord, do not let my child be
 born a woman!

LA QUE COMPRENDE

Con la cabeza negra caída hacia
 adelante
Está la mujer bella, la de mediana
 edad,
Postrada de rodillas, y un Cristo
 agonizante
Desde su duro leño la mira con
 piedad.

En los ojos la carga de una
 enorme tristeza,
En el seno la carga del hijo por
 nacer;
Al pie del blanco Cristo que está
 sangrando reza:
—¡Señor, el hijo mío que no
 nazca mujer!

TINY MAN

Tiny man, tiny man,
Set your canary free for she
 wants to fly . . .
I am the canary, tiny man,
Let me burst out.

I was in your cage, tiny man,
Tiny man what a cage you give
 me.
I say tiny because you don't
 understand me,
Nor will you ever understand me.

HOMBRE PEQUEÑITO

Hombre pequeñito, hombre
 pequeñito,
Suelta a tu canario que quiere
 volar . . .
Yo soy el canario, hombre
 pequeñito,
Déjame saltar.

Estuve en tu jaula, hombre
 pequeñito,
Hombre pequeñito que jaula me
 das,
Digo pequeñito, porque no me
 entiendes,
Ni me entenderás.

Neither do I understand you, but meanwhile
Open my cage for I want to escape;
Tiny man, I loved you half an hour,
Don't ask more of me.

Tampoco te entiendo, pero mientras tanto
Ábreme la jaula, que quiero escapar;
Hombre pequeñito, te amé media hora,
No me pidas más.

Bibliographical Survey of Writings on Latin American Women

Women in the Iberian peninsula have claimed the attention of various scholars. Marcelin Defourneaux, *La vie quotidienne en Espagne au siècle d'or* (Paris: Hachette, 1964), pp. 167–186, describes the life of Spanish women during Spain's Golden Age, from their education to their dress, domestic affairs, and ventures outside the home. The distinguished Portuguese historian Antonio H. de Oliveira Marques, *Daily Life in Portugal in the Late Middle Ages*, trans. S. S. Wyatt (Madison: University of Wisconsin Press, 1971), pp. 167–180, includes the institution of marriage and patterns of affection and sexual relations in his study of daily life in Portugal from the twelfth to fifteenth centuries. Ann M. Pescatello's ambitious attempt to cover almost all aspects of the female experience in Iberia and the Iberian colonies in Asia, Africa, and the New World over a five-hundred-year period, *Power and Pawn: The Female in Iberian Families, Societies, and Cultures* (Westport, Conn.: Greenwood Press, 1976), contains a chapter on women in Spain and Portugal.

Fewer modern scholars have studied Indian women of the preconquest period. A Swedish anthropologist, Anna-Britta Hellbom, *La participación cultural de las mujeres: Indias y mestizas en el México precortesiano y post revolucionario* (Stockholm: Etnografiska Museet, 1967), who relies heavily on Bernardino de Sahagún, *General History of the Things of New Spain* (cited together with other contemporary accounts in the first four footnotes to the introduction to this volume) analyzes the position of Aztec women both before and after the conquest, comparing their lives and activities to those of Indian women in modern times. June Nash, an American anthropologist, discusses the constant dimi-

nution in the power of women as a kinship-based Aztec society became a class-structured empire in "The Aztecs and the Ideology of Male Dominance," *Signs: Journal of Women in Culture and Society*, 4 (Winter 1978), 349–362. Irene Silverblatt presents an overview of Incan women in "Andean Women in the Inca Empire," *Feminist Studies*, 4 (October 1978), 37–61. Two anthropologists, Beverly L. Chiñas, *The Isthmus Zapotecs: Women's Roles in Cultural Context* (New York: Holt, Rinehart & Winston, 1973), and Mary Lindsay Elmendorf, *The Mayan Woman and Change* (Cuernavaca: Centro Intercultural de Documentación, 1972), treat women in different contemporary Mesoamerican Indian cultures.

Nuns have proved the subjects of more serious investigation than have any other group of women in colonial Latin America, as in archival-based articles by Asunción Lavrin, "Values and Meaning of Monastic Life for Nuns in Colonial Mexico," *Catholic Historical Review*, 58 (October 1972), 367–387; "The Role of Nunneries in the Economy of New Spain in the Eighteenth Century," *Hispanic American Historical Review*, 46 (November 1966), 371–393; "La riqueza de los conventos de monjas en Nueva España: Estrutura y evolución durante el siglo XVII," *Cahiers des Amériques Latines*, 8 (1973), 91–122; and by Susan Soeiro, "The Social and Economic Role of the Convent: Women and Nuns in Colonial Bahia, 1677–1800," *Hispanic American Historical Review*, 54 (May 1974), 209–232; "The Feminine Orders in Colonial Bahia, Brazil: Economic, Social, and Demographic Implications, 1677–1800," in Asunción Lavrin, ed., *Latin American Women: Historical Perspectives* (Westport, Conn.: Greenwood Press, 1978), pp. 150–172 (this book of essays comprises the best collection of new scholarship on women in Latin American history, concentrating on the colonial period and the nineteenth century); and by Ann Miriam Gallagher, "The Indian Nuns of Mexico City's *Monasterio* of Corpus Christi, 1724–1821," in Lavrin, ed., *Latin American Women*, pp. 150–172. More has been written about Sister Juana Inés de la Cruz than about any other nun, or perhaps any other woman, of the colonial period. In *Baroque Times in Old Mexico: Seventeenth-Century Persons, Places and Practices* (Ann Arbor: University of Michigan Press, 1959), pp. 172–192, Irving Leonard sympathetically discusses her life and gives some examples of her work. Octavio Paz, a leading Mexican intellectual, has sought to understand and analyze her life and work: "Juana Ramírez," *Signs: A Journal of*

WRITINGS ON LATIN AMERICAN WOMEN / 179

Women in Culture and Society, 5 (Autumn 1979), 80–97 (an issue of the journal containing a special section on women in Latin America). Other writings on Juana Inés de la Cruz include Fanchon Royer, *The Tenth Muse: Sor Juana Inés de la Cruz* (Paterson, N.J.: Anthony Guild Press, 1952), and Anita Arroyo, *Razón y pasión de Sor Juana* (Mexico: Editorial Porrúa, 1971). James D. Henderson and Linda Roddy Henderson also give a sketch of her life in *Ten Notable Women of Latin America* (Chicago: Nelson-Hall, 1978), a collection of biographical vignettes based on standard sources, retelling stories of familiar heroines such as Inés Suárez, Policarpa Salavarrieta, and Gabriela Mistral.

Fewer useful published studies of other groups of colonial women can be found. The pioneering work of James Lockhart, *Spanish Peru 1532–1560: A Colonial Society* (Madison: University of Wisconsin Press, 1968), largely based on notarial records, contains a valuable chapter (pp. 150–170) on Spanish women and the second generation in Peru. Nancy O'Sullivan-Beare, *Las mujeres de los conquistadores. La mujer española en los comienzos de la colonización americana. Aportaciones para el estudio de la transculturación* (Madrid: Compañía Bibliográfica Española, 1956), describes the activities, adventures, and achievements of Spanish women during the early colonial period. The cursory and condescending account by C. R. Boxer, *Women in Iberian Expansion Overseas, 1415–1815: Some Facts, Fancies and Personalities* (New York: Oxford University Press, 1975), contains a chapter on some women in Spanish and Portuguese America. Micaela Bastidas and other women involved in Peru's Indian rebellions of the 1780s are discussed in Lillian Estelle Fisher, *The Last Inca Revolt, 1780–1783* (Norman: University of Oklahoma Press, 1966), especially pp. 192–211. Lavrin, ed., *Latin American Women*, contains two broad essays on colonial women: Lavrin, "In Search of the Colonial Woman in Mexico: The Seventeenth and Eighteenth Centuries"; and A. J. R. Russell-Wood, "Female and Family in the Economy and Society of Colonial Brazil"; as well as more specific essays: Elinor C. Burkett, "Indian Women and White Society: The Case of Sixteenth-Century Peru"; Edith Courturier, "Women in a Noble Family: The Mexican Counts of Regla, 1750–1830"; Johanna S. R. Mendelson, "The Feminine Press: The View of Women in the Colonial Journals of Spanish America, 1790–1810." See also Asunción Lavrin and Edith Courturier, "Doweries and Wills: A View of Women's Socioeconomic Role in Colonial Guadalajara and Puebla, 1640–1790,"

Hispanic American Historical Review, 59 (May 1979), 280–304.

Questions of race relations and marriage have attracted the attention of a number of scholars, leading to general studies such as Magnus Mörner, *Race Mixture in the History of Latin America* (Boston: Little, Brown and Company, 1967), as well as to specialized ones such as Edgar F. Love, "Marriage Patterns of Persons of African Descent in a Colonial Mexico City Parish," *Hispanic American Historical Review*, 51 (February 1971), 79–91; and Verena Martínez-Alier, *Marriage, Class and Colour in Nineteenth-Century Cuba: A Study of Racial Attitudes and Sexual Values in a Slave Society* (Cambridge: Cambridge University Press, 1974), one of the few good books on women in nineteenth-century Latin America, for these women have received less scholarly attention than those of the colonial period or the twentieth century. The now-classic work of Gilberto Freyre, *The Masters and the Slaves*, trans. Samuel Putnam (New York: Alfred A. Knopf, 1946), on slavery and plantation life, including the place of women, in northeastern Brazil, can be compared with the revisionist study by Stanley J. Stein, *Vassouras: A Brazilian Coffee County, 1850–1900* (Cambridge, Mass.: Harvard University Press, 1957), which contains a valuable section on women, both slave and free (pp. 150–160), on coffee plantations in the province of Rio de Janeiro.

Studies of marriage and the family in colonial and nineteenth-century Latin America include Donald Ramos, "Marriage and the Family in Colonial Vila Rica," *Hispanic American Historical Review*, 55 (May 1975), 200–225; Susan Migden Socolow, "Marriage, Birth, and Inheritance: The Merchants of Eighteenth-Century Buenos Aires," *Hispanic American Historical Review*, 60 (August 1980), 387–406; and Silvia Arrom, ed., *La mujer mexicana ante el divorcio eclesiástico, 1800–1857* (Mexico: SepSetentas, 1976). Ann Hagerman Johnson has given us an innovative analysis of the impact of the market economy on lower-class rural family and household structures: "The Impact of Market Agriculture on Family and Household Structure in Nineteenth-Century Chile," *Hispanic American Historical Review*, 58 (November 1978), 625–648. Elizabeth Anne Kuznesof, "The Role of the Female-Headed Household in Brazilian Modernization: São Paulo 1765 to 1836," *Journal of Social History*, 13 (Summer 1980), 589–613, demonstrates what can be done with adequate demographic material, sound methodology, and access to computer time. Studies of marriage and the family in the twentieth century include, for Mexico, María Elvira Bermúdez, *La vida*

familiar del mexicano (Mexico: Antigua Librería Robredo, 1955), Noel F. McGinn, "Marriage and Family in Middle-Class Mexico," *Journal of Marriage and the Family*, 28 (August 1966), 305–313, and Fernando Peñalosa, "Mexican Family Roles," *Journal of Marriage and the Family*, 30 (November 1968), 680–689; for Guatemala, Lois Paul and Benjamin D. Paul, "Marriage Patterns in Guatemala," *Southwestern Journal of Anthropology*, 19 (Spring 1963), 131–148; for Brazil, Antônio Cândido, "The Brazilian Family," in T. Lynn Smith and Alexander Marchant, eds., *Brazil: Portrait of Half a Continent* (New York: The Dryden Press, 1951), pp. 291–311, Thales de Azevedo, "Family, Marriage and Divorce in Brazil," in Dwight B. Heath and Richard N. Adams, eds., *Contemporary Cultures and Societies in Latin America* (New York: Random House, 1965), pp. 288–310, and Manoel Tosta Berlinck, *The Structure of the Brazilian Family in the City of São Paulo* (Ithaca: Cornell University Press, 1969); and for Colombia, Virginia Gutiérrez de Pineda, *Familia y cultura en Colombia* (Bogotá: Universidad Nacional de Colombia, 1968). More recent scholarship on the family in Latin America is found in a special issue of the *Journal of Family History*, 3 (Winter 1978), edited by Francesca M. Cancian, Louis Wolf Goodman, and Peter H. Smith.

The political participation and activities of Latin American women in the nineteenth-century have received very little attention. Their role in the independence struggle in northern South America is examined by Evelyn Cherpak, "The Participation of Women in the Independence Movement in Gran Colombia, 1780–1830," in Lavrin, ed., *Latin American Women*, pp. 219–234. Questions of feminism and women's rights as pursued by educated middle- and upper-class women are analyzed by June E. Hahner, "The Nineteenth-Century Feminist Press and Women's Rights in Brazil," and by Cynthia Jeffress Little, "Education, Philanthropy, and Feminism: Components of Argentine Womanhood, 1860–1926," in Lavrin, ed., *Latin American Women*, pp. 254–285 and 235–253, respectively.

More social scientists than historians have investigated aspects of women's suffrage movements and political activities of Latin American women in the twentieth century. In "Feminism, Women's Rights, and the Suffrage Movement in Brazil, 1850–1932," *Latin American Research Review*, 15(1), 65–111, historian June E. Hahner analyzes the development of women's rights activities and the women's suffrage movement in Latin America's largest nation. The Mexican suffrage movement has been stud-

ied in detail by Ward M. Morton, *Woman Suffrage in Mexico* (Gainesville: University of Florida Press, 1962). Events in Yucatán, a center for women's rights activities during the early 1920s, are scrutinized by Anna Macías, "Felipe Carrillo Puerto and Women's Liberation in Mexico," in Lavrin, ed., *Latin American Women*, pp. 286–301. The political attitudes of Mexican women, once enfranchised, are analyzed by William J. Blough, "Political Attitudes of Mexican Women: Support for the Political System among a Newly Enfranchised Group," *Journal of Inter-American Studies and World Affairs*, 14 (May 1972), 201–224. Elsa M. Chaney considers female political participation, especially in Chile and Peru, in *Supermadre: Women in Politics in Latin America* (Austin and London: University of Texas Press, 1979). See also JoAnn Aviel, "Changing the Political Role of Women: A Costa Rican Case Study," in Jane S. Jaquette, ed., *Women in Politics* (New York: John Wiley and Sons, 1974), pp. 281–303. In *La mujer chilena (El aporte femenino al progreso de Chile) 1910–1960* (Santiago: Editorial Andrés Bello, 1962), Felicitas Klimpel, a Chilean scholar, deals with the role of women in politics in her country, especially their apathy, ignorance, and lack of participation in party politics. A Brazilian scholar, Eva Alterman Blay, discusses women and politics at the local level, "The Political Participation of Women in Brazil: Female Mayors," *Signs: Journal of Women in Culture and Society*, 5 (Autumn 1979), 42–59. That most politically powerful woman, Eva Perón, has been the subject of many books, including Benigno Acossano, *Eva Perón, su verdadera vida* (Buenos Aires: Editorial Lamas, 1955), a sympathetic but generally balanced biography, and Mary F. Main (pseud. María Flores), *The Woman with the Whip: Eva Perón* (Garden City, N.Y.: Doubleday, 1952), an undocumented and somewhat hostile biography; more recent interpretations can be found in Jeane Kirkpatrick, *Leader and Vanguard in Mass Society: A Study of Peronist Argentina* (Cambridge, Mass.: MIT Press, 1971), and Julie M. Taylor, *Eva Perón: The Myths of a Woman* (Chicago: University of Chicago Press, 1979). Nancy Caro Hollander, "Women: The Forgotten Half of Argentine History," in Ann Pescatello, ed., *Female and Male in Latin America: Essays* (Pittsburgh: University of Pittsburgh Press, 1973), pp. 141–158, relates the effects of the Perón years on the status of Argentine women.

Aspects of women's economic activities in Latin America have not gone unnoticed, although studies of women and work in the colonial period or the nineteenth century are rare.

For nineteenth-century Brazil, see the pioneering study by June E. Hahner, "Women and Work in Brazil, 1850–1920: A Preliminary Investigation," in Dauril Alden and Warren Dean, eds., *Essays Concerning the Socioeconomic History of Brazil and Portuguese India* (Gainesville: University Presses of Florida, 1977), pp. 87–117. Blanca Stabile, "The Working Woman in the Argentine Economy," *International Labor Review*, 85 (February 1962), 122–128, points out inequalities in salary and other factors hampering women in one of the most industrialized and prosperous Latin American nations, twentieth-century Argentina, but, remains optimistic for the future. Gloria González Salazar discusses women's limited participation in economic activities in contemporary Mexico: "Participation of Women in the Mexican Labor Force," in June Nash and Helen Icken Safa, eds., *Sex and Class in Latin America* (New York: Praeger, 1976), pp. 183–201, a volume which also contains several other essays on women and work. Margaret Fisher Katzin, "The Business of Higglering in Jamaica," *Social and Economic Studies*, 9 (1960), 277–331, describes the activities of those dealers in local produce. Heleieth I. B. Saffioti, *Women in Class Society*, trans. Michael Vale (New York and London: Monthly Review Press, 1978), not only discusses economic questions, but she also treats many other facets of twentieth-century history of women in her country, Brazil. Additional material on economic and other aspects of women's experience in Brazil from the colonial period to the present are found in the documentary history edited by June E. Hahner, *A Mulher no Brasil* (Rio de Janeiro: Editôra Civilisação Brasileira, 1978). Specific groups of working women such as domestic servants are treated by Margo L. Smith, "Domestic Service as a Channel of Upward Mobility," in Pescatello, ed., *Female and Male in Latin America*, pp. 192–207, and "The Female Domestic Servant and Social Change: Lima, Peru," in Ruby Rohrlich-Leavitt, ed., *Women Cross-Culturally: Change and Challenge* (The Hague and Paris: Mouton Publishers, 1975), pp. 163–180; and by Elizabeth Jelin, "Migration and Labor Force Participation of Latin American Women: The Domestic Servants in the Cities," *Signs: Journal of Women in Culture and Society*, 3 (Autumn 1977), 129–141. This issue of *Signs* contains additional studies on women and development. Questions of women, production, and class are approached largely from a Marxist perspective in the special issue of *Latin American Perspectives*, 4 (Winter and Spring 1977), on "Women and Class Struggle." Five more essays on Latin American women are found in the Fall 1977

issue of *Latin American Perspectives*. An extensive collection of essays on Chilean women, organized by Paz Covarrubias and Rolando Franco, *Chile: Mujer y sociedad* (Santiago: Fondo de las Naciones Unidas para la Infancia/Alfabeta Impresora Ltda., 1975), contains a number of articles on women and work. Accounts by lower-class participants in economic or social struggles are far more rare than analyses by outsiders. Domitilia Barrios de Chungara, a Bolivian miner's wife, has given us her own story, as told to a Brazilian reporter, which includes an account of her participation in the International Women's Year Conference in Mexico City in 1975: Domitilia Barrios de Chungara and Moema Viezzer, *Let Me Speak! Testimony of Domitilia, A Woman of the Bolivian Mines*, trans. Victoria Ortiz (New York: Monthly Review Press, 1979).

Attitudes toward women and images of them comprise another field for investigation. While Louisa S. Hoberman, "Hispanic American Women as Portrayed in the Historical Literature: Types or Archetypes?," *Revista/Review Interamericana*, 4 (Summer 1974), 136–147, concentrates on the colonial period and the nineteenth century, Colin M. MacLachlan, "Modernization of Female Status in Mexico: The Image of Women's Magazines," *Revista/Review Interamericana*, 4 (Summer 1974), 246–257, deals with just one country in the twentieth century. Going beyond *machismo*, Evelyn P. Stevens, "Marianismo: The Other Face of Machismo in Latin America," in Pescatello, ed., *Female and Male in Latin America*, pp. 89–102, constructs and analyzes its feminine complement. The summer 1974 issue of the *Revista/Review Interamericana* also contains several studies of women in literature, as does Pescatello, ed., *Female and Male in Latin America*.

Women's participation in revolutionary movements and the effects of those movements on women's lives and roles have not been ignored. Jane S. Jaquette, "Women in Revolutionary Movements in Latin America," *Journal of Marriage and the Family*, 35 (May 1973), 344–354, considers women in guerrilla movements in the mid-twentieth century, linking the independence period with later events. In his first-hand account of Pancho Villa's forces during the Mexican Revolution, the first major social revolution in Latin America, John Reed, *Insurgent Mexico* (New York: International Publishers, 1969), portrays the life of the *soldaderas* as well as male attitudes toward them. Frederick C. Turner, "Los efectos de la participación femenina en la Revolución de 1910," *Historia Mexicana*, 16 (April–June 1967), 602–

620, describes the effect, or rather, the frequent lack of effect, of the Mexican Revolution on women. In "Women and the Mexican Revolution, 1910–1920," *The Americas*, 27 (July 1980), 53–82, Anna Macías discusses women's significant but overlooked role in the revolution, and stresses their intellectual participation in the country's crisis. María de los Angeles Mendieta Alatorre, *La mujer en la revolución mexicana* (Mexico: Instituto Nacional de Estudios Históricos de la Revolución Mexicana, 1961), also examines feminine participation in the revolution as well as the suffrage movement itself. Elena Poniatowska, *Hasta no verte Jesús mío* (Mexico: Biblioteca Era, 1969), illustrates, in novelistic form, the effects of the revolution on a peasant woman who becomes an urban dweller.

Although their writing varies greatly as to quality and extent, outsiders have shown more interest in women in Cuba, the site of the most recent social revolution in Latin America, than in Mexican women. Differing but sympathetic views of women's roles in revolutionary Cuba appear in the work of such United States social scientists as Susan Kaufman Purcell, "Modernizing Women for a Modern Society: The Cuban Case," in Pescatello, ed., *Female and Male in Latin America*, pp. 258–271; Maurice Zeitlin, *Revolutionary Politics and the Cuban Working Class* (Princeton: Princeton University Press, 1967), whose book contains a chapter on sex and the single worker (pp. 120–131); Max Azicri, "Women's Development Through Revolutionary Mobilization: A Study of the Federation of Cuban Women," *International Journal of Women's Studies*, 2 (January/February 1979), 27–50; as well as in the observations of Chris Camarano, "On Cuban Women," *Science and Society*, 35 (Spring 1971), 48–58; and those comments of a member of the Venceremos Brigade, Joan Berman, "Women in Cuba," *Women: A Journal of Liberation*, 1 (Summer 1970), 10–14. Before his death, Oscar Lewis extended his investigations to Cuba: Oscar Lewis, Ruth M. Lewis, and Susan M. Rigdon, *Four Women Living the Revolution: An Oral History of Contemporary Cuba* (Chicago: University of Illinois Press, 1977). Also of interest are the interviews with Cuban women integrated into revolutionary life found in Margaret Randall, ed., *Cuban Women Now: Interviews with Cuban Women* (Toronto: Dumont Press, 1974); Laurette Séjourné, *La mujer cubana en el quehacer de la historia* (Mexico: Editorial Siglo XXI, 1980), also using interviews; and Fidel Castro's speeches in *Women and the Cuban Revolution: Speeches by Fidel Castro; Articles by Linda Jenness* (New York: Path-

finder Press, 1971). Additional materials on Cuban women can be found in the bibliography compiled by Nelson P. Valdés, "A Bibliography on Cuban Women in the Twentieth Century," *Cuban Studies Newsletter*, 4 (June 1974), and in Meri Knaster, *Women in Spanish America: An Annotated Bibliography from Pre-Conquest to Contemporary Times* (Boston: G. K. Hall, 1977), the most inclusive bibliography on women in Spanish America.

Finally, there are the writings of leading Latin American feminists, including one of Chile's most famous educators, Amanda Labarca Hubertson, *¿A dónde va la mujer?* (Santiago: Ediciones Extra, 1934), and *Feminismo contemporáneo* (Santiago: Zig-Zag, 1947); Argentina's Alicia Moreau de Justo, *La mujer en la democracia* (Buenos Aires: El Ateneo, 1945); and Brazil's Rose Marie Muraro, *A mulher na construção do mundo futuro* (Petrópolis: Editôra Vozes, 1967). Some United States social scientists have also considered feminism in Latin America. Whereas Elsa M. Chaney, "Old and New Feminists in Latin America: The Case of Peru and Chile," in Pescatello, ed., *Female and Male in Latin America*, pp. 331–343, concerns herself with feminists in Peru and Chile and the prospects for women's liberation there, Evelyn P. Stevens, "The Prospects for a Women's Liberation Movement in Latin America," *Journal of Marriage and the Family*, 35 (May 1973), 313–321, considers these questions on a broader scale Doris Meyer, *Victoria Ocampo: Against the Wind and the Tide* (New York: George Braziller, Inc., 1979), has given us a valuable biography of that Argentine writer and feminist, the first woman named to membership in the Argentine Academy of Letters.